Angelic Mistakes

Thomas Merton in the 1960s. Photograph: John Lyons.
With the permission of the Merton Legacy Trust.

Angelic Mistakes

THE ART OF THOMAS MERTON

Roger Lipsey

FOREWORD BY

Paul M. Pearson

Director of the Thomas Merton Center,
Bellarmine University

New Seeds
Boston & London
2006

New Seeds Books

An imprint of Shambhala Publications, Inc.

Horticultural Hall

300 Massachusetts Avenue

Boston, Massachusetts 02115

www.newseeds-books.com

9 8 7 6 5 4 3 2 1

First Edition

Printed in the United States of America

⊗ This edition is printed on acid-free paper that meets the American National Standards Institute z39.48 Standard.

Distributed in the United States by Random House, Inc., and in Canada by Random House of Canada Ltd

Interior design and composition: Greta D. Sibley & Associates

Index by John Dibs

Library of Congress Cataloging-in-Publication Data

Lipsey, Roger, 1942–

Angelic mistakes: the art of Thomas Merton/Roger Lipsey; with a preface by Paul M. Pearson.

p. cm.

Includes bibliographical references and index.

ISBN-13 978-1-59030-313-9 (alk. paper)

ISBN-10 1-59030-313-X

1. Merton, Thomas, 1915–1968—Criticism and interpretation. 2. Christian art and symbolism. 3. Art, Zen—Influence. I. Title: Art of Thomas Merton. II. Merton, Thomas, 1915–1968. III. Title.

N6537.M473L57 2006

769.92—dc22

2005056133

Remembering Thomas Merton
(1915–1968)

And let the beauty of the Lord our God be upon us:
And establish thou the work of our hands upon us;
Yea, the work of our hands establish thou it.

<div align="right">

—Psalm 90:17

</div>

CONTENTS

Three Studies

ACKNOWLEDGMENTS

This book owes much to its friends and to Thomas Merton's friends. The greatest debt, immeasurable, is to Dr. Paul M. Pearson, Director of the Thomas Merton Center at Bellarmine University, Louisville, Kentucky. Without his unique knowledge and utterly generous help, this book could not have been written. I trust that our collaboration will yield more than one fruit.

A team of artists from the University of Louisville, James Grubola, John Begley, and John Whitesell, responded without reserve or delay to my call for studio expertise. The appendix to this book is their work. I thank them most sincerely. I also recall with gratitude an early conversation with Terry Robbins about Merton's printmaking practice.

Mark Meade, Assistant Archivist at the Thomas Merton Center, knows my debt to him. His patience in providing a needy author with documents was so impressive. Jenny Doyle, who created a vast database of passages from Merton's writings and organized the "Children's Crusade" among her college friends, knows my debt to her. And Dianne Edwards, who helped sort things out at the end, knows my debt to her and to her assistant, Lynne Reeve.

The two trustees of the Merton Legacy Trust whom it has been my pleasure to meet, Tommie O'Callaghan and Anne McCormick, kindly welcomed this project. I thank them.

I want to recognize, with friendship and gratitude, the role of Professor Margaret Betz of the Savannah College of Art and Design. Since the early 1980s we have both been aware of Thomas Merton's later art and the need for a book. Over the years we encouraged one another's interest, and it was never clear, or even important, which of us would eventually write it. We knew only that such a thing was needed. There is more to do. It is her turn.

Brother Patrick Hart and Brother Paul Quenon, at the Abbey of Gethsemani, have been friends to this project. I hope never to forget the understated but real solemnity with which, thanks to their request, the painting given to Merton by Ad Reinhardt was retrieved from safekeeping in the depths of the monastery and kindly shown to me.

Individual owners of drawings by Thomas Merton have been generous. Roberto Bonazzi, Tom Cornell, Nancy Holloway, Albert Romkema, and the Jesuits in New York City did everything needed to ensure my

knowledge of works in their possession. How very kind. In a similar vein, Nicholas Wilke generously provided information about his father Ulfert Wilke's work.

Among scholars, publishers, and friends of Thomas Merton, I had the good fortune to receive help from William Claire, Jim Forest, Jonathan Greene, Paul Holbrook, Setsuya Kotani, Kay Larson, and Patrick O'Connell. Without librarians of skill and patience, a book such as this cannot be written. My thanks to you in the rare book and manuscript divisions at Boston College, Columbia University, and the University of Louisville.

I recommend the team at Grey Printing, Cold Spring, New York, for all of my readers' printing and graphic needs. Thanks, Lindsay.

Three special salutes: the first to Gray Henry, a scholar and publisher who warms Louisville with her friendship and enthusiasm for all good things. The second to my friend Mihoko Okamura-Bekku, for her persevering effort to provide a rare photograph of Thomas Merton with D. T. Suzuki and for her help in verifying the authenticity of the Suzuki scroll. And the third to Lorraine Kisly, irreplaceable friend and co-worker, who brought this book to Shambhala Publications.

I want to record my gratitude to David O'Neal, senior editor, and the executive and design groups at Shambhala Publications, for publishing this book and publishing it well.

My wife, Susan, sent me an e-mail when I had just begun to write, in which she explained how to proceed calmly and well. Recall with me something Merton said: "Any moment you can break through to the underlying unity which is God's gift."

ILLUSTRATIONS

Frontispiece portrait: Thomas Merton in the 1960s. Photograph by John Lyons. With the permission of the Merton Legacy Trust.

The Invisible Art of a Highly Visible Man

FIGURE 1 (p. 4) Pen and pencil drawing of a cross by Thomas Merton, ca. 1949–1953. Image size: 9 1/16" h x 7 1/2" w. Thomas Merton Papers, Rare Book and Manuscript Library, Columbia University. With the permission of Columbia University and the Merton Legacy Trust.

FIGURE 2 (p. 4) Brush drawing, head of a woman, by Thomas Merton, before 1960. Image size: 8 1/4" h x 6 1/2" w. Thomas Merton Center 121. With the permission of the Merton Legacy Trust.

FIGURE 3 (p. 5) Brush drawing, head of a monk, by Thomas Merton, before 1960. Image size: 7 1/4" h x 6" w. Thomas Merton Center 259. With the permission of the Merton Legacy Trust.

FIGURE 4 (p. 5) Brush drawing of a monk by Thomas Merton, before 1960. No. 24 in a series. Image size: 9 3/4" h x 6 1/2" w. Thomas Merton Papers, Rare Book and Manuscript Library, Columbia University. With the permission of Columbia University and the Merton Legacy Trust.

FIGURE 5 (p. 11) Thomas Merton with D. T. Suzuki, New York, June 16–17, 1964. Photograph by Mihoko Okamura-Bekku. With the permission of the photographer.

FIGURE 6 (p. 11) Interior of Thomas Merton's hermitage in the 1960s with Sengai calendar. Photograph by Thomas Merton. Thomas Merton Center D102. With the permission of the Merton Legacy Trust.

FIGURE 7 (p. 12) Calligraphic scroll, gift of D. T. Suzuki to Thomas Merton, received February 1965 (lost or destroyed). Photograph likely to be by Thomas Merton. With the permission of the Merton Legacy Trust.

FIGURE 8 (p. 30) Brush drawing by Thomas Merton, *War Bird,* 1965, reproduced from the book jacket of his collected correspondence with W. H. (Ping) Ferry. With the permission of the Estate of W. H. Ferry and the Merton Legacy Trust.

FIGURE 9 (p. 33) Brush drawing by Thomas Merton, untitled, 1967, published in *Voyages* 1:1, Fall 1967.

With the permission of William Claire and the Merton Legacy Trust.

FIGURE 10 (p. 33) Thomas Merton, early fall 1968, just before his departure for Asia. Photograph by Ralph Eugene Meatyard. With the permission of the Estate of Ralph Eugene Meatyard.

FIGURE 11 (p. 35) Brush-drawn matrix used by Thomas Merton to print portfolio image 22. Thomas Merton Center 805. With the permission of the Merton Legacy Trust.

FIGURE 12 (p. 36) Thomas Merton's worktable at the hermitage. Photograph by Thomas Merton. Thomas Merton Center D0086. With the permission of the Merton Legacy Trust.

FIGURE 13 (p. 44) Brush drawing by Thomas Merton, untitled. Image size: 3½" h x 4½" w. Thomas Merton Center 377af. With the permission of the Merton Legacy Trust.

FIGURE 14 (p. 45) Brush drawing by Thomas Merton, untitled. Reproduced from his *Raids on the Unspeakable* (1966), p. 89. With the permission of New Directions Books and the Merton Legacy Trust.

FIGURE 15 (p. 47) *Enso* by Noda Saburo, twentieth century, (detail from a scroll). With the permission of a private collector.

FIGURE 16 (p. 52) The altar in Thomas Merton's hermitage. Photograph by Thomas Merton. Thomas Merton Center 1326c. With the permission of the Merton Legacy Trust.

The Art of Thomas Merton: Thirty-four Images

1 (p. 63) Thomas Merton Center 557. *Jerusalem*, 1960. Image size: 4¼" h x 6½" w. With the permission of the Merton Legacy Trust.

2 (p. 65) Thomas Merton Papers, Rare Book and Manuscript Library, Columbia University. No. 1 in a series donated by Msgr. William Shannon. Untitled. Image size: 7⅜" h x 4½" w. With the permission of Columbia University and the Merton Legacy Trust.

3 (p. 67) Thomas Merton Center. No. 4 in the series sent by Thomas Merton to Ad Reinhardt. Gift of Anna Reinhardt. Untitled. Image size: 11¾" h x 7" w. With the permission of the Merton Legacy Trust.

4 (p. 69) Thomas Merton Center 339. Untitled. Image size: 5½" h x 8" w. With the permission of the Merton Legacy Trust.

5 (p. 71) Thomas Merton Center 356. Untitled. Image size: 7" h x 6¾" w. With the permission of the Merton Legacy Trust.

6 (p. 73) Thomas Merton Center U005f. Untitled, 1964. Image size: 3" h x 5" w. With the permission of the Merton Legacy Trust.

7 (p. 75) Thomas Merton Center 361. Untitled. Image size: 8½" h x 13⅛" w. With the permission of the Merton Legacy Trust.

8 (p. 77) Thomas Merton Center U013f. Untitled, 1964. Image size: 5" h x 4½" w. With the permission of the Merton Legacy Trust.

9 (p. 79) Thomas Merton Center 654. Untitled. Image size: 8" h x 6¾" w. With the permission of the Merton Legacy Trust.

10 (p. 81) Thomas Merton Center 580. Untitled, 1964. Image size: 5½" h x 6½" w. With the permission of the Merton Legacy Trust.

11 (p. 83) Thomas Merton Center 673. Untitled. Image size: 3¼" h x 2¾" w. With the permission of the Merton Legacy Trust.

12 (p. 85) Thomas Merton Center 567. Untitled.

Image size: 5" h x 6¼" w. With the permission of the Merton Legacy Trust.

13 (p. 87) Thomas Merton Center 738. Untitled. Image size: 12" h x 9¼" w. With the permission of the Merton Legacy Trust.

14 (p. 89) Thomas Merton Center 585. Untitled. Image size: 10¾" h x 6" w. With the permission of the Merton Legacy Trust.

15 (p. 91) Thomas Merton Center 573. *Considerable Dance*. Image size: 7¾" h x 8¼" w. With the permission of the Merton Legacy Trust.

16 (p. 93) Boston College, Burns Library Collection. Gift of Mary McNiff. Untitled. Image size: 4" h x 3¼" w. With the permission of Burns Library, Boston College, and the Merton Legacy Trust.

17 (p. 95) Thomas Merton Center 448. Untitled. Image size: 8½" h x 5" w. With the permission of the Merton Legacy Trust.

18 (p. 97) Thomas Merton Center 454. Untitled. Image size: 3" h x 2½" w. With the permission of the Merton Legacy Trust.

19 (p. 99) Thomas Merton Center 702. Untitled. Image size: 11¼" h x 11" w. With the permission of the Merton Legacy Trust.

20 (p. 101) Thomas Merton Center 442. Untitled. Image size: 10¼" h x 7½" w. With the permission of the Merton Legacy Trust.

21 (p. 103) Thomas Merton Center U004. *Emblem*, 1964. Image size: 3¼" h x 2¼" w. With the permission of the Merton Legacy Trust.

22 (p. 105) Thomas Merton Center U011. *Personal or not*, 1964. Image size: 4" h x 4" w. With the permission of the Merton Legacy Trust.

23 (p. 107) Thomas Merton Center 496. Untitled. Image size: 6½" h x 8" w. With the permission of the Merton Legacy Trust.

24 (p. 109) Flogge Collection, on loan to the Thomas Merton Center. Untitled, 1967. Image size: 8½" h x 6½" w. With the permission of the Merton Legacy Trust.

25 (p. 111) Thomas Merton Center 392. Untitled. Image size: 7¾" h x 5½" w. With the permission of the Merton Legacy Trust.

26 (p. 113) Thomas Merton Center 394. Untitled. Image size: 10½" h x 8½" w. With the permission of the Merton Legacy Trust.

27 (p. 115) Thomas Merton Center 480. Untitled. Image size: 10½" h x 7¾" w. With the permission of the Merton Legacy Trust.

28 (p. 117) Thomas Merton Center 487. Untitled. Image size: 10" h x 8½" w. With the permission of the Merton Legacy Trust.

29 (p. 119) Thomas Merton Center 726. Untitled. Image size: 9¾" h x 8½" w. With the permission of the Merton Legacy Trust.

30 (p. 121) Thomas Merton Center 475. Untitled. Image size: 7" h x 5½" w. With the permission of the Merton Legacy Trust.

31 (p. 123) Thomas Merton Center 697. Untitled. Image size: 9¾" h x 8½" w. With the permission of the Merton Legacy Trust.

32 (p. 125) Thomas Merton Center 665. Untitled. Image size: 6" h x 8" w. With the permission of the Merton Legacy Trust.

33 (p. 127) Thomas Merton Center 813. Untitled. Image size: 6⅛" h x 4¼" w. With the permission of the Merton Legacy Trust.

34 (p. 129) Thomas Merton Center 560. Untitled. Image size: 6" h x 8" w. With the permission of the Merton Legacy Trust.

Three Studies

FOREWORD

The Thomas Merton Center at Bellarmine University archives over nine hundred of Merton's original drawings and calligraphies in its collections. Approximately half of these images were completed in the final decade of Merton's life at the time he was experimenting with Zen calligraphy and other forms of drawing and printing. For many of Merton's readers these images have remained unknown and, if known, difficult to understand. They are, however, a significant element in the overall Merton corpus, an element that Merton himself clearly regarded as important and took care to preserve, specifically mentioning them in his Legacy Trust Agreement.

Over the years, Thomas Merton has all too easily been placed in categories by his readers. His early monastic books reflected a relatively short-lived traditional aspect to his writing, soon left behind as he rediscovered his own voice. In his roles as Master of Scholastics and later Master of Novices—key instructional roles in the monastic community—Merton gradually returned to many interests of his pre-monastic life. Gandhi, Eastern thought, William Blake, and Gerard Manley Hopkins were among those renewed interests, approached now from a deeper perspective nourished by his monastic experience and his reading in the Desert Fathers, the Church Fathers, and the great Christian mystics.

For many, his classic books on spirituality such as *No Man Is an Island, Thoughts in Solitude,* and *New Seeds of Contemplation* defined the lofty heights he reached. His later writings on war and other social issues alienated some readers, who preferred their Merton to remain on the mountaintop. Placing Merton in such categories fails to recognize the wholeness he radiated. In reality, his later spiritual writings, produced alongside the writings on peace and society, are among his most enduring contributions.

Merton's poetry and visual art are frequently overlooked. His earliest surviving poetry dates from his time as a schoolboy at Oakham Public School in Rutland, England. At Columbia University, in the 1930s, he published poetry in *Columbia Poetry,* the *New York Times,* and *Spirit.* After he became a monk at the Abbey of Gethsemani, Merton's first published books were collections of poetry, *Thirty Poems* in 1944 and *A Man in the Divided Sea* in 1946, and he continued to

write and publish poetry throughout his life until his untimely death in 1968. Yet he is not generally remembered as a poet, and that dimension of his work has been little studied and appreciated.

In a similar fashion, Thomas Merton's visual art has been ignored. The son of artists, Merton must have spent many of his early years mingling with the arts people with whom his father, Owen Merton, associated. One can imagine him growing up surrounded by his father's paintings and their vision of the world, which he recalled in the early pages of his autobiography, *The Seven Storey Mountain.*

His vision of the world was sane, full of balance, full of veneration for structure, for the relations of masses and for the circumstances that impress an individual identity on each created thing.

At one point, in the original manuscript of his autobiography, he applied Gerard Manley Hopkins's term "inscape" to his father's work—a term that, with Rilke's "inseeing," helps us understand Merton's attraction to many groups such as the Shakers and the Celts, and to individuals like William Blake, Edwin Muir, Boris Pasternak, and Louis Zukofsky. "Inscape" and "inseeing" are terms that came readily to mind as I read the book you now have in front of you.

One of the earliest surviving photographs of Thomas Merton has, in the background, a painting by his father adorning the wall while, in the foreground, the young boy is pictured (in his mother's words on the reverse of the photograph) as "drawing a picture of an aeroplane." Again, in *The Seven Storey Mountain,* Merton recalled "furiously writing novels" while at the Lycée Ingres in Montauban, in 1926. These novels, he wrote, were "profusely illustrated in pen and ink." Though this may sound like the poetic license of a budding author writing in later years, recently discovered manuscripts, dating to December 1929, confirm his description.

A number of the earliest surviving pieces of Merton's correspondence were with artist friends of his father's such as Percyval Tudor-Hart, Owen's art teacher, mentor, and close friend, and Reginald Marsh, the New York artist and another friend of Owen's. In his late teens Thomas Merton met up with Marsh a number of times in New York, and Marsh became a guide for him to the New York scene. Marsh also influenced Merton's artistic output at Columbia, both his cartoons, frequently published in the *Columbia Jester,* and his female nudes. As late as February 1938, when Merton, still not a U.S. citizen, completed a Declaration of Intention for the U.S. Department of Labor, he described his occupation as a "cartoonist and writer."

With Merton's conversion to Catholicism in November 1938, line drawings of religious images came to dominate his artistic output, not yet as simple or stark as those he would draw in his early years in the monastery. As Merton left behind the world-denying monk of the 1940s and early '50s to become the world-embracing monk of the 1960s, his visual art and poetry changed dramatically. Once more, he discovered his true voice. The quiet voice of monasticism, associated by many Catholic readers with Merton's earlier work, had seemingly disappeared into the Gethsemani woods. The new Merton was disturbing and could grate on his readers' sensibilities. The same was true of his art in this period.

Unlike his published writings, Merton's drawings tended to be a much more private concern. Conceived and executed in the solitude of his Gethsemani hermitage, they were frequently given to friends and visitors who he felt would understand and appreciate them. Seldom were they published, and, with the exception

of those in *Raids on the Unspeakable,* publication was generally in obscure literary magazines. Similarly, Merton feared that the exhibit of his calligraphies, which began at Catherine Spalding College in Louisville in November 1964 and subsequently visited a number of other cities, could easily be misunderstood. The fact that so few sold prompted him to suggest to one interested buyer that "if you wait until we crawl out of Santa Barbara, Cal. in September they will be ten cents apiece with a sheaf of green coupons into the bargain."

Thomas Merton's poetry has been described as the barometer of his soul. In a similar way, his visual art parallels his spiritual journey. It moves from childhood drawings to his Columbia cartoons to devout, strong, and simple images in his earlier years at Gethsemani. It moves on from there to the drawings and prints in this book and the photography of the 1960s (made with what he called his "Zen camera"). All of this later work expresses his mature relationship with God, the world, and self. Merton's visual art in the 1960s is a question mark, asking us to pause and reflect on what we are seeing and on the meaning of the spiritual, not just in art but in every part of our lives. These are not unlike the questions he posed in such works as *Conjectures of a Guilty Bystander, Raids on the Unspeakable,* and *Emblems for a Season of Fury* in the same period.

Thomas Merton's readers owe an enormous debt of gratitude to Roger Lipsey for making a representative collection of these images available to the public for the first time. Dr. Lipsey provides incisive and piercing insights into the influences on Merton's visual art at this time. His understanding and assessment of Merton's art is set against Merton's overall personal, spiritual, and artistic development. Dr. Lipsey assists the reader in seeing Thomas Merton's mature art as a vivid, previously unknown facet of his religious searching and his relationship with the Divine.

—Paul M. Pearson
Director of the Thomas Merton Center,
Bellarmine University

The Invisible Art of a
Highly Visible Man

The Invisible Art of a Highly Visible Man

Here is a collection of shapes, powers, flying beasts, cave animals, bloodstains, angelic mistakes, etc., that can perhaps have some visual effect on the local bisons. I suggest selling them for around ten bucks apiece. . . .

—Thomas Merton in a letter to Jim Forest, 1966[1]

It is the puzzling privilege of this book to be the first extensive exploration of Thomas Merton's visual art of the 1960s. In those years, closely studied in other respects by a multitude of skilled and caring authors, Merton had matured into the radiant, questioning, profound human being whose writings reach out to this day with undimmed appeal. Every letter he wrote in those years, every journal entry and notebook, every audio recording of weekend conferences at the Abbey of Gethsemani where he lived, learned, and taught has been preserved and, in many cases, published, although of course there are gaps and losses. Yet his visual art production in the 1960s, which he named in various ways—calligraphy, drawings, signatures, emblems—has scarcely seen the light of day. Few scholars and critics have explored it, and those few have looked only at narrow zones.[2] We need to ask why this was so.

No ironic answers will do. The work is interesting, often brilliant; it sheds new light on Merton's biography and search in religion; and it offers an undisclosed chapter of the spiritual in twentieth-century art. Merton's intuitive grasp of the art of his time and place,

abstract expressionism, fused with his knowledge of Zen Buddhist calligraphy to produce what he once called "contracts with movement, with life, . . . collaborations with solitude . . . , summonses, calls to experiment, trials, gifts, fortunate events."[3] There were many descriptions for an art that progressed rapidly once he found the trailhead.

Merton's art falls into three chronologic periods. The first, corresponding to his college days at Columbia University, from which he graduated in 1938, is of biographical interest only. Merton's drawings for Columbia's undergraduate humor magazine, the *Jester,* are often sexy, sometimes funny, sometimes labored, occasionally political. Behind this published phase of his early efforts was a more reflective series of works in which he explored the themes and forms of contemporary artists he admired, particularly Paul Klee and Pablo Picasso. A later and more accomplished example in this vein (fig. 1), of uncertain date but falling somewhere around 1950, is among the few early works that foreshadow Merton's art in the 1960s. The first period of Merton's art ends with his personal conversion and the conversion of his art: continuing in much

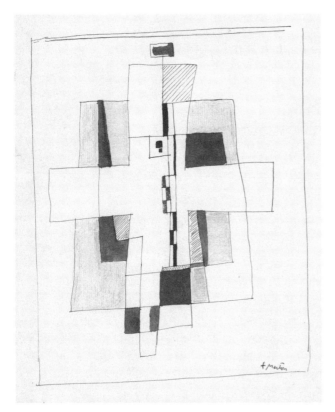

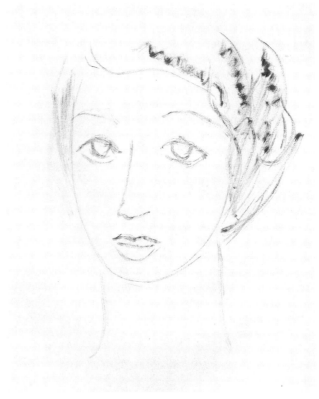

FIG. 1 Pen and pencil drawing of a cross by Thomas Merton, ca. 1949–1953. Image size: 9 1/16" h x 7 1/2" w.

FIG. 2 Brush drawing, head of a woman, by Thomas Merton, before 1960. Image size: 8 1/4" h x 6 1/2" w.

the same style, he turned to Christian themes that reflected his growing attraction to the Catholic Church and discovery of his monastic vocation.

The second period, long and strangely fixed, stretches from his entry into the monastic life on December 10, 1941, until some indiscernible time in the mid to late 1950s when for a time he abandoned visual art. From this period of fifteen or more years, there are hundreds of drawings largely restricted to two subjects. The first recurrent subject is the Blessed Virgin, Mother and Queen of all Cistercian foundations

including the Abbey of Gethsemani (fig. 2). The second recurrent subject is a bearded, tonsured monk, sometimes identified in titles provided by Merton as St. John of the Cross, the Spanish mystic whom he was reading closely in those years (fig. 3). There are other subjects—the Crucifixion, prayerful figures of various kinds, landscape, and still life—but they are less frequent. This stunningly repetitive series of brush-drawn images gave Merton the opportunity to develop his facility with the brush and served as a mirror for his longings and aspirations. At times it seems as if the

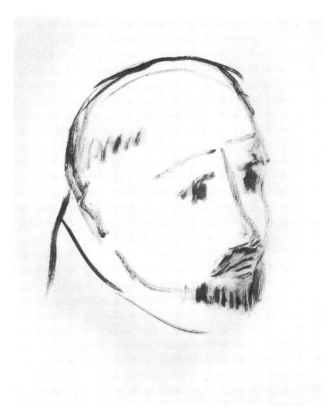

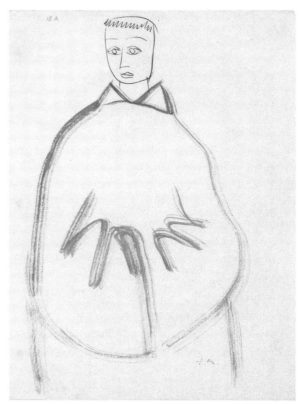

FIG. 3 Brush drawing, head of a monk, by Thomas Merton, before 1960. Image size: 7¼" h x 6" w.

FIG. 4 Brush drawing of a monk, by Thomas Merton, before 1960. No. 24 in a series. Image size: 9¾" h x 6½" w.

brush could jump free and find some richer life and theme, but it does not—not yet. Some of the brush-work in a drawing of a monk (fig. 4) is of this kind; though the head is cartoonlike, seemingly an after-thought, Merton's rendering of the loose-sleeved monastic robe foreshadows in confidence and speed his developed calligraphic art.

In the drawings of this period, the Blessed Virgin and her sisters in religion, such as a female figure of Wisdom, appear in many guises, ranging from a veiled presence recruited from medieval art to an American

girl, lovely and fun and absent. Merton's struggle to come to terms with the feminine is the unstated theme, but in those years the struggle was fixed, cir-cular, and no doubt unhappy. The other repetitive theme, the portrait of a monk, reflects Merton's world but lacks the complexity and formidable drive that we know in his writings of the 1950s, from his superb re-working of journal material in *The Sign of Jonas* (1953) to his homage to the Early Christian Desert Fathers, published in 1960.[4] Had Merton been a simpler man, he might have looked much like the monk in these

drawings. These are the oblique self-portraits of a man who became someone else.

On December 2, 1960, Merton wrote to a friend in religion that he had "not done any drawings for a long time," but in response to her request he mailed off some drawings, seemingly of recent vintage, representing St. Benedict, the Holy Face, the Blessed Virgin, and St. John the Baptist. The themes were consistent with his art in earlier years, but he added a telling comment in the accompanying letter: "They are very modern and sketchy," he wrote, "and you may not like them."[5] I have not seen these drawings. They could be the last of their kind, the end of a cycle of some fifteen years, now outgrown, that had sustained him inwardly and taught him the brush.

Little more than a month earlier, in late October, Merton had passed through a difficult period when few activities had taste or energy. He had a problem, in fact many, and there is a hint in his journal that the physicality and silence of drawing served over the years to restore focus or bring comfort in difficult times. "I ought to be writing poetry and doing creative work. Or nothing," he recorded glumly in his journal on October 28. "Tried some abstract-looking art this week. This [has] no relevance to problem."[6] The melancholy soon passed, although the problems persisted. After two weeks of further exploration, he was thinking that abstract drawings might find a place in "a possible experimental book."[7] A few weeks more and he was ready to show his new work to a certifiably discerning critic, the young art historian Eloise Spaeth, well known in later years as a collector and early advocate of an important public institution, the Archives of American Art. Merton had been working with her on a book, ultimately never published, which was to be called *Art and Worship,* an illustrated guide to sacred art of the long clear past and the narrow confusing present. Merton's note to her, conveying thanks for an initial round of help on the book project, was both diffident and sturdy:

As a gesture of gratitude, here are a couple of abstract sketches of the type I have been doing. I have no illusions about them; they are agitated and dissipated and what not, but I don't care, I think they have a little life of their own and that there is a place for them in the cosmos somewhere. I hope you like them, or can get adjusted to them without too much shock. I suppose I should have called them animated fragments of furniture in an exploding house, but I have been more arty and said "Structures in Movement." In case you don't like them I am adding another, an "Iron Garden," but I myself like this much less. It looks like a sentimental junk yard. Maybe that is what it ought really to be called.[8]

This is the sound of Merton—apologetic, assertive, self-deprecating, funny, reflective—as he began what would prove to be a long new venture in visual art. The ambivalence would last for years, not because he seriously doubted the good quality and even goodness of his art but for other reasons. He had gone out on a limb; he was, as a visual artist, well away from the mighty trunk of the Catholic Church. Further, he was a faithful and experienced monk, not given to tooting his own horn. And, perhaps most important, he had surprised himself: what was to have been a restorative exercise, quickly forgotten—trying his hand at "some abstract-looking art" in a time of inner turmoil—had so impressed him with its expressive potential, its possible value as part of his religious search and the

record he shared with others of that search, that within weeks he was imagining a book of abstract drawings and showing his work to a seasoned critic.

The third period of Merton's visual art spans from this lively *incipit* in the fall of 1960 until his departure for Asia in the fall of 1968—eight full years, during which there were times of great activity and times when he had other things to do. Among those other things, as readers of Merton well know, was his embrace of photography under the brotherly tutelage of the photographer and author John Howard Griffin and (from 1967) in loose partnership with Ralph Eugene Meatyard, the photographer from nearby Lexington, Kentucky, whose work has achieved worldwide recognition. Merton did not take his brushes and paper with him to Asia, but he did take his camera and made certain photographs that are integral parts of his biography as well as independent works of art, once seen never forgotten.

There is great variety and depth in the drawings of those years, as even a skim through the thirty-four full-page reproductions in this book will demonstrate. But our theme for the moment is the forgetting, the neglect of this body of work by writers and scholars who were and are not just interested in Merton but dedicated to exploring who he was and what he taught. Merton's friend, the poet Robert Lax, said many years after Merton's death: "You can't get too much of Merton."[9] Of course, that is not true for everyone, but it is true for some—yet the abstract drawings were overlooked. This was not for lack of interest on Merton's part. When he wrote to one of his closest friends in Louisville, Tommie O'Callaghan, and asked her to accept the burden of serving as a trustee of a newly created trust that would own and control his works in time to come, he did not forget the drawings: "The responsibilities of the trust," he wrote, "will be simply to take care of the publication of unpublished materials and to protect the literary estate, the drawings and so on."[10]

In his lifetime he had not only mounted a public exhibition of his art at a local Catholic college, late in 1964, but had also responded to invitations from other Catholic colleges across the country to tour the exhibition. Responding in some instances, he also occasionally sought venues for the exhibition through well-placed friends. His correspondence reveals him in the role of tour manager, relying on the goodwill of art teachers, academic administrators, and local friends to pack, ship, and receive the exhibition, sell works out of it, expect the arrival of additions to it, have works framed, and suggest new exhibition venues. (See p. 161, "Exhibitions," for a focused study of this process and Merton's spirited approach to it.) Starting in 1963, he also went out of his way to publish the new drawings in little magazines both in the United States and elsewhere—South America, Great Britain—where he had contacts.

Subject to his vows as a monk of the Cistercian Order of the Strict Observance, he had no money (royalties were payable to the monastery, in keeping with his wishes and monastic policy). But his new drawings soon emerged as a kind of monk's money, a currency he could use for barter in exchange for books he wanted or offer as gifts to chosen friends. His exhibitions had entrepreneurial flair; the idea was to sell drawings in order to build a college scholarship fund for an African American girl and later to contribute financially to similar causes. And there was a further use for the drawings. The Catholic Church had, and has to this day, the custom of circulating prayer cards or holy cards, small cards typically showing the image

of a saint or holy scene on one side and a related prayer on the other. Merton did not like the general run of prayer cards—we'll see this soon enough when we explore his taste in art—but he instinctively pressed his drawings into a somewhat comparable role. Circulating in the world, freely given or bartered for some small needed thing, his drawings were subtle, prayerful messages dispatched into the world. But the world could hardly read them. They were written in a language unfamiliar to most people although highly valued, by a few, as the work of his hands.

In 1966, Merton marked a moment in the development of his visual art by arranging to publish fifteen drawings in an outstanding collection of his essays, *Raids on the Unspeakable*. The concluding essay in that book, entitled "Signatures: Notes on the Author's Drawings," is included here on pp. 60–61. Originally serving as gallery notes, this essay accompanied the exhibition through its travels and successive replenishments from late 1964 through 1967. Clearly, Merton intended his art to be seen and hoped that it would be remembered and explored. But the question comes to mind: wasn't it out of character for a monk and priest to take such an interest in abstract art and to give noticeable time and effort to circulating it in the world?

There is an intriguing continuum of value judgments in the monastic language of his time, and still today, which he occasionally toyed with and obviously enjoyed. At one pole is the word *edifying*. This is what a monk is expected to be. However, since we are all sinners and easily lose our way, roughly two-thirds down the continuum, well out of sight of "edifying" and heading toward darkness, is another useful term: *disedifying*. Merton would often enough describe himself, sometimes with good humor, sometimes in all seriousness, as setting a disedifying example for his fellow monks and his readers. But we have not yet reached the abyss and the word that belongs there: *scandal*. This, too, had its uses. Merton would sometimes view himself as nearing scandal, if not fully splashed in it, and from time to time he *was* a scandal from his own or his abbot's perspective—though always for the sake of heaven as matters would in the end work out.[11]

After this journey into monastic values, we can ask: was Merton's art in these years disedifying, perhaps even a scandal? Of course, it was neither—it was an unanticipated, religiously dedicated flowering of his inheritance from his parents, both of whom were artists, and of cultural and spiritual forces moving through and around him in the late 1950s and 1960s. But there was no obvious bridge between his art and the values and traditions of the Catholic Church. As he wrote to a friend in 1963, "What I will send you is some strictly safe abstract art. This I am not hindered in, and I can say what I want perfectly freely because nobody knows what any of it means anyway (for the simple reason that none of it has that kind of meaning)."[12] Merton received considerable though not infinite latitude from his Father Abbot, Dom James Fox, to be and do what his gifted nature bade him be and do. The drawings, the work that went into them, and the organizational work behind the exhibitions fell into that pocket of latitude where the abbot did not look too closely and Merton did not report too fully. Their relations were often strained, but Merton's drawings were no part of the strain.

Still, the church had no categories for art of this kind. For the most part, Merton's imagery shows no evident holy theme. There are a number of beautiful images of the cross (see portfolio images 17 and 33), but most of his work in the 1960s does not draw on the

traditional imagery of the church and seems to know nothing of it. As he wrote in the "Signatures" essay, "one must perhaps ask himself whether it has not now become timely for a Christian who makes a sign or a mark of some sort to feel free about it." This distance from the symbols and traditions of the church explains why very few authors from within the church itself, and there have been many interested in Merton, have found their way to Merton's later art. Conceived at a certain inner distance from the church, his art as it matured did not reenter the church but settled, instead, in an ecumenical, cross-cultural terrain where it awaited its audience.

Merton's art owed debts of learning and inspiration to two cultures, distant from one another and from the church but united in him. Call them Kyoto and Lower Manhattan. Kyoto, with its wealth of temples, gardens, and works of art, is a fit emblem for Merton's deep and complex relation with Zen Buddhism. Lower Manhattan signals his all but unnoticed participation in the dominant American art of his time, abstract expressionism, which in the 1960s remained vital, although by then its innovations and variousness—its ferocity and lyricism, showiness and austerity—had been accepted by a large audience.

Kyoto

In a letter from early 1955 to his friend and publisher, James (Jay) Laughlin at New Directions Books, in which Merton mentions gropingly, as if for the first time, the name of a person who was to become a cherished influence in his life: D. T. Suzuki. Dr. Suzuki (1870–1966) was the long-lived scholar and sage who nearly singlehandedly introduced Zen to the West through his prolific writings. Merton asked: "Have you ever run across any books by D. Suzuki (I think that is how you spell him) on Zen Buddhism? I am anxious to track some of them down and have them."[13] Laughlin often sent him books; the request was not unusual. For a monk who had nothing material, or scarcely anything, the just-audible insistence on "having" the books was a sign of things to come. Merton was poised to enter upon one of the vivid spiritual adventures of his life: not just understanding Zen Buddhism from a cautious distance but allowing it to batter, delight, and transform him.

There is in all this one of the wide loops or circles that occur in the lives of religious people, for whom a return to origins is often the way forward. Through his reading and reflection, Merton was absorbing in these years the penetrating spirituality of the Desert Fathers. These men (we now also acknowledge Desert Mothers)[14] were early Christian refugees from the confusion of cities and the politics of religion, who gathered in the Egyptian desert to practice an ascetic form of Christianity in communities or as hermits loosely bound to one another. Their approach to the life of the spirit, their wisdom and toughness, were infinitely attractive to Merton; he must have felt that he was one of them— but for their distance in time.

What was the sound of the Desert Fathers? In the last year of his life, Merton recorded in his journal a short passage that can speak for the entire tradition, which he was studying in the later 1950s with the project of publishing a selection of translations from ancient sources:

Not to run from one thought to the next, says Theophane the Recluse, but to give each one time to settle in the heart.

Attention. Concentration of the spirit in the heart.

Vigilance. Concentration of the will in the heart.

Sobriety. Concentration of feeling in the heart.[15]

This was the desert—and, in all but name, this also was Zen. In the still living tradition of Zen Buddhism, with roots in the sixth if not the fourth century of our era, Merton discovered what in his view had been lost in Christianity. Recovery of the fullness of monastic practice would require an in-depth encounter with Zen.

Reading hungrily and reworking with instinctive sureness his approach to the inner dimensions of the religious life, Merton took the risk in March 1959 of opening a correspondence with Dr. Suzuki, who lived in a cottage on the grounds of a monastery near Tokyo but often traveled in the West. In that first letter, Merton spoke of his work on the Desert Fathers but also conveyed certain personal insights with utter sincerity:

> I have my own way to walk and for some reason or other Zen is right in the middle of it wherever I go. So there it is, with all its beautiful purposelessness, and it has become very familiar to me though I do not know "what it is." Or even if it is an "it." Not to be foolish and multiply words, I'll say simply that it seems to me that Zen is the very atmosphere of the Gospels, and the Gospels are bursting with it. It is the proper climate for any monk, no matter what kind of monk he may be. If I could not breathe Zen I would probably die of spiritual asphyxiation.[16]

One month later, writing again, Merton commented: "I only wish there were some way I could come in con-

tact with some very elementary Zen discipline, even if it were only something like archery or flower-arrangement."[17] His words reflect a monk's modesty. In the coming years, Merton would become one of the keenest students of Zen in the West. He published essays on Zen topics in a great variety of journals and gathered them periodically into books. But more important still, Zen became a force in his life. It was a touchstone of truth, a code for consciousness, a description of the depths of reality and human nature, a way of being in Nature, a new kind of paradoxical wit and humor, a finger pointing not just at the moon but at a universe of meaning—it was all these things and more. "There are times when one has to cut right through all the knots, and the Zen view of things is a good clean blade."[18] So he wrote in 1962 to a friend in Asia. As others have pointed out, sometimes with an unhappy trace of complacency, Merton did not receive sustained direct instruction from a Zen teacher; his sangha was the brothers at Gethsemani. But his devoted Christian practice of contemplative prayer had created layer upon layer of kinship and receptivity. Writing to a friend in religion in 1968, he could relate Christian and Zen practice with the ease of familiarity and love: "What is really meant . . . is continual openness to God, attentiveness, listening, disposability, etc. In the terms of Zen, it is not awareness of but simple awareness."[19] Merton's embrace of Zen Buddhism moved well past theory and admiration. He lived it. "How I pray is breathe."[20]

Merton made astonishingly few trips outside the monastery during his twenty-seven years as a monk of Gethsemani. By far the most fruitful, apart from his final journey to Asia, were the few days he spent in New York City in the spring of 1964 to visit Suzuki, who was himself engaged in what would prove to be his last journey to the West. Merton's joy in meeting

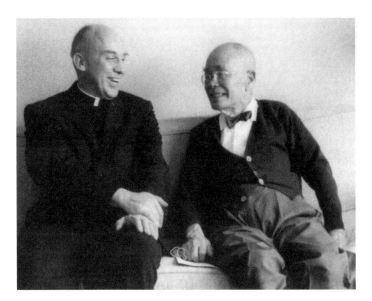

FIG. 5 Thomas Merton with D. T. Suzuki, New York, June 16–17, 1964. Photograph by Okamura-Bekku.

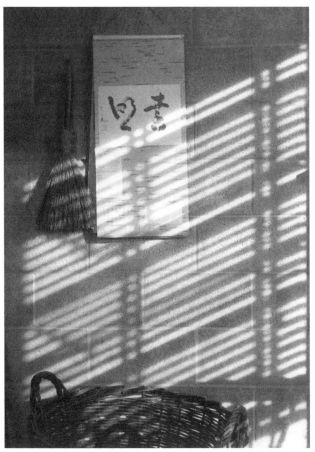

FIG. 6 Interior of Thomas Merton's hermitage in the 1960s with Sengai calendar. Photograph by Thomas Merton.

the man whose writings had opened so much to him is touching even now to encounter—and we shall do so in a study at the back of this book (see the section "Friends," p. 133). A photograph of the two men in conversation on that occasion (fig. 5) is provocative for close readers of Merton and Suzuki, as if two distinguished and largely separate lives knot just here.

Zen was fundamental to Merton's art. Late in 1964, when he was preparing the exhibition notes published here in pp. 60–61, he jotted down: "Neither rustic nor urbane, Eastern nor Western, perhaps can be called expressions of Zen Catholicism."[21] The tools, shapes, and textures of his art, at least until the 1964 exhibition, owe a very great deal to Zen brush-drawn calligraphy, a highly developed art of which priests were often virtuoso practitioners. Through the early 1960s, Suzuki sent Merton annual illustrated calendars featuring images by the eighteenth-century Zen priest and

artist Sengai, which Suzuki cosponsored with a Japanese collector. Suzuki's printed commentary on each image made the calendar an episodic book on the substance and style of Zen.[22] Photographs of the interior of Merton's hermitage show that the Sengai calendar of the year invariably had pride of place (fig. 6). Suzuki also sent Merton a beautifully mounted scroll with calligraphy by his own hand. One of Merton's smallest tragedies was that he never learned what his mentor in

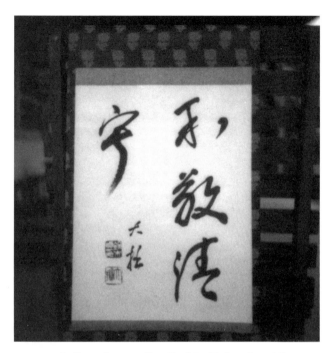

FIG. 7 Calligraphic scroll, gift of D. T. Suzuki to Thomas Merton, received February 1965 (lost or destroyed).

tea. Suzuki described them in *Zen and Japanese Culture* (p. 273) as "the essential constituents of a brotherly and orderly life, which is no other than the life of the Zen monastery." The brushed signature and stamped seals in the lower left identify Suzuki. It is a privilege to read the scroll and receive, as if on Merton's behalf, the intended message.

We were asking earlier whether it was out of character for a Cistercian monk and priest of the mid-twentieth century to interest himself in abstract art and go to considerable lengths to share his work with others. We are better prepared now to take note of two archetypes, or fundamental ancestors, to which Merton was responding. The first such legitimizing ancestor was Sengai himself, priest and artist. In his caption to a Sengai image that happens, by chance, to be visible in a photograph of Merton's hermitage, Suzuki wrote of "that countless stream of people who flooded his room with drawing paper, all asking for his calligraphy or ink-drawings."[23] Calligraphy, offered freely or in return for temple donations, was a customary and in fact ingenious way for the truths of a temple to find their way back to parishioners' homes, and the priests' handiwork was felt to have protective power.

Although the example may have reached him only in 1965, through a book published that year, there was another Zen priest, Hakuin, from whom the same lesson could be learned. Hakuin was both a great renovator of his school of Zen and a master artist-calligrapher. "[He] was not a painter in the professional sense of the term," his biographers have written. "He was a Zen master who used his great talent as an artist in teaching Zen."[24] Their interesting words pose a question to which we will have to return: did Merton's art teach? Did it teach what he knew and sensed of the order of things, of our human nature and search for truth?

Zen had written, and it seemed as if we would share his disappointment because the scroll, lost from sight for many years, was almost certainly destroyed in a house fire some years after Merton's death. However, a diminutive photographic proof print, adrift among uncataloged memorabilia, came to light just as this book was going to press (fig. 7). It shows the Suzuki scroll draped over the back of a chair on the hermitage porch, photographed with documentary intent and fully legible. Did Merton make the photograph? Difficult to say, but in any case we can read what Suzuki thought to convey. The characters are *wa, kei, sei, jaku*—harmony, reverence, purity, tranquillity, the four values traditionally cultivated by practitioners of the art of

Sengai was, then, the first archetype—the first permission from serious times and serious people long past to be a priest-artist. The concepts and sensibility of Zen, and the model offered by Sengai and confirmed by Hakuin, had the power of ignition. There was, however, a second archetype—Western, seemingly secular, perhaps a little less important—in which Merton as a university student had found much inspiration, and to which he returned in his last years to rediscover with mature mind and heart. This was William Blake, the nineteenth-century English visionary poet and artist. For present purposes, it is enough to recognize that Merton was acting profoundly in character, by his own lights if not that of the institutional church, as he found his way toward being something like Sengai, something like Blake, and entirely himself: a priest-artist of our time. He had asked Suzuki at the beginning of their correspondence whether there was "some very elementary Zen discipline" he might practice. He found the answer for himself. What he found did not remain elementary.

Lower Manhattan

In the years leading up to his exploration and practice of abstract art, Merton was uneasy about the art of his time. He had a firm link with the world of contemporary American art through his friendship, formed in college and never lapsed, with Ad Reinhardt (1913–1967). Creator in the 1950s and '60s of his now-celebrated Black Paintings, Reinhardt was a steady though critical participant in the New York School from its earliest beginnings, a peer of Jackson Pollock, Mark Rothko, Barnett Newman, Willem de Kooning, Robert Motherwell, and other members of that loosely constituted "school." Merton in rural Kentucky behind monastery walls could not have been more remote from the studios and bars of Greenwich Village where this art was developed with debate and anxiety and genius and alcohol—but he had discreet access to that world through his friendship with Reinhardt. The preserved correspondence with Reinhardt is fascinating, and Reinhardt called on Merton at Gethsemani in the spring of 1959, an occasion when they could "argue" to their hearts' content, as Reinhardt later wrote, "about art and religion."[25]

Merton's ambivalence in those years was profound: as a man of the church and dedicated religious seeker, he could not approve of much in contemporary art—yet he had an avant-garde friend whom he trusted and admired. Reinhardt was known to his New York peers as "the Black Monk," owing of course to his Black Paintings but just as much to his dark humor and the compressed austerity of his writings on art. Perhaps Merton's views could change; perhaps Reinhardt, like Suzuki, could be an angel or agent of change. But until the early 1960s, where art was concerned he was still—to use one of his best words—cramped. "The things we really need," he wrote some years later,

> come to us only as gifts, and in order to receive them as gifts we have to be open. In order to be open we have to renounce ourselves, in a sense we have to *die* to our image of ourselves, our autonomy, our fixation upon our self-willed identity. We have to be able to relax the psychic and spiritual cramp which knots us in the painful, vulnerable, helpless "I" that is all we know as ourselves.[26]

Merton's taste in art formed early and firmly. Living as a child with his father in southwestern France and

traveling with him to artistic and architectural points of interest, young Tom learned to love the combination of harmonious stability and roaming imagination in French art of the eleventh and twelfth centuries— Romanesque art. As a Columbia undergraduate, he sought out the works of Cézanne, Picasso, Braque, Chagall, Klee, and other heroes of modern art and studied them with exceptional attentiveness. In his journal for those years, there is a long passage that amounts to a deliberate exercise in perception, in which he explores a canvas by Fra Angelico exhibited at the 1939 World's Fair in New York.[27] Not every university student goes to such lengths.

Early in his discovery of his vocation, Merton was deeply moved by the Early Christian mosaic decoration of a church he visited in Rome. He was learning the force of religious art. This experience initiated his enduring love of Byzantine and Russian painted icons; in his hermitage at Gethsemani in the 1960s, this is the art he chose for his chapel—accompanied in an adjoining room by a small Black Painting received as a gift from Reinhardt. Several other phases of Christian art, especially the art of the Italian "primitives" and of Fra Angelico, closed off for him the circle of Christian art that could genuinely "move, delight, and teach," in the stately phrase of St. Augustine.

Merton was just as sure of what he detested in the art of earlier eras and his own time. Bad art was in fact the subject of a sustained personal campaign at the monastery, extending at least from the late 1940s to the end of his life. He recorded in his journal some of the more exciting skirmishes. "Today after dinner," he wrote in 1949,

> I got Father Placid, the Cellarer, to discuss amicably and in sign language the possibility of putting more bookshelves in the vault. . . . I got

him to remove two hideous small statues of plaster saints which I found there when I first came. I had tried to stuff them out of sight but the only place that would contain them had a glass door to it, so you could still see their faces, congealed in expressions of the most fatuous piety. . . . Poor saints! Pray for us, holy saints! May God have mercy on us.[28]

In his first decade at Gethsemani, he encountered only one impromptu art exhibition that met his standards: "Frater John of God got a lot of kids' pictures from a sister in a school somewhere in Milwaukee. The pictures were supposed to be by backward children. Backward nothing. Most of them were of Jonas in or near the whale. They are the only real works of art I have seen in ten years, since entering Gethsemani. . . . These wise children were drawing pictures of their own lives."[29]

In 1958, when he was Master of Novices and thus playing a key role as the instructor of younger members of the community, the campaign against bad art continued. "I wonder if you can do me a favor," he wrote urbanely to a Benedictine friend. "The novices here have their breviaries full of very sad holy cards, and I am secretly planning to descend on them, take away all their favorite trash, and impose on them something good. It is a quixotic scheme, no doubt."[30]

Was there anything at all in contemporary religious art that won him over? Apparently not. "The whole issue of sacred art," he wrote in 1959, "has been terribly confused by the stupid fashion for radiator-cap-modern-pious art in which all that one asks is that the Blessed Virgin look like a Bermuda-rigged sailboat tacking into the bay."[31] This seems to be a go at Catholic adaptations of art deco. Was there anything in the broader range of current art that spoke to him? Until a

series of key events in the early 1960s, which opened the way for him to become an artist fully of his time, the answer again was "apparently not," apart from the work of Ad Reinhardt, whom he knew to be resolutely different from his New York peers, and the work of just one other artist, William Congdon. Until about 1963, with these exceptions, he could rarely bring himself to speak or write about the art of his time without praise and slur in equal measure. He was attracted, he was repelled. Factually, he had had little opportunity to experience it directly—he was rarely at liberty to attend museum and gallery exhibitions—but he had seen and heard enough to make up his mind.

Yet he wished to write about contemporary sacred art, if only to advise seminary and church authorities on how better to choose art for the buildings and communities in their care. By the early 1960s he had been working for a number of years on the troublesome manuscript of *Art and Worship* (see p. 16).[32] The sticky point for Merton was modern sacred art. In that time of change in the late 1950s and early '60s, he was searching for modern sacred art he could respect. When he finally came upon a devoutly Catholic artist, William Congdon, who worked in an abstract expressionist style on sacred themes, he went out of his way to receive the artist warmly at Gethsemani and published a few paragraphs of enthusiastic praise for Congdon's work:

> There is in the recent painting of William Congdon an air of theophany that imposes silence. . . . Here we see a completely extraordinary breakthrough of genuine spiritual light in the art of an abstract expressionist. . . . Here we see a rare instance in which the latent spiritual *logos* of abstract art has been completely set free. The inner dynamism which so often remains pent up and

chokes to death in inarticulate, frustrated mannerism, is here let loose with all its power. How has this been possible? Here the dynamism of abstraction has been set free from its compulsive, Dionysian and potentially orgiastic self-frustration and raised to the level of spirituality.[33]

Merton rarely writes with such furious condemnation. One can't help asking why. In time, unbidden, the memorable face of Jackson Pollock comes to mind. He and Merton looked rather alike in their maturity—sturdy, toughened by hard living, balding in the same way. Merton would have known something of how Pollock lived and died: the alcohol, the endless dramas, the fatal car crash. In an exaggerated version, Pollock lived in his maturity what Merton had tasted and eventually despised as a young man. And so Pollock may have been the Minotaur hidden in the labyrinth of art. If Merton were to embrace the art of his own time and explore with passionate interest forms not wholly unlike those of Jackson Pollock, he would need to understand himself better and more deeply than before.

Certain that William Congdon and his dramatic canvases solved the lingering problem and showed the way, Merton must have felt content—until Ad Reinhardt happened on what Merton had written and fired off a blistering letter that took him to task for his poor judgment. "The other day I received in my mail," wrote Reinhardt,

> a mailing piece and a blurb I couldn't believe my eyes when I saw. . . . Why shouldn't you be human after all and to err is human, we all know, but why should I be forgiving? . . . Have you given up hope? Have you no respect for sacredness and art? Reality-schmearality, as long

as you're sound of body? Are you throwing in the trowel at long last? Can't you tell your impasto from a holy ground? . . . We'll send help, hold on, old man.[34]

Merton had the profound good sense to accept Reinhardt's criticism.

Dear Ad:
Once, twice, often, repeatedly, I have reached out for your letter and for the typewriter. Choked with sobs, or rather more often carried away by the futilities of life, I have desisted. . . . Our lamentable errors. My lamentable errors.

Truly immersed in the five skandhas and plunged in avidya, I have taken the shell for the nut and the nut for the nugget and the nugget for the essence and the essence for the suchness. . . . I have embraced a bucket of schmaltz. I have accepted the mish mash of kitsch. I have been made public with a mitre of marshmallows upon my dumkopf. This is the price of folly and the wages of middle-aged perversity. I thought my friends would never know. . . . I am up to my neck. I am in the wash. I am under the mangle. I am publicly identified with all the idols. I am the byword of critics and galleries. I am eaten alive by the art racket. I am threatened with publication of a great book of horrors which I have despised and do recant.[35]

The surface tone is humorous between two friends of long standing, but they were facing one another, and they knew it. Soon Merton stepped decisively toward the world of contemporary art—in his own way, by the light of his spirituality—rather than away from it. "We have to be men of our time," he told the novices in 1964 in the course of a discussion of art.[36] It was a hard-won conclusion, reaching past art into the fullness of his new perspective.

There was another issue, again a dilemma. In the 1950s and early '60s, Merton had no concepts or language that shed light on the art of his time—at least no concepts or language that he was willing to use in published writings. The ideas he knew, and tried in *Art and Worship* to apply to current art, originated for the most part with St. Thomas Aquinas in the high medieval era. True, they had been reinterpreted and refreshed in the writings of Jacques Maritain, the celebrated French Catholic philosopher who became an intimate friend of Merton's (we will explore this relationship in a later study of friends). Maritain himself wrote in a lovely way about what he called creative intuition in art and poetry, and his short study of the art of Georges Rouault, who was both a true Christian and true innovator in the history of modern art, is a graceful exercise.[37] But Merton couldn't set medieval concepts and language into motion. When he used them to discuss newer art, they made barriers rather than connections, as if there were perfect concepts on one side and imperfect art on the other, and between them the aridity of judgment and aversion.

Such was Merton's artistic dilemma in the early 1960s. He longed for a practice that would represent at least an elementary approach to Zen discipline, and he was deeply drawn to the calligraphic tradition presented by D. T. Suzuki and, in time, other authors. He had in Ad Reinhardt a devoted friend who lived and breathed the world of the New York avant-garde, and Merton not only knew what Reinhardt's art was about but actually had a fine small painting by Reinhardt. While privately, in correspondence with Reinhardt, Merton could take an easygoing, poetic, witty approach to art, publicly he still felt constrained as a monk with

a mission to apply medieval categories to art new and old. The result was predictably awkward and dour, and Merton knew it. He was somehow wrong-footing, again and again.

What to do? How to be? As an artist, he could not go back to his simplistic drawings of Our Lady and a monk. By 1960 he knew too much, had seen too much. His art in earlier years had been cramped and repetitive. As an author on sacred art, he could not turn medieval concepts to a task for which they were unsuited—he had tried and failed. For the troubled manuscript, there was a pragmatic solution and he didn't mind adopting it: on the advice of his friend and publisher Jay Laughlin, he decided to collaborate with a professional art historian who knew modern art well and took a particular interest in modern sacred art. For his own practice as an artist, if there was to be any art at all, it would have to be new.

At this point we must look back again at that moment in late October 1960, when Merton recorded in his journal that he had "tried some abstract-looking art this week." This is the beginning of his journey into abstract art. There is another entry for the same day, Friday, October 28, referring to a trip he had made earlier in the week to the Cincinnati Art Museum in search of illustrations for *Art and Worship*. He had taken time to visit the museum's exhibitions and found much to admire. The words of his journal entry reflect the ease with which he could write of art as a poet and admirer, rather than as a medieval schoolman. Some of the perceptions noted down here in the privacy of his journal became in time points in his "Signatures" essay on his art.

> Enormously impressed, deeply moved by Persian and Indian things, above all by the tomb cover of Imam Riza with its paradise motifs and its Sufi poem. Sacred and wonderful, enigmatic, innocent, alone, by itself. Saying nothing to the uncomprehending people. Also Sivas and Mother Goddesses; the inscrutability of the smiles of the liberated ones all the more inscrutable and even a little sardonic, in a museum. They are very patient with the joke that has brought them there, and put them in our foolish midst, and in our century. . . . Liked the action paintings— deeply impressed by them.[38]

And so in the very week that Merton "tried some abstract-looking art," he also directly experienced Muslim and Hindu sacred art and perhaps for the first time found himself in front of canvases by artists of the New York School or influenced by that circle ("action painting" was a term coined for the dynamic work of Jackson Pollock and others by Harold Rosenberg, an outstanding critic whose perceptions had the power to increase the visibility and reveal the logic of things).

Unfortunately, I have been unable so far to identify what Merton saw. There was no permanent collection of abstract expressionist works by well-known artists, and there was no touring exhibition at the time. Yet he saw *something,* and it deeply moved him. In those few hours at the Cincinnati Art Museum, Merton became an artist of our time.

"This Stuff Is Very Abstract, I Warn You"

"Even so, tell me, how will you go on further from the top of a hundred-foot pole? Eh?"[39] Merton would have known this wonderful impudence among the Zen koans collected in *The Gateless Gate,* a Sung dynasty anthology of Zen (or, strictly speaking, Ch'an) wisdom. In the 1960s, with the boldness and urgency of

maturity, he made more than a few leaps from the top of that hundred-foot pole. His decision to take a public stance as a peace activist was slowly pondered, carefully reached; he had little doubt that the superiors of his order would be unhappy with him. But once he had made up his mind, he took the leap. Not too dissimilarly, his step-by-step adoption of the hermit's life of solitude and religious work was a carefully paced ascent of the hundred-foot pole under the annoying but attentive eye of his Father Abbot. And after moving definitively to the hermitage in the summer of 1965, for all that he remained a much-visited hermit there was enough deep solitude to challenge his soul, shatter routine stability, and show him a new way to be. This, too, was a leap into the unknown, a formidable risk.

As was his acknowledgment, in the spring of 1966, that he had fallen thoroughly in love with the nurse who cared for him at a Louisville hospital after serious surgery. He followed where life led, in profound and excellent contradiction, until it led him back again, changed, to the solitude of his hermitage. That Merton loved fully, with no more and no less dignity than any of us who love, touched his last years with a quality difficult to name: a still greater willingness to turn toward, an assured privacy that welcomed others.

There was another leap in those years: into Asia, in the fall of 1968, and what would prove to be his last journey. As it happened, early in that journey Merton vividly reencountered the idea of the risky leap, in conversation with a Buddhist abbot in Bangkok. "What is the knowledge of freedom?" Merton had asked. His journal records that the abbot replied, "One must ascend all the steps, but then when there are no more steps one must make the leap. Knowledge of freedom is the knowledge, the experience, of this leap."[40] It is no mistake for us to think of Merton in the 1960s under the sign of this leap into new freedoms, new

explorations and expressions. But as always with this grandly complicated man, one has to remember that he was a faithful monk and dedicated religious seeker. He did not leap at random. "We are all in some way instruments," he wrote in 1965 to a friend in religion. "And we all have to be virtuosos at taking a back seat when necessary. Way back. The proper life of a flexible instrument cannot be well ordered. It has to be terribly free. And utterly responsive to a darkly, dimly understood command."[41] He leaped in response to that darkly, dimly understood command. And though it was never guaranteed, he leaped into the light.

The Zen koan offers one further clue. That accomplished man at the top of the hundred-foot pole—there were apparently such things in old Chinese street fairs—is described as having entered the Way. But he is "not yet genuine," as one translation puts it; "not yet the real thing," as another puts it. The text continues: "Proceed on from the top of the pole and you will show your whole body in the ten directions." The alternative translation, more lucid for present purposes, reads that the man who moves on from the top of the pole will "reveal his true self in the ten directions."[42] And so the leap is into generosity, into showing and sharing what one is.

And into discovering what one is. Merton's leap into the practice of abstract art and his enthusiasm for sharing his work was an unanticipated discovery of a new language, a new way of searching, a new way of recording as if in a journal, and a provocative new way of sharing with others. By and large it also belonged to a new place, the "little house," as he put it when the hermitage was still very new, "the most beautiful little house in the world, mostly for conversations with Protestant ministers who come here to find . . . peace and quiet and some agreement."[43] Built at the end of 1960, with Merton much in mind, that house gradually

became his hermitage and home. Plain in all respects, though with an inviting porch that overlooked a field and distant view, this was his place of keenest encounter with the Good Lord and with himself. Least in the order of things, this also was his studio. Nearly a mile by foot from the monastery proper, it was the quiet, independent space where he could explore— among much else—the endlessly surprising correlation between marks on paper and the marks in one's mind and heart. "It is true," he wrote shortly after beginning to spend time there, "places and situations are not supposed to matter. This one makes a tremendous difference. Real silence. Real solitude. Peace."[44] A few years later he referred to his art as "collaborations with solitude."[45] It was the solitude of the hermitage. Had there been no hermitage, there would probably have been no art.

I do not think that Thomas Merton in the 1960s *had* to become a visual artist of such concerted intent and drive. That he wrote was destiny. That he kept a journal was, no doubt, destiny. That he lived a life of unceasing inquiry and prayer, and was a capable scholar of Christian literature—these things were somehow seeded and likely. That his search for a living Christian mysticism ultimately led to rich parallel worlds in Zen Buddhism and later in Tibetan Buddhism—this, too, though impossible to anticipate, belonged to his calling. With rigor and heart, one thing led to another. But nothing, it seems, led inexorably, nonnegotiably, to the serious practice of abstract art. We can construct a plausible biography around the fact that he freely chose in late 1960 to begin exploring with brush and paper the common ground between Zen calligraphy and the visual language of his contemporaries "in the world." In earlier pages we have begun to do just that, and a number of forces and circumstances at work in Merton's life still remain for discussion. But we

should recognize that his visual art, sustained over some eight years, arose from the surplus in him—a surplus of energy and intelligence, inquiry and camaraderie. Merton knew the concept of "the Prolific" in William Blake. That memorable term refers to those who give abundantly to their fellow human beings. In his maturity Merton was of this kind, and his art was of this kind.

That his art was not part of the command performance we all perceive in certain zones of our lives offers another explanation for the fact that it was largely ignored after his death, in decades when his literary works, journals, and correspondence were given definitive editions by skilled and dedicated scholars. Merton as a visual artist strayed beyond the admittedly generous confines where scholars and readers expected to find him. Even that most learned and devoted advocate, Robert E. Daggy, director for many years of the Thomas Merton Center, was coolly dismissive of the visual art. "Merton did practice a form of pseudo-calligraphy,"[46] he wrote. His choice of words hardly draws one in.

As an author, Merton was sure of his readership, although his writings in the 1960s on social issues alienated some confirmed readers who expected him to remain within pious bounds. As a visual artist, he was never quite sure of his audience: "This stuff is *very* abstract, I warn you. I don't know how it would be liked. . . . If anyone is really interested, not just curious, I might send a few drawings and perhaps they could be framed and hung up somewhere."[47] This limp conclusion from our master of language echoes in 1964 doubts we encountered in his letter four years earlier to Eloise Spaeth ("I think . . . there is a place for them in the cosmos somewhere."). Merton's leap into visual art had delivered him into a world where he was uncertain, a beginner. And as time went on and he

gained greater fluency in the new visual language he was exploring, he found a way to renew the uncertainty he faced as an artist—but that turn of events lies ahead in this narrative. It is worth noting that to be a beginner suited him. In one of his last and best writings, he clearly spoke from experience:

> One cannot begin to face the real difficulties of the life of prayer and meditation unless one is first perfectly content to be a beginner and really experience himself as one who knows little or nothing, and has a desperate need to learn the bare rudiments. Those who think they "know" from the beginning will never, in fact, come to know anything. . . . We do not want to be beginners. But let us be convinced of the fact that we will never be anything else but beginners, all our life![48]

This is achingly close to the spirit of a man of whom Merton had heard just a little by 1968 and hoped sometime to meet: Shunryu Suzuki, author of the classic *Zen Mind, Beginner's Mind,* published two years after Merton's death. Those of us who still feel the abruptness of Merton's departure can measure it, in part, by meetings that didn't occur.

If Merton's visual art in the 1960s was an unanticipated extra, a superbly free and sustained choice when other choices might easily have been made, it nonetheless had deep roots and met keenly felt needs. As we have seen, his exploration of calligraphic brushwork offered a living link with Zen. It was a creative, whole-bodied response to his admiration for D. T. Suzuki and his sense of kinship with the priest-artists of traditional Japan. As well, it renewed a time-honored spiritual practice, familiar not only in Asia but also in the scriptoria or writing halls of Western medieval monasteries, where monks wrote by hand and decorated the books of their long tradition. Early Cistercian books, the books of his order, are particularly treasured.

By choosing to explore without reserve or irony a fully contemporary visual language, abstraction, Merton also entered into solidarity with artists of his own time and place, above all with Ad Reinhardt. Merton recognized the potential of abstract art to speak of and from the spirit in our own way, rather than in ways routinely imitated from ages of faith long past. He had been intrigued for years with the idea that abstract art could somehow play that crucial role. As early as 1957, he had written to his friend Robert Lax, "Abstract art is a gold mine. Tell Reinhardt, and see what he replies."[49] This is teasing; it puts Merton in an unaccustomed light for the fun of it. But it is teasing that probes new possibilities, and there was gold in the mine.

Soon after sending off that letter, Merton received from Reinhardt a small Black Painting, which he had requested not long before. It stunned him. He wrote in thanks to Reinhardt a haunting description of the painting:

> It has the following noble features, namely its refusal to have anything to do with anything else around it, notably the furniture, etc. It is a most recollected small painting. It thinks that only one thing is necessary and this is true, but this one thing is by no means apparent to one who will not take the trouble to look. It is a most religious, devout, and latreutic small painting.[50]

Three years later he would begin to try his own hand at the creation of recollected, small, abstract images.

One further point needs to be made about this unanticipated extra, Merton's emergence as a truly interesting contemporary artist. He had the innate capability. He was the son of two artists, Ruth Jenkins Merton and Owen Merton. Though his mother died when he was still a boy and he lost his father to cancer when he was in his teens, Merton was raised in a bohemian arts milieu, not lacking its touch of F. Scott Fitzgerald glamour and *tristesse*. Owen Merton was an artist of considerable skill and charm, whose work is now undergoing a modest revival thanks to an excellent exhibition and catalog produced by Christchurch Art Gallery in Owen's native New Zealand.[51] Owen's son had been making drawings since childhood. That he turned seriously to image making in the 1960s and produced an extensive body of work that he was willing to submit to public judgment must have had for him some taste, some faint and good link, of taking his place alongside his lost father.

The Peculiar Circumstances of This Monastery

Earlier in this essay I mentioned that in late 1960, when Merton first began to experiment with abstract ink drawings, he had persistent problems. It is time to look more closely. For some years he had been restless at the monastery. Immersed in its daily round of communal prayer, communal work to earn a self-sufficient income, and communal all things—apart from the occasional chance to walk freely in the woods or study and pray in privacy—Merton experienced a call to solitude. Try as he might, he could not disregard the call, and in time he launched a campaign to reintroduce into his order the lost practice of eremitical living—the hermit's life. The campaign was partly a matter of

scholarship: he had to find in the long history of the order enough hermits, preferably admired hermits, to argue the case that eremitical living had been forgotten over the centuries of Cistercian life but once had its place. The campaign also had a political dimension: he had to persuade Father Abbot—a man slow to persuade—that it would be a good thing to advocate a revival of the eremitical life in the highest council of the order, which met from time to time and naturally viewed its principal task as preservation rather than innovation. And, of course, there was a moral dimension: Merton had to persuade Father Abbot that his longing for the life of a hermit was sound and edifying, not just an idée fixe or overreaction to the normal stresses of community. Alongside this campaign, there was a concurrent campaign with the same aim: if he were not permitted at Gethsemani to live as a hermit, could he then transfer to another order in which the eremitical life was an established practice—or found a new monastic experiment, perhaps in South America?

This wearisome overall campaign, which reached a particularly bitter point in 1959–1960, was frustrating for years and years but ultimately successful. Late in 1965 Merton was freed from nearly all of his monastic duties and authorized to live at the hermitage. However, the campaign was about more than living quarters and a bit of privacy to experience one's life in an unfiltered way. It was also about institutional authenticity, and it reflected Merton's desperation over what he had expected of the monastery, what it was in fact, and what future lay in store for it. He had expected the monastery to serve as a receptive home for the life of contemplative prayer, for an ascending search guided by faith in Christ Jesus and by contemplative traditions preserved in the church. Was it anything of the kind? He returned to this question often in his

correspondence, for example in late 1959, in a letter to a former monk of Gethsemani with whom Merton obviously felt that he needn't mince words:

Unfortunately . . . the peculiar circumstances of this monastery prevent real spiritual growth. Underneath the superficial and somewhat false good humor, with its facade of juvenile insouciance, lie the deep fear and anxiety that come from a lack of real interior life. We have the words, the slogans, the notions. We cultivate the pageantry of the monastic life. We go in for singing, ritual, and all the externals. And ceremonies are very useful in dazzling the newcomer, and keeping him happy for a while. But there seems to be a growing realization that for a great many in the community this is all a surface of piety which overlies a fake mysticism and a complete vacuity of soul. Hence the growing restlessness, the rebellions, the strange departures of priests, the hopelessness which only the very stubborn can resist, with the aid of their self-fabricated methods of reassurance.[52]

Had this been his sole experience of the monastery in 1959 and his sole view of it nearly two decades after entering the religious life, he would have risked losing his vocation in a storm of anger and cynicism. However, at quieter moments in the early 1960s, he could view himself and his brothers in a much warmer light. For example, to the head of the entire order he could write, honestly, in 1962: "I am very thankful in my monastic vocation, my vocation at Gethsemani, my vocation to be a strange and funny creature, a sort of twentieth-century juggler. But my brothers tolerate me and they love me; I also love them very much. God will do the rest."[53] By 1964, he was reasonably satisfied that

his unique patchwork of cares, perseverances, interests, and purposes made a whole. Even under "the peculiar circumstances of the monastery," as he had put it in that damning letter of 1959, he could after all search and grow—provided that he had sufficient solitude to encounter himself cleanly. "Some conclusions," he recorded in his journal in the summer of 1964, "literature, contemplation, solitude, Latin America—Asia, Zen, Islam, etc. All these things combine in my life. It would be madness to make a 'monasticism' by simply excluding them. I would be less a monk. Others have their own way, I have mine."[54]

This discussion of Merton's quarrels and reconciliations with church and monastery could reach book length without exhausting the spiritual and psychological riches of what is now a tale, but was then a fire in Merton's life, sometimes burning, sometimes warming. For present purposes, we need only note that by the end of the 1950s Merton had long since been knocked away from his initial reliance on church and monastery, and was consolidating a much broader, richer identity than in the past. He was a monk, a monk of Gethsemani. And a rebel. His capacity to live this contradiction and make it, again and again, fruitful not only for himself but for all people with whom he came in contact personally or through his writings, lies somewhere near the heart of his enduring magic. It is also just this that allowed him to turn toward the language of abstract art with curiosity, playfulness, and determination. No one else was doing such a thing—except in Kyoto and Lower Manhattan. No one at Gethsemani would see what he was doing, at least not for a time and never in depth. No one cared, and no one would really understand, except a few artists who were geographically distant. He was quite alone. But then, he had the hermit's vocation. It was worth a try.

At Work and at Rest

It is tempting in this first extended study of Merton's visual art to lose sight of other currents in his life from 1960 forward. That would be an error. He did not work on art morning, noon, and night; he seems to have dedicated to it bursts of energy and concern, with a longer, more sustained period of work in 1964. In the very early sixties, when his exploration of abstract art had just begun, he had three compelling concerns quite apart from his concern for the evolution of the church and of monastic life.[55] The first was his new and advancing work as a writer—for example, his work toward retelling philosophical anecdotes and reflections of the Taoist patriarch Chuang Tzu, a favorite of Merton's and one of the most lovable, sharply etched figures in early Asian spirituality. The result of that study was a book he regarded in later years as his best or most delightful: *The Way of Chuang Tzu* (1965). It was a kind of handbook for a lighter touch in life, serious and clear-sighted but free.

Logically enough, his study of Chuang Tzu also exposed him to the magic of Chinese ideograms, ancient and contemporary. He pored over the remote, unfamiliar pattern of Chinese brushed signs and tried to master the use of a Chinese-English dictionary with help from a scholar friend. He didn't make much progress, and forgave himself for that, but the forms of Chinese ideograms found their way into his art—for example, in portfolio images 11, 16, and 18 (and even more so in other works, not illustrated here, in the collection of the Thomas Merton Center).

In the year after his *Chuang Tzu* appeared in print, he published another major work: extended excerpts from his journal under the title *Conjectures of a Guilty Bystander*. He described it as "a personal version of the world in the 1960s."[56] Merton the visual artist lived alongside Merton the writer throughout the 1960s.

The second current, belonging to the early 1960s, arose from his concern to revise or at least "reposition" some of his most influential earlier writings to reflect his new, warmer, more accepting and inquiring perspective. In a letter of late 1962 to a friend in religion, he spoke to this issue: "Most Benedictines judge my statements almost exclusively in the light of earlier books in which I was much more rigid and doctrinaire than I believe I have since become. . . .Though I have by my early and more impetuous efforts deserved to get shoved into a pigeon-hole, I still meekly protest."[57] One year later, in a new preface to the Japanese edition of *The Seven Storey Mountain,* the autobiographical work of 1948 that established his fame as a writer, he returned to the same theme: "When I wrote this book, the fact uppermost in my mind was that I had seceded from the world of my time in all clarity and with total freedom. The break and the secession were, to me, matters of the greatest importance. Hence the somewhat negative tone of so many parts of this book. Since that time, I have learned, I believe, to look back into that world with greater compassion, seeing those in it not as alien to myself, not as peculiar and deluded strangers, but as identified with myself."[58]

Merton's third concern in the early 1960s was encompassing, upsetting, and difficult: his decision to raise his voice as an influential writer and Catholic thinker on behalf of the antiwar movement. A stream of writings followed from this decision. In a journal entry for November 22, 1960—just a few weeks after his encounter with "action painting" at the Cincinnati Art Museum—he recorded the uneasy state of his search for a position on public issues: "Sense of obscure struggle to find a genuinely true and honest position in this world and its belligerent affairs. I wish I

knew where to stand. I think I stand with a Gandhi more than with anyone else. But how to transpose his principles to suit my own situation? . . . A growing obscure conviction that this country, having been weighed in the balance and found wanting, faces a dreadful judgment."[59]

This is a current in Merton's life, really a torrent, that we cannot follow here at length, but we should be aware of it. A year later, well into his cycle of writings on peace and war, he had been partially silenced by the authorities of his order and was launching a campaign of *samizdat,* modeled on the typed, privately circulated dissident literature of the Soviet Union. If he could not properly publish much of his thinking, owing to the refusal of ecclesiastical censors, he could still circulate it as mimeographed letters to friends, who would circulate it to other friends. These were his *Cold War Letters.*

I have felt that it would be a matter of fidelity to my vocation as a Christian and as a priest, and by no means in contradiction with my state as a monk, to try to show clearly that our gradual advance toward nuclear war is morally intolerable and even criminal and that we have to take the most serious possible steps to realize our condition and do something about it.

The question is, what does one do?

At present my feeling is that the most urgent thing is to say what has to be said and say it in any possible way. If it cannot be printed, then let it be mimeographed. If it cannot be mimeographed, then let it be written on the backs of envelopes, as long as it gets said.[60]

These three currents of striving and concern—new writings, revisions, and peace activism—flowed along-side the magnificently settled practices of the monastic life: Sext and None and Vespers (these and other daily "hours" of communal prayer in the vast church at Gethsemani); *lectio divina,* the careful reading and pondering of religious texts; instructional sessions with the novices, for whom Merton was long responsible; regular Sunday talks by Merton on topics freely chosen from his profusion of topics—it astonished him that they were so well attended; the solitude of the hermitage; walks in the woods; reforestation under his general guidance; private prayer and meditation as a child of God, an explorer of being; and so much else, some of it annoying, some of it altogether nourishing. There were, as well, surprisingly frequent meetings with friends and guests—some local and very dear, some from as far away as Hiroshima and Vietnam, whom he would meet just once but vividly.

As time went on, the hermitage became his home. In March 1962, he was authorized to live full days there; in August 1965 he moved in, returning to the monastery just once each day to say Mass and take a meal with his brothers. By 1967 he thought of himself as "practically laicized": "I have the usual *agonia* with my vocation, but now, after twenty-five years, I am in a position where I am practically laicized and de-institutionalized and living like all the other old bats who live alone in the hills in this part of the country."[61] Of course, he was laicized after his own manner. Some of his classic spiritual writings were in progress at the time, and more still lay ahead in the short time remaining. For example, his truly superb "Letter on the Contemplative Life" is dated August 21, 1967.[62] At the time, he was living like all the other old bats in the Kentucky hills.

Merton's search in art was a counterpoint to these intense activities and concerns. It must have been a rest for him: writers rest in zones of experience that

are freer of words. It was surely a kind of play, refreshing but religious. It started out as a low-stakes activity: no mission, no message, no public, just stirred curiosity and an inscrutable sense of promise. It became a high-stakes activity because it so engaged him that he explored it deeply, gained respectable mastery of the brush and of certain image-making techniques, and sought a public for his art. It became a second journal.

Chronology and Change

Apart from 1964, when he was preparing a public exhibition, Merton dated few images, perhaps sixty among hundreds. For this reason, the chronology of his art in that decade has foggy patches. Still, with the exception of a few missing years, there are dated works all along the way, and groups of similar images are anchored in time by at least one dated image in each group. On the basis of dated works and sustained themes, with hints from correspondence, notebooks, published art, and published writings, a reasonable sequence of his works and progress can be developed. This matters because his skill and technique and, more important by far, the thought underlying his work evolved over time.

Merton began this cycle of work as, in effect, a student of Ad Reinhardt's; his initial work is Reinhardt-like. He quickly went on to explore in his own terms the expressive power of Zen calligraphy and attained remarkable mastery at this stage; the best of his work in this mode can hold its own in any company. He would occasionally use his calligraphic art, now well developed, to make political statements in support of his writings on peace and war, though that was never a dominant practice. At some point in late 1963 or 1964 there occurred a major shift in technique and a corresponding change in his images. Perhaps responding to technical hints from a fellow artist, perhaps observing methods in print shops to which he had access and drawing his own conclusions, he explored printmaking techniques that he quickly found to have compelling advantages over direct brushwork. Thereafter he created nearly but not quite all of his images as monoprints, single images generated by simple printmaking techniques. This form of image making carried him into original artistic terrain. The lightly printed, evanescent, almost vanishing images of the later 1960s are probably the ones he valued most highly. They are also the most challenging to us as viewers; we will need to learn their language and intuit their close links with themes in his later writings. Addressing a friend in 1965 about a photographer who was choosing works to photograph for a newspaper, Merton commented: "The best ones would not attract his attention because they are the most nearly 'formless.'"[63]

We have scarce but strong documents at the beginning: journal entries and Merton's letter to Eloise Spaeth of fall 1960, both of which link to the first work in the portfolio of images in this book. That image carries the title *Jerusalem* and the date 1960. His whimsically deprecating description of a work he sent to Spaeth in November of that year, "animated fragments of furniture in an exploding house," is a possible though unfriendly description of *Jerusalem*. What he sent to her must have resembled it. There is a second connection of interest: Merton's angular, multipart composition bears more than a passing resemblance to Ad Reinhardt's art of about a decade earlier, with which Merton was sure to be familiar.[64] He had received a visit from Reinhardt at the monastery little more than a year earlier, and Reinhardt is likely to have brought exhibition catalogs and other documents—Merton's friends knew enough to bring him supplies.

Merton was not as remote from art media as one might imagine. He read—and surely browsed—from time to time in two substantial libraries in Louisville. That he received art magazines at the monastery, no doubt through the kindness of friends who mailed or personally delivered them, was demonstrated with scientific accuracy by a gift of documents that arrived at the Thomas Merton Center in Louisville at a time when I was there. The gift was three or four mainstream art magazines dating to the 1960s—among them *Artforum*, the messenger of the avant-garde. Having recently surfaced at the monastery, they were forwarded to the center on the assumption that they might be of interest in Merton studies. Because it is so difficult to know what Merton actually saw of contemporary art, this packet of cast-off documents was a thrill. Despite his monastic seclusion—this was a man who had scarcely ever watched television—he was able to see something of contemporary art. Merton is unlikely to have had stacks of art magazines in the hermitage, but he was not wholly cut off from the flow of images and ideas moving through the art community at large. How else to explain journal entries that record tidbits of information with casual expertise?

> P. Bonnard, the post-impressionist painter, has died, after instructing someone where to put the last blob of yellow on a last great painting.[65]

Merton's time frames may have been sketchy on occasion—Bonnard died in 1947, but Merton reports it as a recent event—but there can be no doubt that he had some degree of access to the work of contemporary artists. His own work shows kinships that would be hard to account for if he had had no access whatever (on this topic, see the section "Unlikely Peers," p. 154).

A number of works, apart from *Jerusalem,* are dated 1960. There seems then to be a gap without dated works in 1961–1962, although he must have continued his practice of abstract art because dated works of 1963 show both further explorations of Reinhardt-like imagery and the new exploration of Zen calligraphy.[66] In fall 1963, perhaps in September, Merton sent to a literary magazine in Mexico City, which he would have known through his work on peace issues, a suite of four recent calligraphic drawings with an offer to publish them if the editors found them worthwhile. The drawings were indeed published in 1964 in *El Corno Emplumado,* and they probably represent Merton's debut in print as a visual artist. Shortly after making these arrangements, he was invited by the editor of a little magazine making its own debut at the University of Iowa to contribute an essay in literary criticism. Merton responded in late October 1963 by offering both an essay and a suite of four calligraphic drawings. The publication of that suite in the first issue of *Charlatan* (1964) again gives us a group of works that must date to 1963.

I have not included here images from these two suites because Merton is still searching for his art in them. In light of what came soon after, these works are tentative, slightly unformed, as if seeking an order that still eludes their maker. Merton himself was critical of the suite published in the Mexican journal and felt better about the works in *Charlatan*. Writing to a Latin American friend in the fall of 1964, he commented: "The abstract drawings I did for *Charlatan* were the beginning of a flood of 'abstract calligraphies.' I have done scores of them, and in fact some are being framed and will be exhibited in Louisville this fall, perhaps also elsewhere. . . . You saw some that were not very good in *El Corno*."[67]

Between his selection of drawings for the journals and his preparations for the exhibition of late 1964, there is a clear notch in the calendar: calligraphic drawings sent by Merton to Reinhardt in three batches at known dates. The first batch must have been sent in late September 1963. The second would have accompanied Merton's surviving letter to Reinhardt of October 31, 1963, and the third, a New Year's gift, went out with Merton's letter of January 12, 1964.[68] Only one of the images sent to Reinhardt is explicitly signed and dated ("For Ad, Happy New Year of the Dragon—1964—Tom Merton"), but all of them must represent "the latest thing," as Merton relied on Reinhardt for feedback and also for a supply of fine paper. It was in his best interest to be as impressive as possible, and in truth some of the works he sent are exceptional. One of them is published in this book as portfolio 3. It presents an extraordinarily dynamic stack of motion, vertical yet windblown, open in structure yet well ordered, as if this were the X-ray or bone structure of an *arhat,* a Buddhist saint of ancient times. The visual language of this work has a trace debt to Reinhardt's angular compositions of the late 1940s but dominantly offers Merton's individual interpretation of flowing Zen calligraphy. This excellent work is unsigned, undated: Merton was a monk, and his passage among us was both a fiery thing, noticed by millions, and a discreet, self-denying brevity.

By late 1963, Merton had hit his stride as a brush calligrapher. Other strong brush-drawn works in our portfolio of images must date to 1963–1964—most notably portfolio 16, but there are many others.

The batches of work sent off to Reinhardt included one image that is quite directly reminiscent of Merton's first essays in a Reinhardt-like, angular style—therefore, reflecting the past. But Merton also included several examples of an image-making technique that would be of compelling interest to him in the future: printmaking. As noted earlier, there is a turning point in Merton's art, a transition from direct brushwork to printmaking. That transition must have occurred in 1963, and if the gifts to Reinhardt are a reliable guide, it probably occurred in later 1963.

Sept 28, 1963

Dear Ad.

Ulfert Wilke was here, and before that I was doing calligraphy—but since I have done more. As this is the most rapid form of art production I have now thousands of calligraphies and the only reason I don't have millions is that I have been in the hospital with a cervical disc.

Let's hear from you some time.

All the best,
Tom

This quick note, essentially thanking Reinhardt for sending Ulfert Wilke around, is more significant than it sounds. The dates of the first meetings between Merton and Wilke were September 6 and 7, 1963, corresponding to an initial meeting at Gethsemani followed by lunch the next day at Cunningham's, a Louisville restaurant that turns up more than once, and hauntingly, in Merton's biography. It was a secular sanctuary for him, with private dining booths where he could freely meet friends. As Merton was something of a celebrity, the swinging doors of private booths ensured privacy.

Ulfert Wilke, long a faculty member in studio art at the University of Louisville, was a friend of Reinhardt's and a formidably able practitioner of a calligraphic approach to abstract art. He had studied both in Europe and in Kyoto, and his friends included many leading American and European artists. We will return to Wilke in a focused study at the back of this book. For the moment, we need only recognize that Merton's transition to printmaking seems to coincide with his meeting with Wilke, who gave him a perfectly beautiful portfolio of his own Zen-influenced prints, produced in 1960 in a small edition on a fine Kyoto press.[69] I have found no evidence that Wilke coached Merton to explore printmaking as a possibly interesting extension of his practice of direct brushwork, and Merton spoke of having devised his own method. But the dates suggest that Wilke had some hand in it, however indirect, and Wilke's own mastery of printmaking ensures that he could have done so.

Merton's transition to printmaking and the possible reasons underlying his preference for printmaking deserve separate discussion, and soon. But we should first complete what we can of the chronology of Merton's art in the 1960s. The next clear phase coincides with Ulfert Wilke's reappearance in Louisville in the summer of 1964, after spending the academic year as an art instructor elsewhere. Probably at Wilke's instigation, in August 1964 Merton received from Sister Mary Charlotte, director of the art program at Louisville's Catherine Spalding College, an invitation to show his art in the college gallery in the fall.[70] That invitation, accepted with the approval of Father Abbot, created a new urgency in Merton's life as a visual artist. Like many other artists facing exhibition deadlines, he almost certainly produced more work than ever before or after in the months leading up to the exhibition, which opened just before Thanksgiving 1964. He also signed

and dated more work, supplied brief poetic titles, and wrote an artist's statement (the essay republished here on pp. 60–61).

He was dead against giving titles to his works; he felt strongly that they should not be tied down by verbal associations of any kind, let alone precise titles. However, he was willing to take into account the anticipated needs of an actual audience. His letter to Sister Mary Charlotte, accepting her offer to mount an exhibition, shows him struggling with this issue and, along the way, acknowledging the presence of Ulfert Wilke:

> The drawings are extremely abstract, and have something of the nature of the abstract "calligraphies" which Ulfert Wilke, an artist well known in Louisville, was doing for a while. Perhaps I might have to write a short explanation of what my purpose was in making these drawings. . . . A lot of them are untitled. I could perhaps get titles. We shall see. Thanks again for your kindness. I hope the drawings will not be considered too far out, but they probably will by many. This I expect. It is understandable.[71]

We will return in later pages to the theme of the Spalding exhibition and the touring exhibition that followed from it. The correspondence and much else surrounding these events are both fascinating and instructive. But for present purposes we now have an explanation for the disproportionate number of works dated 1964, often signed. In the portfolio at the center of this book, images 6, 8, 10, 21, and 22 all date to 1964—and, needless to say, they were chosen for quality, not date. The year 1964 was a high point of Merton's work in visual art.

This must be the moment to mention that in the fall of 1964, while preparing the Spalding exhibition,

Merton also began to explore photography and remained thoroughly interested in it in the coming years. Charting the points of contact between his work with brush and ink and his work with the camera exceeds the scope of this book, but that project would be well worth the time of a historian of photography. When Merton damaged the simple camera he was using in September 1964, it was repaired and returned to him. "Darling camera," he recorded in his journal, "so glad to have you back!"[72] I don't know that he ever said such a thing to a brush.

The Spalding exhibition can be reconstituted up to a point. A checklist of the titles of the works on exhibition is preserved in the Thomas Merton Center (see fig. 22, p. 163), but it is impossible to match many of the titles to images. He thought well enough of the works in the Spalding show to include fifteen of them, in reproduction, in his memorable essay collection *Raids on the Unspeakable*, published in 1966—but there purism prevailed and the titles were dropped (this is the book that includes the essay on his own art). Periodically replenished with new works as others were sold, the Spalding exhibition traveled for several years to other Catholic institutions of learning and ultimately landed in the Fun House, an avant-garde coffee shop/gallery in Washington, D.C. Merton grumbled in the distance: an "inauspicious name from the start."[73] The year was 1967, and what remained of the exhibition he offered to a friend in D.C., in support of her Catholic good works.

And so a line in time extends from Thanksgiving 1964 through the very end of 1967, three years in which an exhibition of Merton's art moved with periodic breaks from site to site across the country. He was always aware of it, always ready to replenish it with new works. In fact, as noted earlier, he took an active hand in touring it smoothly from place to place.

I missed it at Paraclete Book Center in Manhattan, in November 1966, a magical bookshop with a crisp monastic atmosphere and a faint sense of eternity, where one could find the works of Thomas Merton *in extenso* and all sorts of rare treasure.[74]

Through these years, Merton continued to publish his art in small journals. One such participation, in *The Lugano Review* (1965:1), gave him a striking new compositional idea to explore for what must have been the next several years. The circumstances are surprising. In the course of my research on Merton's art, I couldn't help noticing that one series of closely similar works, anchored around an image dated 1967,[75] looked as if Merton had inexplicably become an early Russian modernist—as if he were part of the circles around Kasimir Malevich and Vladimir Tatlin in the years just before and after the revolution. I couldn't account for this phenomenon and attributed it to Merton's surprisingly broad visual culture and an affinity he would not have failed to discover between his search in religion and the spirituality of Malevich. The works in that series are subtle and very beautiful; two are published here as portfolio 25 and 26. But where did the awareness of Russian modernism come from?

The editor of *The Lugano Review,* a Columbia classmate and friend, James Fitzsimmons, sent Merton as a normal courtesy several copies of the issue in which five of his drawings had appeared (two direct brushworks dated 1964, three undated prints). By chance or providence, there was a long, well-illustrated article in that issue exploring Russian modernism in its larger European context.[76] Merton would have encountered in this article something of the spirituality of artists in these circles but, still more important, he must have given keen attention to three reproductions of work by Tatlin and Malevich. The Tatlin is a lost three-dimensional construction in what appear to be

panels of wood, paper, and other materials, his *Complex Corner Relief* of 1915. This work, known only through a newspaper photograph, is famous among art historians. Soon after, although we don't have the convenience of dated works to tell us how soon after, Merton began a series of prints that reinterpreted in his own terms Tatlin's construction and Malevich's porous edges and enigmatic passages between things. It seems preferable to reserve to later pages an interpretation of this remarkable series of works.

Our present business is to complete the chronology of Merton's work insofar as possible. Alongside Merton's writings as a peace activist and advocate of racial justice in the United States, one would expect to see some sign of those concerns in his visual art. He did send to his comrade-at-arms on issues of war and peace, W. H. (Ping) Ferry, a series of drawings called "war birds." While few of these images have so far come to light, Ferry put what must have been one of the strongest on the jacket of his edition of Merton's letters, published in 1983 (fig. 8).[77] Merton's own word for images of this kind was "pugnacious."[78] This particular one is signed and dated 1965. Merton was aware of birds of prey and scavengers around the hermitage—he had good things to say about hawks, tolerant things to say about crows—but it's more likely that his war bird imagery derives from a sight that for years caused him sorrow: the passage closely overheard at Gethsemani of Strategic Air Command bombers, carrying nuclear weapons, which took off and landed at a nearby air base. This was Gethsemani's share in the cold war. "I have seen the SAC plane," he wrote in 1965, "with the bomb in it, fly low over me and I have looked up out of the woods directly at the closed bay of the metal bird with a scientific egg in its breast!"[79] Merton's rapacious birds and other creatures owe some debt, as well, to the biblical imagination, to prophe-

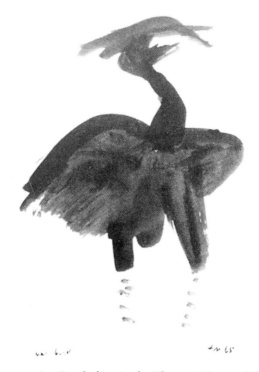

FIG. 8 Brush drawing by Thomas Merton, *War Bird*, 1965, reproduced from the book jacket of his collected correspondence with W. H. (Ping) Ferry.

cies and psalms that predict or lament devastation. This was not the strongest part of Merton's work as a visual artist. Anger did not become him; his brush became awkward.

One further event in mid-1965 calls for discussion: his encounter with traditional Chinese concepts and language for the art of the brush. The issue here is not dated works but an intellectual and spiritual event. It is an astonishing experience to open an ancient text and discover that it speaks to one directly. This was Merton's experience of a huge book, *The Tao of Painting,* a set of interpretive texts and translations from traditional sources by a versatile Chinese American

author, Mai-Mai Sze, who was for a time a well-known actress. Merton came upon her book in the library of Victor and Carolyn Hammer, friends in Lexington, Kentucky. Artists and letterpress printers of great sophistication, whom we will meet properly in a later study (see p. 141), they were kind enough to loan the book to Merton in June, when he was on the way to the hospital in Louisville for one of his all too frequent surgeries. (Merton in later years was sturdy—he looked a bit like a longshoreman—yet surprisingly susceptible to physical problems: things were almost always going wrong or getting better.) Reading into that book was a major experience, reflected in extensive passages transcribed into a study notebook with emphatically underlined phrases. "I take delight in Mai-Mai Sze's *Tao of Painting,* a deep and contemplative book," he recorded in his journal. "I am reading it slowly with great profit. She is becoming . . . one of my secret loves."[80]

By mid-1965, Merton had long since found an angle of view and language that suited his art—this is evident in the essay of 1964 on his own art. He must have known the works of D. T. Suzuki virtually by heart, including Suzuki's illuminating discussions of the priest-artist Sengai's art of the brush. He also knew the chantlike, dry brilliance of Ad Reinhardt's published meditations on art. These rich sources, joined with his own powers as a poet and artist, were quite enough to generate a language. Yet what Merton encountered in *The Tao of Painting* was dazzling. It must have revealed to him what he had been thinking all along. Art making is a discipline of mind, heart, and hand, potentially sacred, potentially linked with deep levels in oneself. It is a path of entry into profound contact with nature, a means of belonging here and now to what one sees, feels, and records with the brush. It is a Way. The scholar-artists of traditional China shared this view, practiced on this basis, and

conversed in a luminous language that did not chill or kill art; it helped call it into being. Their language and perspective did not supersede everything Merton had known and felt in the past; it confirmed and extended, invited new explorations. "All the steps of the painter's arduous training," Merton transcribed,

all his accumulation of all the means available, all his efforts in the long process of his development of *the self, should be directed by the concept of the Tao and so be ritual acts sanctifying the painting that he produces.* Then the tactility of the brushwork is evidence less of the personal touch than of the power of the *Tao.* The anonymity of the ritual act is, in effect, oneness with the *Tao.* And painting is not self-expression but an expression of the harmony of the *Tao.*[81] [emphasis added by Merton]

Merton confirmed in the pages of *The Tao of Painting* the rightness of his own quest for a contemplative art that supported and furthered his search for an ever-deepening practice of contemplative prayer and meditation. You will find further passages from this book in Merton's transcriptions, facing pages in the portfolio of images. "The brush dances and the ink sings"[82]—in Kentucky as in China.

Just three further elements of chronology and change should be added here. I mentioned toward the beginning of this essay that Merton worked as an artist in what seem to have been bursts of energy and concern. There were dry patches, and patches when other concerns were foremost. In the late spring of 1967, for example, he replied as follows to the editor of a literary magazine, William Claire, who had solicited drawings for publication after seeing the exhibit of Merton's art in Washington:

Very glad . . . to learn that you had seen and liked the drawings. . . . This summer, if I can, I want to get back to doing some more drawings. I haven't had a chance to do much in the last year or so. If I do some new ones, I'll let you see a few that might be useful for the magazine. Yes, they reproduce quite well, but in my mind they look best when on a grey mat and so on. They are deceptive. One has to live with them to see what they are really doing. Actually there are now quite a few of them spread around here and there all over the hemisphere (quite a few in Latin America, I don't know where they all are now) and a few also in England.[83]

We can take from him the point that one has to live with his art for a time to see it, especially the later works. That has been my own experience. But of more immediate concern, there is a gap in the chronology "in the last year or so," meaning perhaps from spring 1966 through June 1967 (I know of just one work dated 1966.[84]) As noted earlier, in the spring of 1966 Merton fell in love with the nurse who cared for him at a Louisville hospital after serious back surgery. They saw each other for some months until various circumstances, dramatic and keenly felt, separated them from one another. Merton's journal in that year, as well as "A Midsummer Diary for M.," and poems from that time (recently republished in a larger collection) are a still-heartrending witness to their shared experience and his return to solitude.[85]

If Merton made few drawings in this period, as his own account indicates, one can't help asking: did he later make any at all that reflect this unique passage of love into and through his life? He resumed his practice of art at some point in 1967, presumably after his June letter to William Claire. As it happens, among the images he sent to Claire for publication there is a most unusual work, signed and dated 1967 (fig. 9), which quietly asks to be read as an emblem or history of love. It is reproduced here from the journal itself; the original is lost or mislaid.[86]

In two respects, there are few works like it in Merton's creative output. It combines fine direct drawing with printed images, suggesting that the printed marks came first and the pattern of lines that link them came next—a rare compositional choice. And it tells, however enigmatically, some special tale by means of recognizable objects: an applelike fruit, perhaps an emblematic heart, a dark smudge at the top occupying some part in a drama we dimly grasp. We are now in the realm of "fools rush in"; there are too few clues to permit secure interpretation. But is there some poem here of innocence undermined? Are there two fruits here, one from Eden and one from hell? This heavy work will guard its secret.

Here is where we should end this account of chronology and change in Merton's art. But life has a genius for anticlimax, and so we must look briefly at two further documents. The series of drawings that Merton sent to Claire for his literary magazine included a dated work of 1967, a print closely resembling portfolio 24, also dated 1967. There are several other "pulls" of the same print at the Thomas Merton Center and in private collections. The image clearly interested Merton; there are very few multiple prints of a single image. Let us defer for now an interpretation of this image, but we can hardly avoid the observation that toward the end of his life Merton was exploring complex images and textures. In this work we are far from the light, airy brushstrokes of earlier years. If there is something unresolved here, a new study still needing to be pursued and mastered, that is no surprise.

FIG. 10 Thomas Merton, early fall 1968, just before his departure for Asia. Photograph by Ralph Eugene Meatyard.

FIG. 9 Brush drawing by Thomas Merton, untitled, 1967, published in *Voyages* 1:1, Fall 1967.

[The hermit] knows where he is going, but he is not "sure of his way," he just knows by going there. He does not see the way beforehand, and when he arrives he arrives. His arrivals are usually departures from anything that resembles a "way."[87]

In the fall of 1968, the hermit was departing for Asia. On September 9 he said his last Mass at the hermitage in the company of monks who were also friends,

and he was soon on his way (although not at once to Asia—he spent his first month of travel in the western United States and Alaska). The last document we need to consider for this chronology is a joyous one, a photograph of Merton taken by Ralph Eugene Meatyard, the photographer of genius who had been a friend and photographic companion since they met in early 1967 (fig. 10).[88] Taken in the hermitage just days before Merton left Gethsemani to begin his journey to the East, it shows Merton in proper Cistercian robes, white and black, with a pair of bongo drums caught between his knees. He's drumming with a lovely smile and the closed or half-closed eyes of a musician who has found his groove. To Merton's left, light falls on his worktable where we see eyeglasses, books, a fat manila envelope, stray papers—and a calligraphic drawing. Perhaps he was just tidying up; the drawing could be an old one. But perhaps it was new.

Thomas Merton, Printmaker

"Now what do you think of the printing method I have devised . . . ? I think it makes for very nice small obscure calligraphies and comes out more fine than the great brush. I am nuts about my method."[89] So Merton wrote to Ad Reinhardt in January 1964—as almost always with Reinhardt, joking, and as almost always, serious beneath the surface. The effort to understand *that* Merton made prints, *how* he made prints in a hermitage with no equipment and no hope of equipment, and *why* he made prints proved to be the keenest challenge of this exploration into Merton's art. He didn't refer to his work as prints; they were calligraphy, calligraphic drawings, or just drawings. His own description of the printing method came to light unexpectedly in an unpublished letter that could easily have been missed. The one eyewitness account of Merton at work as an artist is somewhat misleading. And the evidence gathered by one's own eyes can be uncertain.

For the longest time I assumed that the majority of the hundreds of images I was examining were direct brushwork—sometimes very fine, made with the lightest touch and the driest possible brush; sometimes textured with astonishing patience; but direct brushwork all the same. Printmaking requires a proper studio, a press of good size, racks of tools, supplies, and inks, and so he couldn't be making prints. Yet it gradually dawned that certain images, including some of the most impressive, might after all be prints. Uneasy, no longer certain even of the definition of a print, I asked the chairman of the art department at the University of Louisville to come to the rescue. James Grubola was kind enough to join me at the Thomas Merton Center with two faculty colleagues, John Begley and John Whitesell, both of whom, like himself, had long

experience in the print studio. However Merton had made his prints, these seasoned artists would surely be able to detect and describe his methods. That proved to be true. The results of their research, which included experimentally duplicating Merton's techniques, are gratefully published here as an appendix: "Thomas Merton, Printmaker: Reconstructing His Technique" (see p. 166).

What the artists do not report in their study is the moment of epiphany, of proof perfect as to how Merton worked. We had been looking at one of Merton's finest images, a titled, signed, and dated work of 1964, *Personal or not,* published here as portfolio 22. We also had at hand a cleanly trimmed and stapled booklet, possibly acquired by Merton during an expedition to the monastery print shop. Originally a blank book with a textured cardboard cover, he had used it, in effect, as a diary for images. One of his most poignant works, the Crucifixion published here as portfolio 33, was in its pages. It happened that there was also a brush drawing on the cover (fig. 11), a miserable thing, washed out, awkward, perhaps a trial piece. But one of the artists was curious about it. He looked more closely, set it alongside the very beautiful *Personal or not,* inspected and inspected again, and finally commented: "I think this is the paper matrix he printed from." Dr. Paul Pearson, director of the center and witness to these discussions, offered at once to make a transparency of the washed-out image—and within minutes we were able to superimpose transparency on print. The fit of form to form was perfect; texture corresponded to texture. We had stumbled on a surviving matrix that Merton had actually used in his printmaking process. This explained why the cover image was washed out: used to transfer ink, it was part of the image-generating process, not a finished work. *Personal or not,* which might conceivably have been created by patient brushwork, was

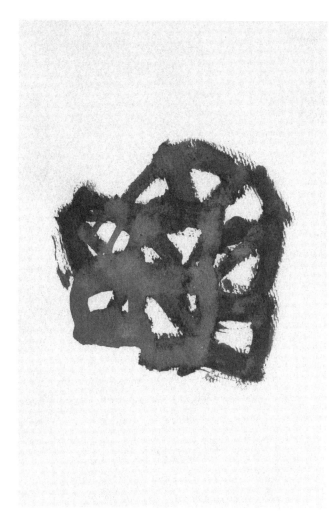

FIG. II Brush-drawn matrix used by Thomas Merton to print portfolio image 22.

which his exhibition had traveled. Sister Gabriel Mary, no doubt a studio artist, had been sensible enough to ask Merton about his technique. "Oh, and about how I did them, or some of them," he replied.

> Many are just brush and ink drawings, "calligraphic" style, with free and unorthodox handling of the brush. Others I first do on a piece of scrap paper and then print off on the good Japanese paper, which is what gets that nice rough effect and the tone. It is very fascinating to do this, at least I find it so. You never quite know what is going to come out, and often it is a big surprise. I am always interested in new papers. If you have any samples of new textures lying about I would be delighted to have them to play with. Actually, I do best with Japanese papers, at least for the finished "print." But all sorts of non-absorbent papers are good for the negative.[90]

We meet here Merton's own language for what he was doing. He found the terms he needed in photography: negative and print.

The portfolio of images in this book includes examples of nearly all of the types of prints Merton made.[91] Portfolio 21, for example, an extraordinarily elegant composition, would have been brushed with ink onto a textured paper "negative" or matrix and then printed onto fine paper by the pressure of Merton's hand. That he often or always used his hand to make prints is suggested by the complex image, portfolio 24, which we have begun to explore: the three artists noticed in it the actual contact of his fingertips at the top of the image and the heel of his hand at the bottom. This is a hand-sized print. Works such as portfolio 25 and 26, discussed in the appendix (pp. 170–171) and a focus of the artists' effort to duplicate Merton's technique, must have

beyond dispute a print, as were many other images. After this unexpected discovery, I began to see prints as prints, direct brushwork as direct brushwork.

Some weeks later, a wonderfully informative letter came to light. Merton was replying in mid-1965 to the director of the art department at a Catholic college to

been printed from a lightly inked collage or assemblage of stamped envelopes—Merton's daily mail pouch, serving as the point of departure for remarkable images. The same spirit of transformation prevails in works such as portfolio 27 and 28, in which the matrix or negative would have been a sheet of stiff paper on which he placed grass stems in a pattern he found interesting, applied ink to the stems and supporting paper, and pulled his print. An alternative procedure is evident in portfolio 29 and 30: he must have brushed an image onto the negative, covered it with a pattern of uninked grass stems, and then pulled the print. To create portfolio 31, he would have placed a circular object—is it a veneer-thin slice of wood?—against textured paper, then inked and printed. The magnificent Crucifixion, portfolio 33, would have been made with just a few envelope edges, lightly inked and printed off. Portfolio 34, the lush and innocent image of a fruit, seems to be an exercise in mixed media: a lightly printed, textured ground with a directly brushed central emblem.

And so Merton was working with nearly nothing as his points of departure for these images: grass stems gathered outside the hermitage, mailing envelopes, stray objects found along the way in the woods or in monastery shops. "The hills are suddenly dark blue," he wrote in his journal toward the beginning of his exploration of art. "Very green alfalfa in the bottoms. Yellow or mustard or siena sage grass in my own field. Here there is no impatience."[92] He brought those grasses inside to become parts of his image world. His ink did not derive from a precious *sumi* ink stick from Japan, which must be moistened and ground in a traditional manner—nothing so fine as that. He used Higgins India Ink, a common American product still on the market. One of the most haunting photographs of the hermitage (fig. 12) shows his worktable, rather

FIG. 12 Thomas Merton's worktable at the hermitage. Photograph by Thomas Merton.

bare and sunlit, upon it an unexpectedly dignified bottle of Higgins India Ink. The shape is unmistakable.

Merton struggled with technique. Ulfert Wilke, the German American artist who was so helpful to Merton, had sent him fine printing papers and offered advice. In a letter of October 19, 1964, when he was preparing his first exhibition, Merton reported his technical findings to Wilke:

The paper you gave me is good but I have not yet quite hit off the right thing to do with it. A "second printing" results only in a few patches. In fact the problem seems to be patchiness all along, and blots. I will come up with something, but for the last few weeks I have not been able to work at it as we have had meetings and what not and I have been very rushed.[93]

"Patchiness all along, and blots"—these were problems he had to contend with, and in the end he sometimes signed works that had their share of patchiness and blots. Merton's reference to a second printing tells us that he was exploring whether subsequent, more lightly inked prints could better convey what he had in mind. As the artists' technical discussion in the appendix suggests, he had little interest in creating multiples; he did not make editions of identical prints. For Merton, printmaking was drawing. With few exceptions, the resulting image was unique, never to be repeated.

I mentioned earlier that what is apparently the sole eyewitness account of Merton creating images is somewhat misleading. It would be misleading only if we were to assume, as I did for a time, that it says all there is to say about Merton's technique. Two friends, the photographer Ralph Eugene Meatyard and the writer Guy Davenport, were visiting Merton at the hermitage in 1967 or '68. Davenport recalls: "[Merton] made drawings for us by dipping weeds in ink and slapping them onto a sheet of typing paper. He drew a horse, very Zen in its strokes."[94] Through this vivid account we can see Merton at work—but only in one way, using a wonderfully offbeat technique of his own devising. The majority of the later images were surely created in the ways we have been discussing.

Inops et pauper ego sum:
The Transformation of Simple, Unnoticed Things

"Incline thy ear, O Lord, and hear me: for I am needy and poor (*inops et pauper*)." The verse is from Psalm 85 in the Latin that Merton read, Psalm 86 in English Bibles. These words came to Merton's mind as he wrote in the mid-1950s to a staunch older friend, the Catholic philosopher Jacques Maritain, and his wife Raïssa:

> So pray for me, dear Jacques and Raïssa. *Inops et pauper ego sum.* There is so much talk about being poor, but it is ghastly to be poor. Yet I suppose if I were poorer, I would be less poor.[95]

Merton's paradoxical reflection signals that his monastic vow of *conversatio morum* (conversion of manners), taken so many years earlier, remained for him a work in progress, a living sign. The vow includes much, not least the commitment to poverty. Outer poverty had never troubled him—he welcomed at once and always the austerity of monastic life. Inner poverty was not so simple a matter. He was a writer endowed with profuse inner life, a thinker who deeply needed to weigh the value of ideas. He was an appreciative human being who felt that he was doing some part of our common task by noticing all the details of Creation and, like Adam, naming them. Merton was far from poor. He was stupendously rich.

Yet even at early stages of his religious search, he was drawn by another, hidden pole: emptiness, nothingness, poverty, self-abandonment in absolute faith that God knows better than oneself how to shape and guide a soul. A journal entry for mid-June 1961, toward the beginning of his work as a visual artist, reflects many such entries over the years:

> It all cleared up after High Mass when I saw my only solution is to do what I have always wanted to do, always known I should do, always been called to do: follow the way of emptiness and nothingness, read more of the "nothing" books than those of the others, forget my preoccupa-

tions with ten thousand absurdities, to know without wanting to be an authority.[96]

The most beautiful passages in his writings often touch on these values. Here he records an urgent call to himself to strive still more firmly toward inner freedom. And in the following journal passage, written a few years later, he finds the luminous language that sometimes came to him when he knew without doubt and could speak what he knew:

> The only response is to go out from yourself with all that one is, which is nothing, and pour out that nothingness in gratitude that God is who He is. All speech is impertinent, it destroys the simplicity of that nothingness before God by making it seem as if it had been "something."[97]

These two passages—there are many others of equal power—provide a context for thinking briefly about Merton's reliance in his art on simple, unnoticed things. He worked with grass stems, envelopes, found objects, and discovered in them complexity enough for his purposes. Such humble objects served readily as the material basis for visions reaching far beyond themselves. Merton's "studio" was no more elaborate: brush, paper, commercial ink, the hermitage worktable. Only where paper was concerned did he petition artist friends for materials that the world would recognize as special, and even then, some of his finest images were executed on odds and ends of paper (portfolio 16, a majestic image from the heart of his love of Zen, was brushed onto an oblong, not even a properly square, sheet of paper).

Merton's art was an expression of his monastic commitment to poverty. Yet strangely, and I would say beautifully, his focus on simple, unnoticed things and their transformation converged with the established practice of collage in twentieth-century art. As a young man who went out of his way to see and learn about art, he would have been familiar with cubist collages and Dada constructions. Every kind of ordinary thing—newspaper, postage stamps, cast-off wood, interesting bits of the world wherever found—would enter into works of that period. The fascinating challenge of composing a satisfying pictorial world from the debris of the world at large has never lost its appeal. As well, in the hands of some artists it has never lost a quiet undercurrent of spirituality, as if to make things of this kind carefully, attentively, sensitively is a small redemption, a pledge of loyalty. Invented nearly a century ago, collage remains an art of our time. And collage or assemblage—the gathering of grasses and other small elements into a promising pattern—was a key step in Merton's art of the print.

If Merton's art conformed to the poverty he shared with his monastic brothers, it also expressed the austerity of the hermitage, where he was on his own. Here he could come to grips with what he called bare attention: "Buddhist 'mindfulness' or awareness, which in its most elementary form consists in that 'bare attention' which simply *sees* what is right there and does not add any comment, any interpretation, any judgment, any conclusion. It just *sees*. Learning to see in this manner is the basic and fundamental exercise of Buddhist meditation."[98] And it was the basic and fundamental exercise of the hermitage, beyond or prior to any specific religion. On the basis of that bare attention, one could be more fully Christian, more fully Buddhist.

Merton's mature understanding of the theme we have engaged—the passage through poverty to fulfillment, from abjectness and lostness to confidence and joy—deserves long and patient exploration.[99] But for present purposes we have entered into it enough to

grasp the continuity between his search in religion and his search in art. Just one theme more needs attention to round out our understanding of that continuity.

Chance/Providence

Why, after the first years, did Merton prefer printmaking to direct brushwork? To understand this would be to understand a large and largely unspoken dimension of his work. We have already encountered what I take to be, apart from banter with Ad Reinhardt, his one explicit comment about the appeal of printmaking: "[Prints]," we have heard him say to a gallery director, "I first do on a piece of scrap paper and then print off on the good Japanese paper, which is what gets that nice rough effect and the tone. It is very fascinating to do this, at least I find it so. You never quite know what is going to come out, and often it is a big surprise."[100] A bland comment, it might prompt us to stop right here—well, he just liked printmaking, he liked the unexpectedness. But there is more to it than that, signaled by certain phrases in his essay on his art and in notes he took as he prepared to write that essay in the fall of 1964.

Feeling obliged to say something about his art for visitors to the Spalding exhibition, he repeatedly returned to the idea of impersonality, of the erasure of ego in favor of something or someone else. These works are "signatures of someone who is not around," he wrote in the essay as eventually published. In the notes toward it, he explored more thoroughly the question of "Who is the maker?"

> Footprints of the unconscious (as a child might make deliberate footprints in the snow)
>
> But difference—not a sign that "I" passed this way.

> Footprints *divested of ego and yet not anonymous*
>
> This I do not know how to explain.
>
> That movement of the world was thus registered on paper was due to my decision—it is important only in so far as my brushstrokes are not those of a machine. But neither are they "mine," nor are they those of a particular artist. Nor of a medium or shaman.[101]

Here is where we can fruitfully look for the printmaker's motives. Merton viewed the art of his time as in part a playground for ego. For example, in 1961 he described Picasso as "undoubtedly a great genius . . . but perhaps that is the trouble."[102] The whole of his Catholic and monastic training summoned him in another direction, to self-abnegation and self-emptying. If he was to be an artist, it could not be on what he took to be the standard terms. It would have to do with the vanishing of self, not with self-exhibition; with an art practice that leads to depths not surfaces, and to completed work that might, in time, enrich the lives of others in a spiritual dimension difficult to describe. About how his art might be received by others, he could not have been more elusive, though he spoke of it: "The seeing of [these works]," he wrote, "may open up a way to obscure reconciliations and agreements that are not arbitrary—or even to new, intimate histories. . . . If these drawings are able to persist in a certain autonomy and fidelity, they may continue to awaken possibilities, consonances; they may dimly help to alter one's perceptions."[103] In other words, he didn't quite know. He was sure of the possibility of an exchange in depth, of serious communication. He was sure, as well, that this possibility had nothing to do with egoistic assertion. In the last months of his life,

speaking with a fellow monk, he expressed much of this with impromptu poetry yet great precision: "Any moment you can break through to the underlying unity which is God's gift in Christ. In the end, praise praises. Thanksgiving gives thanks. Jesus prays. Openness is all."[104] Where praise praises and thanks give thanks, there is no willing place for the anxious contractions of ego.

Zen brush calligraphy is quickly done. The medium itself calls for speed: wet ink on sensitive paper isn't for lingering, can't be corrected. As Merton well knew, the traditional calligrapher practices brushstrokes for years and often prepares at length in meditative stillness before dipping brush into ink, but the actual moment when hand and brush move is typically quite brief. "The work of art springs 'out of emptiness,' he wrote in 1959 or 1960,"

> and is transferred in a flash, by a few brush strokes, to paper. It is not a "representation of" anything, but rather it is the subject itself, existing as light, as art, in a drawing which has, so to speak, "drawn itself." The work then is a concretized intuition: not however presented as a unique experience of a specially endowed soul, who can then claim it as his own. On the contrary, to make any such claim would instantly destroy the character of "emptiness" and suchness which the work might be imagined to have.[105]

Merton's attitude toward the end of this passage is slightly cramped—he would be less categorical in judgment as the decade progressed—but we can't miss how ready he was to practice the art he describes.

Because the brushstrokes are transferred in a flash and Merton was giving real time to his art, toward the end of 1963 he could write with vast exaggeration and a grain of truth to his friend Robert Lax that he had done millions of drawings: "I tell you Charlie I got ten million. I make the fastest calligraphic paintings in the world, twenty nine a second, zip zip zip all over Kentucky they fly in the air the doves bear them away to no galleries."[106] However many there were in reality— hundreds are preserved—he gained remarkable fluency in the medium. He was not formally trained; he spoke of his "free and unorthodox handling of the brush." But works such as portfolio 3, 11, and 15 through 17 leave no doubt concerning his imaginative and technical capability. Up to some limiting point, a very generous limiting point that gave him much creative freedom, he could do what he wanted. That may have been why he became a printmaker.

For several years, there must have been enough unknowns to keep this explorer content. The vocabulary of abstract forms he was developing, expanding, and learning to use was wholly new to him. The brush itself is astonishingly alive and variable. The integration and transformation in his creative imagination of lessons from two inspiring sources, abstract expressionism and Zen calligraphy, was surely a great challenge. Works that must be from 1963–1964, whether airy and light (portfolio 15) or weighty and sculptural (portfolio 16), are the expressions of a rich mind and capable hand. He could have continued for years, just so.

Yet a technical observation full of consequence and an insight equally full of consequence seem to have changed the course of events. The technical observation was straightforward, although we may never know whether he reached it entirely on his own or through a hint from an artist or printer with whom he was in touch. The three Louisville artists have suggested— without conviction but without disbelief, either—that Merton may one day have blotted a brushwork image and discovered that the image transferred to blotting

paper had its own life. However the event came to pass, Merton recognized that pulling prints from drawings brushed onto textured surfaces yielded images far different from the source drawing: more aerated and porous, with the potential for velvety textures and minute, vanishing detail. He must have found these effects of compelling interest. True, there were additional technical features to manage. The risk of "patchiness all along, and blots" increased tremendously. But the process was promising, and as he developed it new ideas occurred—above all, the idea of including found objects such as grass stems, the use of found objects as stencils, and the challenge of creating worthwhile compositions with the use of simple dividers such as envelope edges. A new world of design opened up in which Zen-like images cohabited with images more akin to abstract expressionism and Russian modernism than to Sengai and Hakuin. Along the way, he created some strikingly original images (including portfolio 29–31) with few if any debts to his contemporaries, which may record the spaciousness of his meditative life in those years.

No specific document signals to us the nature of the second agent of change. Some new insight, some discovered need for still greater linkage between his search in religion and his search in art made itself felt with enough force to change things. But many documents, addressing the question of the self in search of its own truth and in search of God, obliquely suggest what that insight must have been. A passage from Merton's journal in the earlier 1960s can speak for them. He jumps off in it from current reading in the French Catholic and existentialist thinker Gabriel Marcel to issues that touch closely on his art:

> Gabriel Marcel says that the artist who labors to produce effects for which he is well known is unfaithful to himself. This may seem obvious enough when it is baldly stated: but how differently we act. We are all too ready to believe that the self that we have created out of our more or less inauthentic efforts to be real in the eyes of others is a "real self." We even take it for our identity. Fidelity to such a nonidentity is of course infidelity to our real person, which is hidden in mystery. Who will you find that has enough faith and self-respect to attend to this mystery and to begin by accepting himself as *unknown*? God help the man who thinks he knows all about himself.[107]

Once Merton had learned the way of the brush to a very respectable degree and could produce work that was original, deft, and interesting by any standards, he must have found himself facing anew questions of the kind raised in this passage. And this had consequences. I believe that he did not wish simply to exercise the individual mastery he had achieved. I believe that he wished to enact still more rigorously than in the past his commitment to images that are not "'mine,' nor are they those of a particular artist," as he put it. However clearly or indistinctly, he must have felt the need for some means of opening out his work still further, of *destabilizing* it for the sake of gaining access to a new art and perhaps still greater truth than before. Printmaking served these purposes elegantly well. It opened his image-making process to a new collaborator with a mind of its own.

Who or what was the collaborator? Though Merton never names it in documents I have seen, two terms pitted against each other come to mind: chance and providence. In the letter briefly describing his methods, he was matter-of-fact about this element in his printmaking process: "You never quite know what

is going to come out, and often it is a big surprise. It is very fascinating to do this." When he made prints, he could truly know and say that the images were not exclusively his. They were collaborations with some force or shaper of outcomes other than himself—with providence. Alternatively, the prints could be experienced as resulting in part from chance. He acknowledged, of course, that he bore some responsibility for them. It was after all his brushstrokes they began with, his caring delight in laying out found objects in just a certain way and not another, his instinct to apply more pressure here, less there as he generated a print. But the resulting images, whether majestic or "patchiness all along," were no longer fully in his control. There was another participant, capable of transforming the everyday into *kairos,* meaning in Christian tradition a revelatory moment when something new, unexpected, and very good makes itself known.

I don't even remotely suggest that Merton entertained a sentimental view of the collaborative force he had invited into his image-making process, as if the Good Lord or an angel descended. But still, there was a kind of magic. He did his part, and then something else—something that need not be named, and he didn't name it—did its part. The resulting image could be more awkward, less controlled than directly brushed images, or it could be remarkable, more evocative by far than direct brushwork and arresting in ways that Merton could never have predicted. The best analogy in other arts is the potter's traditional wood-fired kiln, a mighty instrument with a mind of its own. Potters can know a great deal about their wood-fired kilns and exercise considerable control over a firing, but they can't control everything and have no wish to do so. They regard the fire as co-creating the finished work. Because the forces they set in motion are somewhat unpredictable, they open their kilns with anxious curiosity and a measure of stoic acceptance. Certain pieces will be more beautiful than anticipated, while others are likely to be cracked, melted together, or otherwise fit only to discard. Some potters are superstitious enough to put a tiny clay kiln god on top of the kiln to help tilt the future.

If my language has been imprecise in the effort to shed light on this most enigmatic aspect of Merton's preference for printmaking, the reason is gaps: the gap between chance and providence, the gap between the simplicity of Merton's procedure and its large consequences. Chance is uncontrolled and uncontrollable, unforeseen and unforeseeable. Providence is divine intention at work, however obscurely. Chance can look like providence, and providence can look like chance. Radically different from one another, they can wear the same face. I have not found any evidence at all that Merton pondered his printmaking process in light of these two terms, but they shed a useful light when we now look back. They show us what we are encountering, if not every detail we might wish to know.

Merton did ponder the zone of experience in which events occur decisively yet inscrutably, well up and disappear, astonish with a kind of perfection and depart without trace. His perspective derived from Zen Buddhism. In *Cables to the Ace,* a long poem of the 1960s, he spoke to all this very well:

The perfect act is empty. Who can see it? He who forgets form. Out of the formed, the unformed, the empty act proceeds with its own form. Perfect form is momentary. Its perfection vanishes at once. Perfection and emptiness work together for they are the same: the coincidence of momentary form and eternal nothingness. Form: the flash of nothingness. Forget form, and it suddenly appears, ringed and reverberating with

its own light, which is nothing. Well, then: stop seeking. Let it all happen. Let it come and go. What? Everything: i.e., nothing.[108]

These lines are perhaps the best evocation we shall have of the spirit underlying Merton's adoption of printmaking. By relinquishing an element of control and personal authorship, he "let it all happen, let it come and go." What? "Everything: i.e., nothing."

These Are Not "Drawings of": Interpreting Merton's Art

Merton surrounded his visual art with as many walls, trip wires, and rabbit traps as he could think of to keep interpreters away. The images are not "drawings of," he said. They are "summonses to awareness" but "not to awareness *of*." In case we still miss the point, he insisted that "their 'meaning' is not to be sought on the level of convention or of concept" and "there is no need to categorize these marks." They are "signatures of someone who is not around." In other words, no interpretation is appropriate and no artist is available for discussion. This is the situation as we approach the engaging task of interpreting his art. We are unwelcome.

Merton's resistance makes sense: he did not wish his art to be tagged by critical concepts that tamper with its immediacy. As he noted in his journal early in his development as a visual artist, "the work of art is to be *seen*—not imagined, worked over intellectually by the viewer. Central is the experience of seeing."[109] He wants us to experience directly, hopes that we can find the ground in ourselves from which the works came to life in him, and so meet him and his art on common ground. This is a sensible challenge. We must not approach his work to enclose it even inadvertently in

some tight framework. But it is a mistake to consign works of art or literature to an airless place where they are to be appreciated without comment, however much their makers or admirers prefer silence to what they fear will be smart chat. Works of art need to be tossed around. We have to lean against them to see what they're made of. We have to question them. They survive the experience quite nicely, all the more strong if the basic strength is there. I offer in the following pages ways of looking at Merton's art and points of reference that may enrich what we see. But the works will remain free.

PORTFOLIO IMAGES 1–2

There is an interesting transition between Merton's earliest abstract work, represented here by portfolio 1, and the next stage (portfolio 2). His image of Jerusalem is a labyrinth, perhaps reflecting impressions from the distance—he never visited the Holy Land—of narrow streets and stone houses in the old quarters of the city. Looking closely in his "streets," one may also see living things: a figure crouched in prayer, a rooster, who knows what else. The work is not completely realized, it is more sketch than finished work, but its pulsing rhythm and deft handling of geometry are promising. That promise begins to be realized in portfolio 2, which retains the structural sense of the earlier image but animates it with a healthy breeze. Merton's brush is now alive, pliant, and quick. We are beginning to see brush-drawn signs of genuine eloquence, sure in motion, sure in structure, at ease with the kinds of things that brush and ink do: thick and thin, wet and dry, contact and release, density and airiness. Merton has moved closer to his models in Zen calligraphy, priest-artists for whom the brush was infinitely varied in expression. And we encounter in this image a key trait of Merton's visual

art: dynamism. This was a man of boundless energy, and his art as it became more freely his own, through technical progress and greater familiarity with the brush, reflected his buoyancy. In his notes, he once described his art as "contracts with movement, with life." Portfolio 2 and the closely related portfolio 3 show us what he must have meant by these words. They convey not thought but sensations of movement, buoyancy, and joy. Yet these things are not conveyed thoughtlessly; high intelligence orders and offers here.

PORTFOLIO IMAGE 3

In any sound approach to abstract imagery, it helps to be alert to the afterimage or recessive image—an evocative form that is barely present, so that one can't be sure of it, yet one falls under its spell. One senses that "something else," difficult to name, is there. In portfolio 3, the subliminally sensed image is of a standing, robed figure, perhaps distantly akin to ancient Chinese figures of the Buddha in which the robe flares out in elegant pleated folds. I cannot say that this is so; I can only say that there is the bearing of a standing figure in this dynamic yet stately image.

PORTFOLIO IMAGES 4, 6, 7, 14

Merton could be counted on to produce a lively school of Christian fish, and he does not disappoint. The version on this page (fig. 13), though undated, is almost certainly early—its dense brushwork can be found in dated images of 1960. A fish rendered in a few simple lines or brushstrokes is the invariably touching Early Christian emblem of "Jesus Christ, Son of God, Savior," each opening letter in the phrase corresponding to a letter in the Greek *ichthys,* "fish." This early work is jaunty and optimistic, slightly awk-

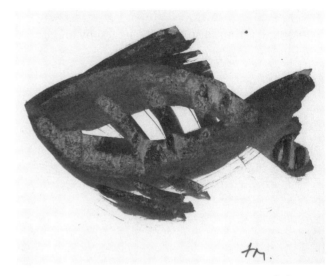

FIG. 13 Brush drawing by Thomas Merton, untitled. Image size: 3 ½" h x 4 ½" w.

ward, again full of promise. Merton must have liked it. He reproduced it in 1968 in his little magazine, *Monks Pond,* published by the monastery print shop, and juxtaposed it there with a passage from Thoreau about fish swimming upstream at the start of spring.[110] That sort of dynamism—energy large enough to swim against the current—was evident in Merton's art from start to finish.

As Merton gained mastery of the brush, he continued from time to time to explore the emblem of the fish in ways increasingly impressive. What I take to be a later version, portfolio 4, knows the brush better and brings to the ancient sign Merton's characteristic energy and dynamic motion. This fish is not one to dawdle in safe places, nibbling dreams. It is a fish on the move, a questing fish. Arguably a still later image, portfolio 6, dated 1964, draws the traditional Christian icon entirely into his own world of signs, the world he described as teeming with "shapes, powers, flying

beasts." This image bears some resemblance to aboriginal cave art but also to Zen calligraphy and to the art of Paul Klee, the only twentieth-century artist with whom Merton felt a reverential link well beyond simple admiration.[111] Leaving nothing to be desired, it can be counted among Merton's quiet masterpieces. It shows us how to swim—perhaps without utter clarity of vision, but with energy, committed weight, and direction.

Fish are not the only species in Merton's visual art and writings. "The monk is a bird who flies very fast," he wrote in 1964, "without knowing where he is going. And always arrives where he went, in peace, without knowing where he came from."[112] What a fine, koan-like reflection. Not surprisingly, there are birds and birdlike signs in his art that compel attention. Portfolio 7, closely resembling a beautiful image published by Merton in *Raids on the Unspeakable* (1966, p. 7), suggests a rush of activity, the headlong flight of an eagle—pure Merton in its energy and overall elegance. The comparable work in *Raids* is more abstract, less densely inked, as much butterfly as eagle, and quite grand. Another drawing in *Raids,* here figure 14, depicts a powerful bird within a circle that gives the impression of impeding free flight. The creature flies powerfully, yet takes constraints with it. I do not like one-to-one equivalences, as if anything could be something else exactly; Merton didn't like obvious analogies either. Yet one recognizes something of the human dilemma in this image of flight and constraint, and Merton surely recorded here something of his own person.

Portfolio 14 revisits the theme of the eagle in headlong flight: it too is an image of flight, suggesting several birds rising frantically from a heavy presence below. One cannot and should not be dogmatic in assigning identities to elements in Merton's art, but his emblems

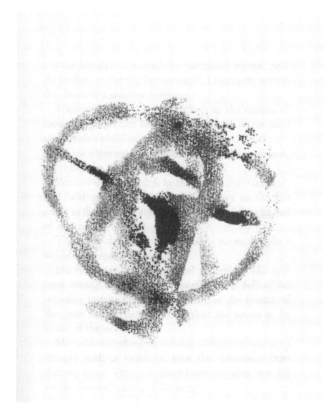

FIG. 14 Brush drawing by Thomas Merton, untitled.

are not random: they speak from mind to mind, heart to heart of real things, however much they are things best said in the oblique language of abstract art.[113]

PORTFOLIO IMAGES 10–13, 15

There must be secrets deposited here and there in Merton's art. On the other hand, portfolio images 12 and 15, the latter one of few with a highly descriptive title, *Considerable Dance,* seem to me without secrets. The first is a registration of pure movement, Merton's live brush finding its way boldly in a pictorial world

that is all bounce, all float, owing more to abstract expressionism than to Zen. The second is much more designed and sophisticated: an armature of mostly diagonal brushstrokes creates a tilted platform for dancing curved strokes that set the image into joyful motion. Close readers of Merton might want to fold this image between the pages of their copy of his *New Seeds of Contemplation,* the 1961 revision of an older book to which he added a beautiful closing chapter, "The General Dance."

> The world and time are the dance of the Lord in emptiness. . . . No despair of ours can alter the reality of things, or stain the joy of the cosmic dance which is always there. Indeed, we are in the midst of it, and it is in the midst of us, for it beats in our very blood, whether we want it to or not. . . . We are invited to forget ourselves on purpose, cast our awful solemnity to the winds and join in the general dance.[114]

If these two works harbor no secrets, and their "message" is no more and no less than shared joy, there are three works not unlike them, portfolio images 10, 11, and 13, about which something more should be said. Portfolio 10 is an ingenious thing. Merton is again working his diagonals—like innumerable artists before him, he sensed the inherent dynamism of diagonal compositions. Against a rhythmically patterned field, a tight cluster seems to race to the left. And just as one is about to take leave of this image, the thought occurs that, after all, Merton lived near Louisville, home of the Kentucky Derby, and like all people who live in or near Louisville, whether in monastery or mansion, he was aware of the Derby. This image may well be his delighted and delightful homage to a great local tradition. It looks like a photo finish.

Portfolio 11, immediately following, tells no such story even secretly. As much as any work from his hand, it escapes interpretation and needs none. It perfectly fulfills Merton's stated program of offering "signs without prearrangement," "summonses to awareness" (words from the essay at the beginning of the portfolio). The image relies on contrasts—heavy and light, lower and upper, axial and diagonal—but to say this is only to describe, not to interpret. It is a sign made by a free spirit, inviting us to be free. Its lightness and spring call out the same in us.

Portfolio 13, one of Merton's largest works and among the most complex in design, calls for another kind of reflection. As suggested by the passage from Merton facing this image, its exuberant complexity recalls the Baroque style of Catholic Europe in the seventeenth century—and recalls, as well, the tightly woven compositions of Jackson Pollock, of whom Merton was well aware. We are looking here at a flickering, dynamic weave of dry brushstrokes that evoke the atmosphere of a complex Baroque altar with levels, niches, candelabra, and who knows what else. We cannot and should not pin down the image to any specific meaning or message, apart from the message of its buoyant energy: "Sleepers, awake!" is the unspoken message.

PORTFOLIO IMAGES 5, 8

A number of portfolio images—numbers 5 and 8 (and, as well, the eagle in flight previously discussed)—offer Merton's transformations of the most fundamental icon of Zen: the brush-drawn circle, or *enso.* As a point of reference, figure 15 reproduces a fine example by a twentieth-century Japanese tea master who was a serious Zen practitioner. The traditional *enso,* often drawn with a single brushstroke, can be richly and

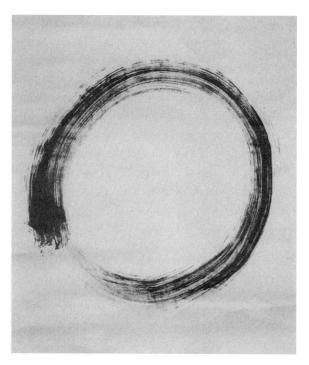

FIG. 15 *Enso* by Noda Saburo. (Detail from a scroll.)

endlessly expressive. It may speak of the grand design of things, of emptiness and fullness, continuity and stop, or it may convert a familiar object of this world—for example, a common tea cake—into an icon of large meaning. The poem or phrase typically accompanying the brush-drawn circle lets the viewer in on the artist's thought. The *enso* in figure 15 is paired with the brush-drawn characters for *mugen*, meaning "limitless."[115]

Merton was drawn to this traditional form—the fair number of images preserved in archives suggests that it was more than a casual interest—but he had difficulty finding his way with it. From Merton's brush, the unadorned traditional circle is tentative, awkward. He experimented with various inks and papers and effects, but the deceptive simplicity of the

circle somehow defeated him as an artist, so the evidence indicates, until he dynamized it or made it more intricate. Then he was again on home ground. Several images of this kind are among his strongest. Portfolio 7, the eagle in flight, and the image resembling it in *Raids on the Unspeakable* bear out this observation: the austere simplicity of the circle provides in both works the compositional basis for dynamic, eloquent images. Much the same can be said of the fish, portfolio 5, in which multiple turns of the brush and cheerful tail fins convert the solemnity of the traditional *enso* into another spirited fish for the Christian aquarium. When Merton intuitively found a way to dynamize the circular form—to convert it into a fish, as here, or into some other creature on the move—his art is sure, captivating, and in this case even entertaining. He made the *enso* his own, not by imitation of the traditional icon but through its transformation.

Portfolio 8 must be counted among Merton's masterpieces. Not even remotely entertaining, it breathes the spirit of what Miguel de Unamuno memorably called the tragic sense of life. At a time in early 1964 when he happened on a photograph of the recently deceased French painter Georges Braque, one of whose recurrent images was a peaceful, beautifully drawn dove, Merton briefly weighed the possibility in his own art of "Emblems. Equivalences. Finding my own system of emblems."[116] Something of this kind is present in his art as it developed, although understated or even unstated, and unsystematic. Portfolio 8, yet another transformation of the traditional Zen *enso,* is one of his strongest emblems, though it does not give its secret away. Dark and heavy on the right, open and spacious on the left, it reports some enigmatic perception of what we are or the larger design of things. The pattern is circular, but the eye soon enough registers a subtle horizontal flow across the

circle (from Merton's humble grass stems, here serving as a latticelike mask in the printmaking process). This is a message-bearing *enso,* however difficult the message may be to put in words; it is full of darkly sparkling life. It must have surprised Merton as much as it surprises us: there are textures he could surely not have predicted. Chance and providence cooperated well.

> This is . . . the monk's chief service to the world: this silence, this listening, this questioning, this humble and courageous exposure to what the world ignores about itself—both good and evil. If [I] speak frequently of the concept of "dread," it will be in this existential sense.[117]

PORTFOLIO IMAGES 16–17

Portfolio 16, one of Merton's most impressive images, is mysterious. Although it looks as if it could be a sketched model for a monumental sculpture, perhaps a fountain for a public space, it is factually a small image brushed onto what seems more like leftover paper than a deliberately chosen, fine surface. Merton published in *Raids,* as the first of fifteen images, a work related to it in style and force of expression.[118] Grouping these two works with the remarkable Celtic cross reproduced here as portfolio 17, we catch sight of a season in Merton's art—perhaps summer 1964 extending into 1965—when he found a calligraphic style of dark and powerful expressiveness. He would move on; there was more to come. But his art at this stage had a kind of grandeur and certainty.

I am slow to interpret the image in portfolio 16, but a few observations may increase its visibility, and that

is always the point. It stands firmly on two legs, has a clear and rather constructed vertical/horizontal design, and reaches for the sky. The two uppermost elements, dry-brushed, are lighter and less dense than the supporting structure. Most of the vertical elements are topped by horizontal platforms that also give the impression of opening to the sky. How to "read" this work, once all of these forms are duly registered in our minds? We should willingly come under Merton's stricture not to "seek meaning on the level of convention or concept," and not to "categorize these marks." The image must come from a place without words, or very nearly without words, and goes to that place in us. And yet . . . this is a prayerful image. Its planted weight and poignant lift to the heavens surely reflect something of the prayerful seeker's life.

> The hermit in our context is purely and simply a man of God. This should be clear. But what prayer! What meditation! Nothing more like bread and water than this interior prayer of his! Utter poverty. Often an incapacity to pray, to see, to hope. Not the sweet passivity which the books extol, but a bitter, arid struggle to press forward through a blinding sandstorm. The hermit, all day and all night, beats his head against a wall of doubt. That is his contemplation.[119]

From a late writing, this passage says perhaps all that need be said as an echo of the grave beauty of this image.

Portfolio 17, the Celtic cross, reflects what Merton once called Zen Catholicism—a phrase borrowed from Dom Aelred Graham, a Benedictine abbot and author whom Merton admired. This is a magnificent rendering, uncanny but still comfortable and settled in its

fusion of freely brushed Zen calligraphy with the unique design of the Irish medieval cross. Here is the Zen brush-drawn circle yet again, at home in an unexpected place. A joshing letter from Merton to his friend Robert Lax in the summer of 1964 gives a rough sense for when this image, and others like it in style and power, may have been created: "What I study," he wrote, "is Irish monks and you be surprised they are not all ragging around with that colleen stuff like the Irish you and me remember they are serious monks but a bit quaint."[120]

PORTFOLIO IMAGES 19–20

These two works are puzzling and interesting for different reasons. There was a period in the 1960s, difficult to identify more closely because there is no dated image, when Merton explored the expressive uses of a wide brush. He was looking with keen interest in summer 1966 at the translation of an early Chinese text, which included original text in Chinese characters, and that may be the anchoring date we need, but the anchor slips a bit in the sand because other influences could also have been at work.[121] Both of Merton's models in Zen calligraphy, the priest-artists Sengai and Hakuin, had occasionally used a fat brush to create thick linear patterns. Ad Reinhardt had worked for some years in thick brushstrokes. As well, it's just possible that Merton saw photographs of the then-emerging sculpture of the American Mark di Suvero in current art magazines.[122] Who knows what visiting friends or the Louisville libraries had to offer? Portfolio 20, a strikingly sophisticated graphic conception, so immediately reflects the aesthetic of di Suvero's large metal sculpture that one can't help wondering.

However this may be, the wide brush allowed Merton to create emblems, not reproduced here, that recall the simple structures of early Chinese pictographs. More to the point, it also related him to an austere and sometimes brilliant zone of twentieth-century art, the minimalism of the 1960s. Portfolio images 19 and 20 are his fairly stunning contributions to the genre. The first of the pair is not as simple as it looks: it takes taste, daring, and an almost choreographic sense for the behavior of line to create such a thing. The second, similarly elegant and studied, is a superb exercise in combining fixity and motion in a unified pattern. I don't want to entangle readers of this book in the more arcane concerns of art criticism, but it's worth noticing that Merton seems to have been exploring how an image can press against the edges of the paper. His fellow abstract artists in the world were finding much poetry in the visual relation of image to edge.

Merton was aware of the white space, often a great deal, that he left around images. In a letter of 1965 to his friend and publisher, Jay Laughlin, he raised this issue with surprising specificity. Laughlin was helping him circulate the exhibition that had started life in Louisville: "Here are some prints of the drawings," Merton wrote. "They are not any good for reproduction nor do they represent the whole drawing in the sense that the whole sheet is not taken: there is much more white space. But they can give a fair idea. Good enough to interest a possible exhibitor."[123]

How to sum up an impression of these two works? Merton is exposed in them, and willingly so. He is working with the simplest of means, as if fulfilling a design school exercise and discovering rhythmic patterns of elegance and force. They are surprising; they lie outside the mainstream of his art; yet here they are, strangely memorable.

At a certain point Merton's art quiets. It becomes the visual journal of a contemplative, recording in enigmatic images something of the pattern or texture of contemplative experience and serving as a means of exploring contemplative experience. This phase of his art is quite far from Zen calligraphy, closer to certain currents in abstract expressionism, although that may seem surprising. American artists at midcentury tended to be uneasy about "the spiritual in art." They would affirm and deny their interest in it. And some who affirmed mightily were perhaps less sensitive than others who barely said a word. Whatever the spiritual was or was not, leading critics wouldn't countenance it. In their view it was extraneous to midcentury art and no part of sound practice. Yet some artists, either with keen awareness of what was at stake or by a kind of instinctive migration, retained a persevering interest in how things seen can reflect things unseen. They knew that art, and specifically their own art, could be more than an original, sophisticated entertainment. Even simple things—bright goldfish in a bowl (Matisse), a grid of subtly shifting colors (Klee), a cluster of bottles (Morandi), a pattern of clouds (Stieglitz)—can speak of more than themselves.

Merton had no fear of the spiritual in art, but he wanted it to breathe freely, to be "inconsequent," as he put it in his essay on his art, "to be outside the sequence and to remain firmly alien to the program." His art was gestural, even visceral. He made it first and then discovered what it was. He seems to have trusted a certain attitude on his part and trusted also his tools and processes. The resulting images must often have been as surprising to him as they are to us.

What is contemplation? Merton wrote of it often—we could turn to any of a hundred passages. But the following, brief and sure from 1967, is reminder enough:

> The contemplative is not the man who has fiery visions of the cherubim carrying God on their imagined chariot, but simply he who has risked his mind in the desert beyond language and beyond ideas where God is encountered in the nakedness of pure trust, that is to say in the surrender of our own poverty and incompleteness in order no longer to clench our minds in a cramp upon themselves, as if thinking made us exist.[124]

Portfolio 22, *Personal or not,* dated 1964, is the work that has helped more than any other to anchor our understanding of Merton's art. In earlier pages we discussed the Louisville artists' discovery of the matrix or negative from which Merton printed this image (see fig. 11, p. 35). Looking at the matrix and print together helps us grasp the simplicity but also the transformative power of Merton's printmaking process. The title also is interesting. Though Merton was dismissive of titles, here he offers one that could serve as the generic title for all of his images. It captures the paradox he was already probing in his notes toward the Catherine Spalding exhibition: "Footprints *divested of ego and yet not anonymous.* This I do not know how to explain."[125]

Both this image and the one that follows, portfolio 23, reveal Merton's interest in cellular, semi-open structures. Some elements are enclosed within porous boundaries while others are open to the white space surrounding the image. It would be foolish to propose with much firmness an interpretation of this pattern in his art—his art doesn't ask for that, it remains evocative and free. But is it saying too much to suggest

that a porous structure of this kind, orderly but open, condensed but very light, sums to a highly abstract portrait of the person of privacy and inner life, who is nonetheless open to the world and others? However one interprets, one looks at this image from one's own interior with a kind of recognition. The emblem is simple and effective.

The untitled work that follows, portfolio 23, is the first here to show what could occur when Merton transferred a clump of field grass to his hermitage studio for use as a stencil. He must have brushed a somewhat squared-off image onto textured cardboard, carefully layered over it a lattice of grass stems, and pulled the print—without quite knowing what could result. His incorporation of grass into his working process is an act of homage from Gethsemani's official forester and unofficial, wide-ranging walker in the woods. Writing to a Venezuelan philosopher and poet from the hermitage in 1965, Merton spoke of grass and much more:

That is where the silence of the woods comes in. Not that there is something new to be thought and discovered in the woods. But only that the trees are all sufficient exclamations of silence, and one works there, cutting wood, clearing ground, cutting grass, cooking soup, drinking fruit juice, sweating, washing, making fire, smelling smoke, sweeping, etc. This is religion. The further one gets away from this, the more one sinks in the mud of words and gestures. The flies gather.[126]

PORTFOLIO IMAGE 24

This image must have fascinated Merton—fascinated him as an expressive visual design or fascinated him as a technical challenge to which he returned more often than to any other. Something of an edition can be assembled from various collections, university-based and private, each differing from the next in print quality and even in Merton's emphasis among the varied elements from which he was printing. This is the print in which the Louisville artists discovered the impress of Merton's fingertips at the top and the heel of his hand at the bottom. They also speculated that Merton used an envelope with an address window to generate the central part of the image. The print clearly has its "patchiness all along, and blots," but that mustn't have bothered Merton as he signed and dated it; it must sufficiently convey what he wished to convey.

The image is likely always to keep its secret, but here is a proposal. One of Merton's most beautiful photographs of the interior of his hermitage (fig. 16) shows the simple and touching gathering of icons in the small chapel added only in the last year or so that Merton lived there. As in the Orthodox icon of the Mother of God with its tiered images, Merton created a little hierarchy of images on the bare cement block wall. It wouldn't surprise me if this orderly impression of tiered icons has somehow found its way into the difficult but important print we are exploring. The Catholic vision of the order of things has from early centuries focused on hierarchies—on thrones, dominations, and powers, cherubim and seraphim, and more still. Particularly in the earlier periods of Christian art that Merton greatly preferred, artists knew how to create the image of many-tiered worlds and the holy figures that belonged to them. Merton's interesting image resists interpretation, but I detect in it both this element of religious imagination and something dark, a foreboding or sorrow.

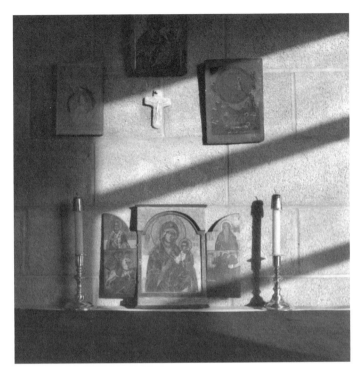

FIG. 16 The altar in Thomas Merton's hermitage. Photograph by Thomas Merton.

If we ask of art to be finished and perfected in all respects, then this is a failed work, bumpy and unresolved. If we ask of art to speak to us, this work meets that test. It speaks memorably.

PORTFOLIO IMAGES 25–26

In earlier pages we initiated discussion of these two images and others of their type, which Merton created by using stamped envelopes as a source of pattern. They were almost certainly inspired by Merton's appreciation in the mid-1960s of the work of early Russian modernists, particularly Tatlin and Malevich. And they

are quite simply magical. Complex in design, angular but filled with light and air, scarcely material, these images are formidably clever transformations of common things—but they are more than that. Have we arrived in these images at the margin of experience, at some boundary half-spirit, half-matter? I think of them as a poet's maps for a spiritual journey. The maps are faint and complex. The terrain is puzzling. Still, they might just help. "Who can return 'nowhere'?" Merton asked in the later 1960s, and he continued:

> But for each of us there is a point of nowhereness in the middle of movement, a point of nothingness in the midst of being: the incomparable point, not to be discovered by insight. If you seek it you do not find it. If you stop seeking, it is there. But you must not turn to it. Once you become aware of yourself as seeker, you are lost. But if you are content to be lost you will be found without knowing it, precisely because you are lost, for you are, at last, nowhere.[127]

This quality and intensity of religious quest inspired the two images we are exploring. The words and images are not identical with each other or literally about each other, but they point in the same direction.

PORTFOLIO IMAGES 27–30

Though these four works differ entirely in form from the two preceding images, the same perspectives apply to them: they can be understood as glimpses of another world, another quality of energy and organization, not maps but something more like visions from the margin of experience, where matter and energy become interchangeable. And these are among Merton's "grass

works." I suppose that name suits them. The first pair appears to do completely without the brush; he seems to have inked grass stems and pulled prints directly from them. In the second pair, brushwork must have been layered with a dense lattice of uninked grass stems, which functioned as a kind of stencil. Merton surely found it pleasurable to create such fragile, temporary patterns of grass. That nearly empty, luminous drifts of energy or matter appeared in prints derived from these fragile setups must have been a shock. Again, chance and providence met.

When first encountered, these works may seem slight and odd. What a great distance has been traveled from the majestic Zen brushwork of portfolio 16 or the lyrical emblem (a print) in portfolio 21. Is it distance gained? The notion of gain or loss is misleading at this point in Merton's development as an artist; there is simply change in a search that no longer measured itself and perhaps never measured itself along a line of progression. But I can report from my own experience that these images of little visible substance, hovering at some "incomparable point" in space, once seemed to me slight but now strike me as remarkable. This is not a critical claim or perspective. It simply asks us to keep looking.

PORTFOLIO IMAGE 33

This perfectly grand image of the Crucifixion was found in a booklet, a kind of diary of drawings, as just one among ten or so brush drawings, the others of no special interest. Though monumental in "feel" and impact, it is factually a small print produced by inking and printing with the edge of an envelope or something of the kind. The method could hardly be simpler; the result could hardly be more majestic. This image recalls medieval carvings of the Crucifixion to which Merton was exposed as a boy in France, especially of the Romanesque period before the elaborations of Gothic art.

It would be unwise to take the view that this work represents the fulfillment of Merton's quest as a visual artist. So much in this body of work is brilliant and compelling. It is nonetheless true that this image of Christ Crucified draws together, remarkably, the values he most cared for as a contemporary artist and the values he most cared for as a monk.

PORTFOLIO IMAGE 34

This luscious fruit, echoing the theme of Paradise that Merton explored in some writings of the 1960s, appears to be a brush-drawn image against a lightly printed, grassy ground. The loose horizontal/vertical order of the background contrasts with the freely drawn fruit, which has an improvised quality as if the Creator had just decided on it. Matisse-like and inviting, this fruit appears at the end of the portfolio in case the reader is hungry.

Epilogue: "Go on! Go on!"

> Go on! Go on!
> There is no place left.
> —Journal entry, September 13, 1968

The summer of 1968, Merton's twenty-seventh at the abbey, was as hot as any he could remember. "Steamy, heavy, soggy," he recorded in his journal.[128] Now approaching his mid-fifties and careful about physically overdoing it—back surgery had left its mark—he was

reading a very great deal, writing not a great deal but as always there was something on his desk, and looking to the future. The election of a new abbot in January, Father Flavian, had changed things for Merton. This was a man whom Merton had in part trained in the monastic life and whom he could securely regard as a friend. The first to adopt the hermit's way of life at Gethsemani after Merton, Father Flavian had now been called from solitude to serve the community. Naturally, he understood Merton's vocation to solitude. He also understood Merton's need to reexperience the world by entering it, by travel. Subject to their shared judgment, Father Flavian freed Merton to respond at last to the best of invitations from beyond the monastery walls. Merton had been in demand for years, and the former abbot had for as many years preferred him to decline all but a very few invitations to conferences, retreats, and such. Merton's meeting in New York with D. T. Suzuki had been an enormous exception. In May, Merton had at last journeyed forth, with the new abbot's blessing, to religious houses in California and New Mexico.[129]

While the abbatial election was under way earlier in the year, Merton had received an invitation to speak at a monastic conference in Bangkok. During those soggy June days, the topic came up again between Merton and Father Flavian, who encouraged him to plan an extended journey through Asia that would take in not only the Bangkok conference but also centers of Buddhist learning in India and Sri Lanka (then still called Ceylon). This was Merton's wish. He wished to see, feel, and sense the reality of Buddhist communities, and to see, feel, sense, and learn from Buddhist teachers who had dedicated their lives to meditative disciplines and concepts of human identity about which, thus far, he had only been able to read. He was

a resourceful reader; it's difficult to imagine anyone deriving more of substance from reading than Merton did. But reading has its limits, and his brief time with Dr. Suzuki and a very few others over the years had shown him the unique value of conversing with, being with individuals who fully and responsibly *are* their traditions.

"For me the wind blows to Asia," he wrote to a friend in religion in early September, 1968. "The Asians have this only: that for thousands of years they have worked on a very complex and complete mental discipline, which is not so much aimed at separating matter from spirit, as identifying the true self and separating it from an illusion generated by society and by imaginary appetite. At the present moment this illusion has become law, even for Christians."[130] His slight but noticeable restriction—"this only"—would vanish in the months to come, when he would be received by Tibetan monks and others as a brother in religion, and he would receive them without reserve as brothers.

Merton spent the summer preparing for the journey. Preparation was a matter of passport, credit card (wholly unfamiliar), and immunizations, but that was the surface. In depth, he was readying himself for one more leap from the hundred-foot pole. There is no sign of brushwork and printing, though perhaps it continued. On the other hand, the camera is much in evidence, as is that mind, that spirit. Someone wrote after Merton's death that he was not an original thinker—I can't recall who. Perhaps so. But he was something else: an original experiencer. His capacity to enter into experience, to question experience without distancing himself from it, and to report on experience in a way wholly fruitful for others was an original gift of the spirit. "What am I?" he asked in his last completed writing. And he responded,

I am myself a word spoken by God. Can God speak a word that does not have any meaning?

Yet am I sure that the meaning of my life is the meaning God intends for it? Does God impose a meaning on my life from the *outside,* through event, custom, routine, law, system, impact with others in society? Or am I called to *create from within,* with him, with his grace, a meaning which reflects his truth and makes me his "word" spoken freely in my personal situation? My true identity lies hidden in God's call to my freedom and my response to him. . . . I cannot discover my "meaning" if I try to evade the dread which comes from first experiencing my meaninglessness![131]

The thought of creating from within must have been much with him through the summer. After a few hours of reading and meditation in the sun at the edge of a bean field somewhere near the hermitage, he returned to his journal. "[I] realize more and more," he wrote, "that what really matters to me is meditation—and whatever creative work really springs from it."[132]

We cannot follow him to Asia. We have been following his brush and paper and grass stems, and where he set them down we too must stop. But now we know something of what was on his mind and heart as he prepared for the journey, and to this I would add one thing further. Though Merton died in Bangkok, in a terrible accident, he knew what was coming in American and, dare I say, global spirituality. By this I mean that he was aware of the most promising and authentic currents in the emerging spirituality of his time. Thich Nhat Hanh, then a young Buddhist teacher and Vietnamese exile, had visited him at Gethsemani. The Dalai Lama offered him his friendship and searching conversations when they met in north India. Merton had met, liked, and foreseen an interesting future for a young Tibetan exile, Chögyam Trungpa Rinpoche. He seems to have made a promise to himself to visit when possible a most interesting teacher in northern California, Shunryu Suzuki, about whom he had heard a little. He had also encountered and appreciated the wisdom of Rabbi Zalman Schachter-Shalomi and the refinement of a Sufi sheikh, visitors to Gethsemani at different moments in the 1960s. In his own tradition, he had befriended a number of younger religious—David Steindl-Rast and others—who would help the next generation of Catholics rediscover the teachings of the church on contemplation and deep prayer. Though Merton abruptly left this world on December 10, 1968, he had touched on much that was to come.

For Merton as a seeker, a few words that he recorded in his journal four days before his death provide a fitting end to our reflections. "Suddenly there is a point," he wrote, "where religion becomes laughable. Then you decide that you are nevertheless religious."[133]

For Merton as an artist, the closing words of his essay on his art can now have for us larger resonance than when we began:

The only dream a man seriously has when he takes a brush in his hand and dips it into ink is to reveal a new sign that can continue to stand by itself and to exist in its own right, transcending all logical interpretation.

The Art of Thomas Merton

THIRTY-FOUR IMAGES

A Preface to the Images

The images in this portfolio were chosen from among hundreds in various collections, primarily the collection of the Thomas Merton Center at Bellarmine University, Louisville. The selection is representative, but more than that: it shows Merton's work at its best, in a sequence that reflects the changing themes and methods of his art in the 1960s. The great majority of the images have never been published. Facing each image is a passage or passages from Merton's journals, correspondence, and published writings of the 1960s, reflecting ideas and experiences he was exploring in the years when the images were produced. What lines of shared meaning can be drawn from image to written word? Many, and of many different kinds, although the words are not captions and the images are not illustrations. Word and image together are markings on his compass.

Merton insisted that words and assigned meanings have nothing to do with his art. He hoped that the images could enter our minds and hearts freely, unhindered by words. His art "should really have no literary trimmings at all, including titles,"[1] he wrote in 1963. Yet he supplied titles for works in the 1964 exhibition at Catherine Spalding College. Both he and his college sponsor thought that, practically speaking, titles would help. For us now, titles remain a good thing; where provided, they offer a further, sometimes explanatory glow.

By 1968 he must have had second thoughts about the value of associating his art with well-chosen words, if not titles. In *Monks Pond,* the little magazine he published from Gethsemani (just four issues), he juxtaposed two of his drawings with short passages from Thoreau and Goethe.[2] Broadly speaking, that is the model adopted here.

Readers who have come this far on the journey will know that Merton published only one essay on his art. Originally conceived as gallery notes for the 1964 exhibition, the essay was slightly revised for the traveling exhibition that took to the road soon after. Merton thought well enough of the essay to publish it in 1966 in *Raids on the Unspeakable,* which also offers reproductions of fifteen works in the 1964 exhibition. This portfolio of images begins with the essay.

Signatures: Notes on the Author's Drawings

By Thomas Merton

Since judgments are usually based on comparisons and since opportunities for comparison in the visual arts today are so many and often so irrelevant as to be overwhelming, the viewer is not invited to regard the abstract drawings presented here as "works of art."

Nor is he urged to seek in them traces of irony. Nor need he read into them a conscious polemic against art. These signs lay claim to little more than a sort of crude innocence. They desire nothing but their constitutional freedom from polemic, from apologetic, and from program.

If the viewer is not encouraged to judge these drawings in terms of familiar categories, he is also urged not to consider himself in any way, implicitly or otherwise, judged by them. For it must be admitted that the ambiguities of abstraction tend to set some people on edge, as though accusing them of not understanding something that is doubtless not intended to be understood. But by now everyone knows that it is unwise to ask what abstractions are "of." These are not "drawings of."

It would be better if these abstractions did not have titles. However, titles were provided out of the air. The viewer will hardly be aided by them, but he may imagine himself aided if he wishes. The most deliberate titles, those of the Genesis series, are at best afterthoughts. In any case, the viewer who wants titles can make up his own.

Once this is admitted, there should not be too much trouble for the observer who desires to be at peace with these rude signs, provided that he is himself a basically peaceable man and content to accept life as it is, tolerating its unexpected manifestations, and not interpreting everything unfamiliar as a personal threat.

These abstractions—one might almost call them *graffiti* rather than calligraphies—are simple signs and ciphers of energy, acts or movements intended to be propitious. Their "meaning" is not to be sought on the level of convention or of concept. These are not conventional signs as are words, numbers, hieroglyphs, or symbols. They could not be assigned a reference by advance agreement because it has been their nature to appear on paper without previous agreement. On the contrary, the only "agreements" which they represent were momentary and unique, free, undetermined and inconclusive. They came to life when they did, in the form of reconciliations, as expressions of unique

and unconscious harmonies appropriate to their own moment though not confined to it. But they do not register a past and personal experience, nor attempt to indicate playfully the passage of a special kind of artist, like footsteps in the snow. It is not important whether anyone passed here, because these signs are not sufficiently accounted for as records of "events." However, the seeing of them may open up a way to obscure reconciliations and agreements that are not arbitrary—or even to new, intimate histories.

In a world cluttered and programmed with an infinity of practical signs and consequential digits referring to business, law, government and war, one who makes such nondescript marks as these is conscious of a special vocation to be inconsequent, to be outside the sequence and to remain firmly alien to the program. In effect these writings are decidedly hopeful in their own way in so far as they stand outside all processes of production, marketing, consumption and destruction, which does not however mean that they cannot be bought. Nevertheless it is clear that these are not legal marks. Nor are they illegal marks, since as far as law is concerned they are perfectly inconsequent. It is this and this alone which gives them a Christian character (Galatians 5), since they obviously do not fit into any familiar setting of religious symbolism, liturgical or otherwise. But one must perhaps ask himself whether it has not now become timely for a Christian who makes a sign or a mark of some sort to feel free about it, and not consider himself rigidly predetermined to a system of glyphs that have a long cultural standing and are fully consequential, even to the point of seeming entirely relevant in the world of business, law, government and war.

Ciphers, signs without prearrangement, figures of reconciliation, notes of harmony, inventions perhaps, but not in the sense of "findings" arrived at by the contrived agreement of idea and execution. Summonses to awareness, but not to "awareness *of*." Neither rustic nor urbane, primitive nor modern, though they might suggest cave art, maybe Zen calligraphy. No need to categorize these marks. It is better if they remain unidentified vestiges, signatures of someone who is not around. If these drawings are able to persist in a certain autonomy and fidelity, they may continue to awaken possibilities, consonances; they may dimly help to alter one's perceptions. Or they may quietly and independently continue to invent themselves. Such is the "success" they aspire to. Doubtless there is more ambition than modesty in such an aim. For the only dream a man seriously has when he takes a brush in his hand and dips it into ink is to reveal a new sign that can continue to stand by itself and to exist in its own right, transcending all logical interpretation.[3]

A prophet is one who cuts through

The monk who ceases to ask himself "Why have you come here?" has perhaps ceased to be a monk.[4]

To live well myself means for me to know and appreciate something of the secret, the mystery in myself: that which is incommunicable, which is at once myself and not myself, at once in me and above me. From this sanctuary I must seek humbly and patiently to ward off all the intrusions of violence and self-assertion. These intrusions cannot really penetrate the sanctuary, but they can draw me forth from it and slay me before the secret doorway.[5]

August 6, 1960. A prophet is one who cuts through great tangled knots of lies.[6]

Thomas Merton Center 557. *Jerusalem*, 1960.
(image size: 4 ¼" h x 6 ½" w)

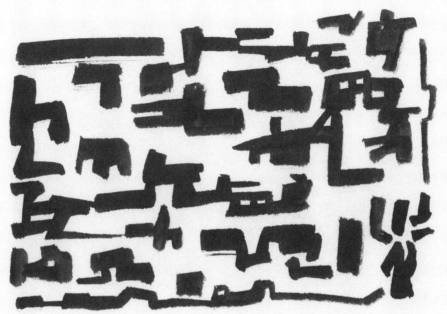

tM. '60.

Jerusalem.

2

Even with motionless movement

Imagination has the creative task of making symbols, joining things together in such a way that they throw new light on each other and on everything around them. The imagination is a discovering faculty, a faculty for seeing relationships, for seeing meanings that are special and even quite new.[7]

May 11, 1964. So we must all move, even with motionless movement, even if we do not see clearly. A few little flames, yes. You can't grasp them, but anyway look at them obliquely. To look too directly at anything is to see something else because we force it to submit to the impertinence of our preconceptions. After a while though everything will speak to us if we let it and do not demand that it say what we dictate.[8]

The artist should preach nothing—not even his own autonomy. His art should speak its own truth, and in so doing it will be in harmony with every other kind of truth—moral, metaphysical, and mystical.[9]

Thomas Merton Papers, Rare Book and Manuscript Library, Columbia University. No. 1 in a series donated by Msgr. William Shannon. Untitled. (image size: 7⅜" h x 4½" w)

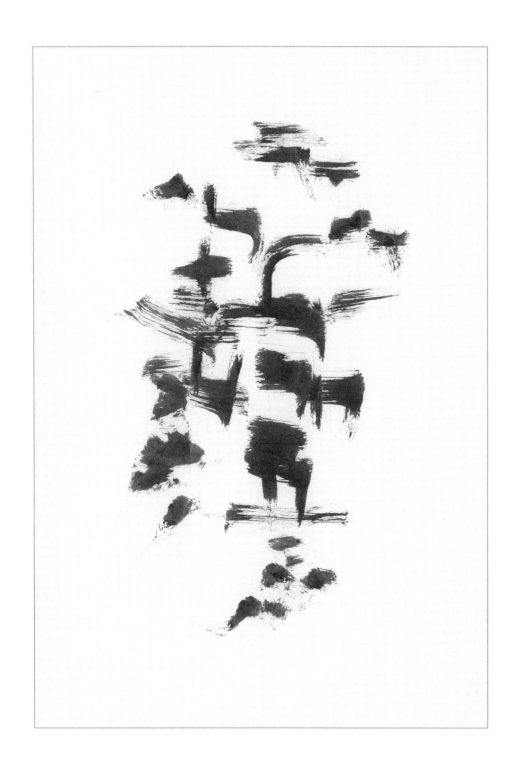

3

An inner dynamism

December 23, 1967. We must face the challenge of the future realizing that we are still problems to ourselves. Where the religious dimension enters in is not just in pious clichés but in a radical self-criticism and openness and a profound ability to *trust* not only in our chances of a winning gamble, but in an inner dynamism of life itself, a basic creativity, a power of life to win over entropy and death. But once again, we have to pay attention to the fact that we may formulate this in words, and our unconscious death-drive may be contradicting us in destructive undertones we don't hear.

In other words, we have all got to learn to be wide open, and not get closed up in little tight systems and cliques, little coteries of gnostic experts.[10]

In the case of a Zen artist, there is then no artistic reflection. The work of art springs "out of emptiness" and is transferred in a flash, by a few brush strokes, to paper. It is not a "representation of" anything, but rather it is the subject itself, existing as light, as art, in a drawing which has, so to speak, "drawn itself." The work then is a concretized intuition: not however presented as a unique experience of a specially endowed soul, who can then claim it as his own. On the contrary, to make any such claim would instantly destroy the character of "emptiness" and suchness which the work might be imagined to have.[11]

Thomas Merton Center. No. 4 in the series sent by Thomas Merton to Ad Reinhardt. Gift of Anna Reinhardt. Untitled.
(image size: 11 ¾" h x 7" w)

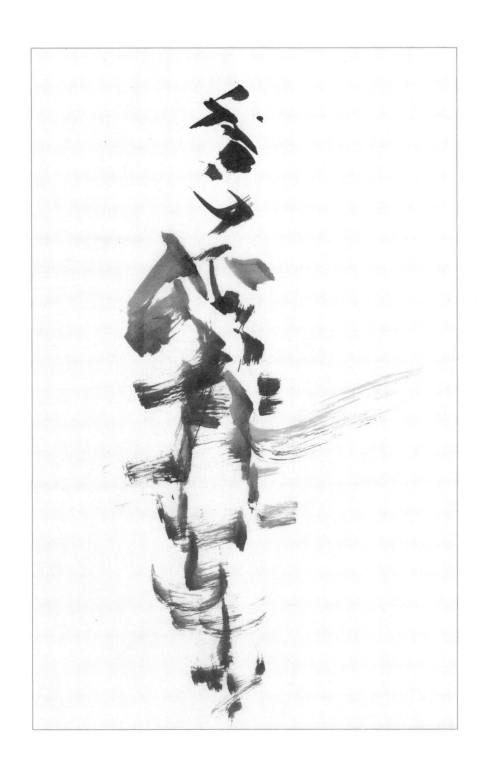

4

Constant self-revision and growth

January 25, 1964. I am aware of the need for constant self-revision and growth, leaving behind the renunciations of yesterday and yet in continuity with all my yesterdays. For to cling to the past is to lose one's continuity with the past, since this means clinging to what is no longer there.

My ideas are always changing, always moving around one center, and I am always seeing that center from somewhere else.

Hence, I will always be accused of inconsistency. But I will no longer be there to hear the accusation.[12]

Late 1965. To say that I am a child of God is to say, before everything else, that I grow. That I begin. A child who does not grow becomes a monster. The idea "Child of God" is therefore one of living growth, becoming, possibility, risk, and joy in the negotiation of risk. In this God is pleased: that His child grows in wisdom and grace.[13]

Thomas Merton Center 339. Untitled.
(image size: 5½" h x 8" w)

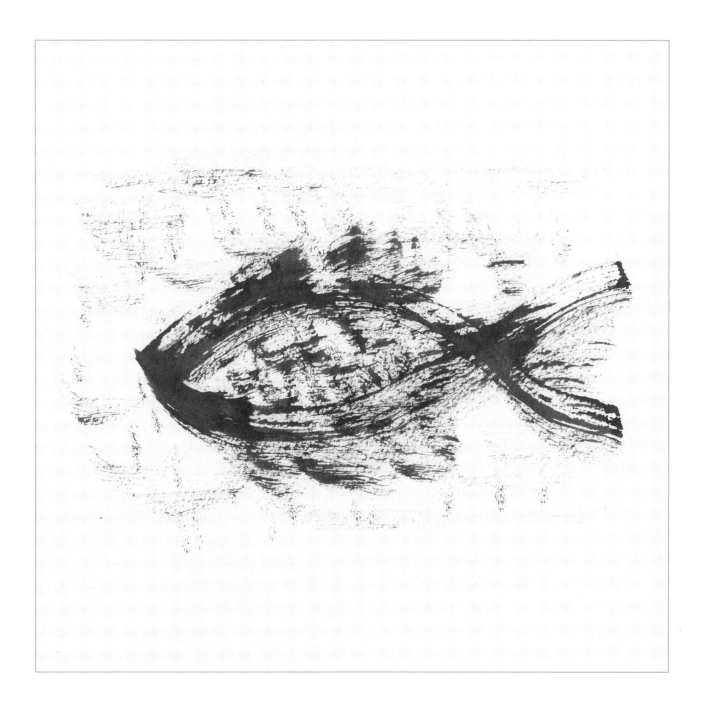

5

Not a shadow but a sign

The nineteenth-century European and American realists were so realistic that their pictures were totally unlike what they were supposed to represent. And the first thing wrong with them was, of course, precisely that they were pictures. In any case, nothing resembles reality less than the photograph. Nothing resembles substance less than its shadow. To convey the meaning of something substantial you have to use not a shadow but a sign, not the imitation but the image. The image is a new and different reality, and of course it does not convey an impression of some object, but the mind of the subject: and that is something else again.[14]

True artistic freedom can never be a matter of sheer willfulness, or arbitrary posturing. It is the outcome of authentic possibilities, understood and accepted in their own terms, not the refusal of the concrete in favor of the purely "interior." In the last analysis, the only valid witness to the artist's creative freedom is his work itself. The artist builds his own freedom and forms his own artistic conscience, by the work of his hands. Only when the work is finished can he tell whether or not it was done "freely."[15]

Thomas Merton Center 356. Untitled.
(image size: 7" h x 6¾" w)

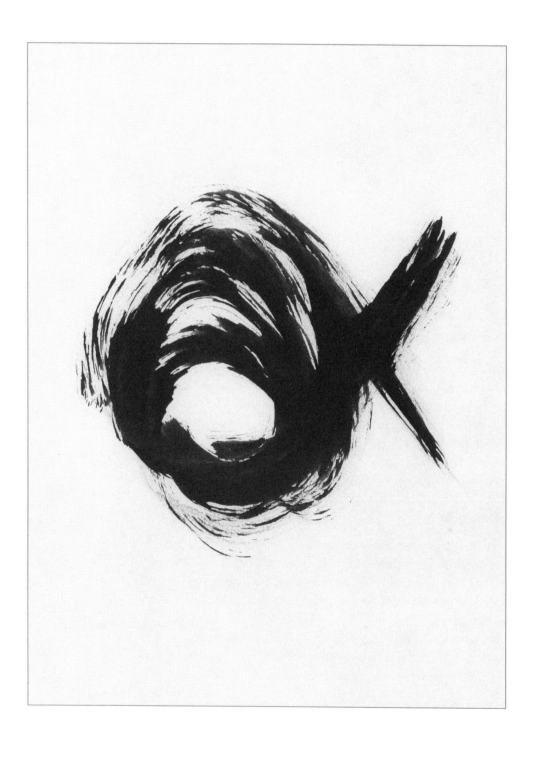

6

Enough self-respect to attend to this mystery

December 18, 1966. The need to open up an inner freedom and vision, which is found in relatedness to something in us which we *don't really know*. This is not just the psychological unconscious. It is much more than that. Tillich called it the ground of our being. Traditionally it is called "God," but images and ideas of the deity do not comprehend it. What is it? . . . The real inner life and freedom of man begin when this inner dimension opens up and man lives in communion with the unknown within him. On the basis of this he can also be in communion with the same unknown in others. How to describe it? Impossible to describe it.[16]

Gabriel Marcel says that the artist who labors to produce effects for which he is well known is unfaithful to himself. This may seem obvious enough when it is baldly stated: but how differently we act. We are all too ready to believe that the self that we have created out of our more or less inauthentic efforts to be real in the eyes of others is a "real self." We even take it for our identity. Fidelity to such a nonidentity is of course infidelity to our real person, which is hidden in mystery. Who will you find that has enough faith and self-respect to attend to this mystery and to begin by accepting himself as *unknown*?[17]

Thomas Merton Center U005f. Untitled, 1964.
(image size: 3" h x 5" w)

7

The monk is a bird who flies very fast

May 11, 1964. The monk is a bird who flies very fast without knowing where he is going. And always arrives where he went, in peace, without knowing where he came from.[18]

I wish I had more charity. Perhaps I should say I wish I had at least a little charity. I wish I were less resentful of dead immobilism: the ponderous, inert, inhuman pressure of power bearing down on everyone to keep every beak from opening and every wing from moving. Authority sitting in its office, with all the windows open, trying to hold down, with both hands, all the important papers and briefs, all the bits of red tape, all the documents on all the members of the Body of Christ. I wish I could stop hoping the whole mess would blow away.[19]

Elias becomes his own wild bird, with God in the center.[20]

Thomas Merton Center 361. Untitled.
(image size: 8½" h x 8½" w)

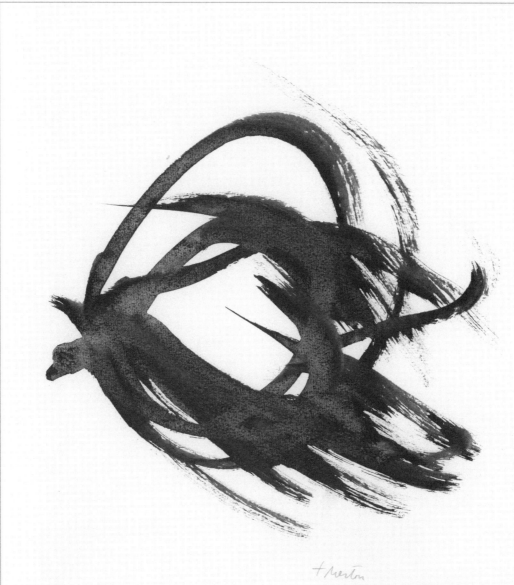

8

The sense of the Holy

March 18, 1960. The sense of the Holy, that lays one low: as in Isaias. To read Hallaj makes one lament and beat his breast. Where has it gone, this sense of the sacred, this awareness of the Holy? What has happened to us? . . . Is there no one left to wrestle with the angel, like Jacob and . . . Hallaj?[21]

You realize that prayer takes us beyond the law. When you are praying you are, in a certain sense, an outlaw. There is no law between the heart and God.[22]

December 9, 1964. The only response is to go out from yourself with all that one is, which is nothing, and pour out that nothingness in gratitude that God is who He is. All speech is impertinent, it destroys the simplicity of that nothingness before God by making it seem as if it had been "something."[23]

Thomas Merton Center U013f. Untitled, 1964.
(image size: 5" h x 4 ½" w)

9

Psalms and tea and the silence

July 24, 1962. Asked to speak in a "scientific" symposium on New Knowledge in Human Values, [Suzuki] handled it with consummate wisdom and latent humor, the serious, humble, matter-of-fact humor of emptiness. "If anything new can come out of human values it is from the cup of tea taken by two monks."[24]

December 1, 1965. When I got up it was about thirty on the porch and now at dawn it is down to twenty-one. These are the coldest hours—meditation, *lectio,* and hot tea with lemon and a good fire.[25]

January 22, 1966. By mid-afternoon was tired and distracted but psalms and tea and the silence of snow re-ordered everything.[26]

February 22, 1967. Rain and sleet tonight. The kettle boils for some tea before I go to bed.[27]

Thomas Merton Center 654. Untitled.
(image size: 6¾" h x 8" w)

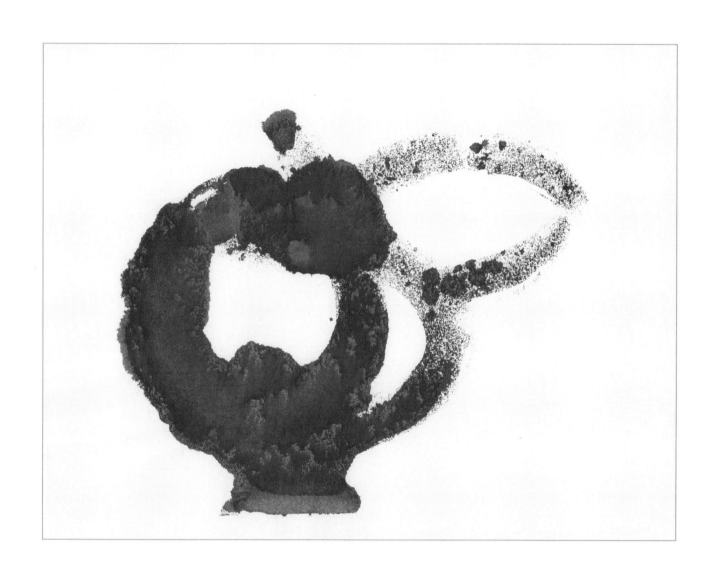

Each stroke is first and last

October 9, 1963. It is stimulating to hear that you like the calligraphies. The title I gave them was "Shamanic Dictation" but now, thinking about it, I think it is rather cheap and misleading. . . . Such calligraphies should really have no literary trimmings at all, including titles. There should really be nothing that misleads the spectator by seeming to give him a "clue." That is the curse of the literary incrustations that have still remained on so much abstract art: the mania for satisfying the spectators' foolish question about "what is it?" Until they can be content to accept the fact that the picture is simply itself, there is no point in trying to explain it, especially if the explanation seems to indicate that it is something else.

 These calligraphies (this word is not a title but simply an indication of the species of drawing to which they belong) should really be pure and simple as they are, and they should lay no claim to being anything but themselves. There should be no afterthoughts about them on the part of the artist or spectator. Each time one sees them is the first time. Each stroke is so to speak first and last, all goes in one breath, one brushful of ink, and the result is a statement of itself that is "right" insofar as it says nothing "about" anything else under the sun. Therefore to bring in the notion of a pseudo-mystical experience is fraudulent in the extreme, even though it is only a joke, and meant to warn the spectator to reverse it and understand the opposite. Such maneuvers are silly and, as I say, misleading. So I would prefer to drop "Shamanic Dictation" as nonsense, and just call them calligraphies. Actually they have a kind of musical character, in a derivative sort of way. Though of course visually only.[28]

Thomas Merton Center 580. Untitled, 1964.
(image size: 5½" h x 6½" w)

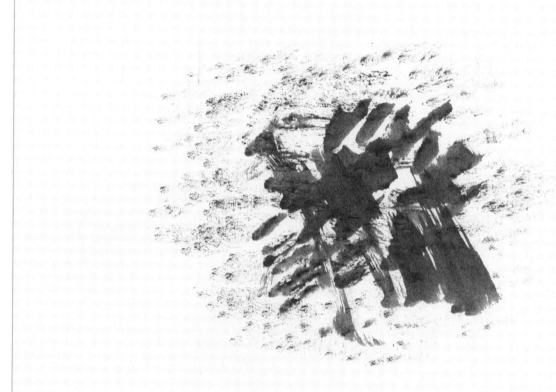

+Merton '64.

Contracts with life

In the autumn of 1964, Merton drafted notes toward the essay on his art published at the beginning of this portfolio. The following is drawn from those notes:

These are contracts with movement, with life, in which no one can be bound except to what was and is now definitive.

Not a question of conjunction of idea and execution.

Inventions yes: but also collaborations with solitude.
Summonses, calls to experiment, trials, gifts, fortunate events.

Neither rustic nor urbane, Eastern nor Western, perhaps can be called expressions of Zen Catholicism.

Rearrangement of forms leads to change of perception: registering certain signs—in order to become aware of certain new possibilities and consonances. Not without self criticism.

But in what terms! Fidelity to Zen-like experience of wholeness.[29]

Thomas Merton Center 673. Untitled.
(image size: 3¼" h x 2¾" w)

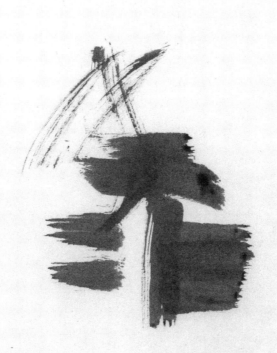

Buried under the dam calligraphies

March 5, 1964. About your poems my dear Mappo I find myself in the
position of being sorely inhibited by a trance. When I look at so many long
small poems and say to myself that I am to get busy and edit, I am overcome
with a faintness and with a swound. The luster comes and goes in my eye
quickety quick and then the head goes out with a swump and I am smack off
in the moon or someplace doing another thing of vast triviality. All the time it
is the same swound when I got to do anything artistic except calligraphies.
With calligraphies on the other hand it is always a great storm of creative
action and the calligraphies pile ten miles high and I am buried and smother
under the dam calligraphies there is so much action and creation.[30]

Thomas Merton Center 567. Untitled.
(image size: 5" h x 6¼" w)

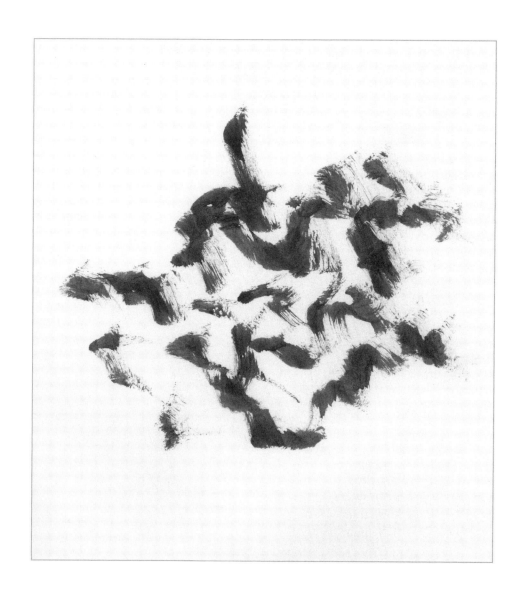

13

The daring of Baroque

February 4, 1962. I admire especially the daring of Baroque that was not afraid
to risk terrible lapses of taste, and yet managed almost always to come off
with some marvels of ingenuity and playfulness. In former days I found it hard
to take seriously, but now I think nevertheless its significance grows on me.[31]

Thomas Merton Center 738. Untitled.
(image size: 12" h x 9 ¼" w)

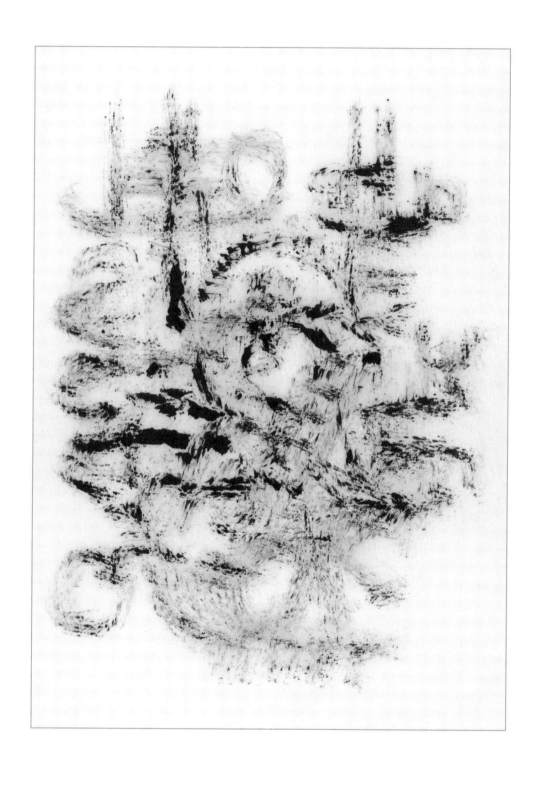

14

A sign of freedom, a sign of truth

He should be a sign of freedom, a sign of truth, a witness to that inner liberty of the sons of God with which Christ has come to endow us.[32]

The "new being" of the Christian . . . is the effect of an inner revolution which, in its ultimate and most radical significance, implies complete self-transcendence and transcendence of the norms and attitudes of any given culture, any merely human society. This includes transcendence even of religious practices. . . . There is in the depths of man's heart a voice which says: "You must be born again." It is the obscure but insistent demand of his own nature to transcend itself in the freedom of a fully integrated, autonomous, personal identity.[33]

July 10, 1965. I can say as a Christian, and an existentialist Christian, that I have often experienced the fact that the "moment of truth" in the Christian context is the encounter with the inscrutable word of God, the personal and living interpretation of the word of God when it is lived, when it breaks through conventional religious routines and even seems in some ways quite scandalous in terms of the average and accepted interpretation of what religion ought to be.[34]

Thomas Merton Center 585. Untitled.
(image size: 10¾" h x 6" w)

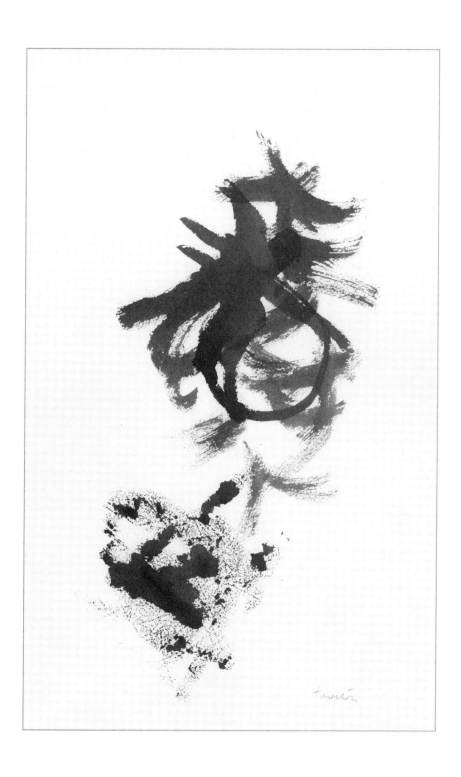

15

To catch echoes of that dancing

The Lord plays and diverts Himself in the garden of His creation, and if we could let go of our own obsession with what we think is the meaning of it all, we might be able to hear His call and follow Him in His mysterious, cosmic dance. We do not have to go very far to catch echoes of that game, of that dancing. When we are alone on a starlit night; when by chance we see the migrating birds in autumn descending on a grove of junipers to rest and eat; when we see children in a moment when they are really children; when we know love in our own hearts; or when, like the Japanese poet Basho, we hear an old frog land in a quiet pond with a solitary splash—at such times the awakening, the turning inside out of all values, the "newness," the emptiness and the purity of vision that make themselves evident, provide a glimpse of the cosmic dance.

For the world and time are the dance of the Lord in emptiness. . . . No despair of ours can alter the reality of things, or stain the joy of the cosmic dance which is always there. Indeed, we are in the midst of it, and it is in the midst of us, for it beats in our very blood, whether we want it to or not.

Yet the fact remains that we are invited to forget ourselves on purpose, cast our awful solemnity to the winds and join in the general dance.[35]

Thomas Merton Center 573. *Considerable Dance.*
(image size: 7 ¾" h x 8 ¼" w)

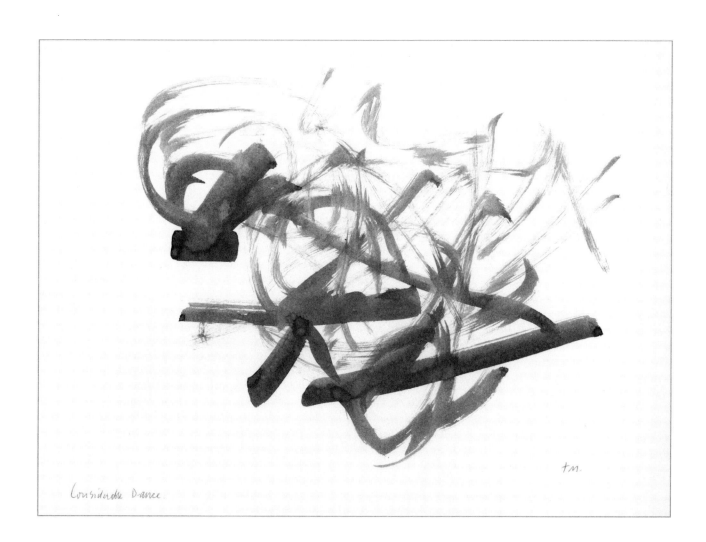

Considerable Dance.

tn.

16

He does not demand light

Contemplation is essentially a listening in silence, an expectancy. And yet in a certain sense, we must truly begin to hear God when we have ceased to listen. What is the explanation of this paradox? Perhaps only that there is a higher kind of listening, which is not an attentiveness to some special wave length, a receptivity to a certain kind of message, but a general emptiness that waits to realize the fullness of the message of God within its own apparent void. In other words, the true contemplative is not the one who prepares his mind for a particular message that he wants or expects to hear, but who remains empty because he knows that he can never expect or anticipate the word that will transform his darkness into light. He does not even anticipate a special kind of transformation. He does not demand light instead of darkness. He waits on the Word of God in silence, and when he is "answered," it is not so much by a word that bursts into his silence. It is by his silence itself suddenly, inexplicably revealing itself to him as a word of great power, full of the voice of God.[36]

Boston College, Burns Library Collection. Gift of Mary McNiff. Untitled.
(image size: 4" h x 3¼" w)

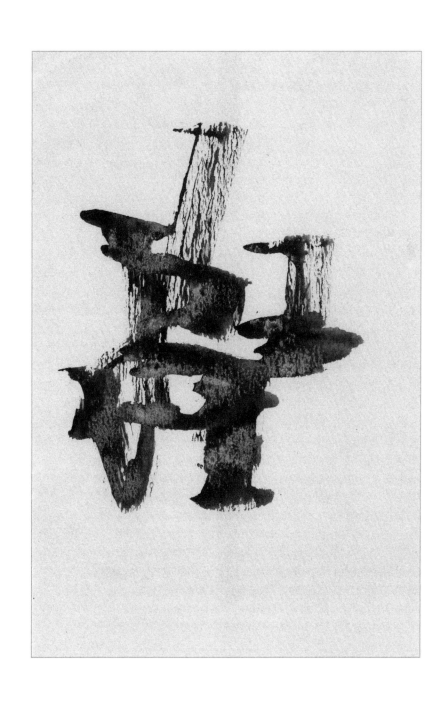

Christ comes through the ruins

July 5, 1965. The greatest comfort is to be sought precisely in the Psalms, which face death as it is, under the eye of God, and teach us how we may also face it. They bring us, at the same time, into contact or rather communion with all those who have so seen death and accepted it before us. Most of all, the Lord Himself, who prayed the Psalms on the cross.[37]

Slowly slowly
Comes Christ through the ruins
Seeking the lost disciple
A timid one
Too literate
To believe words
So he hides[38]

The monk who is truly a man of prayer and who seriously faces the challenge of his vocation in all its depth is by that very fact exposed to existential dread. He experiences in himself the emptiness, the lack of authenticity, the quest for fidelity, the "lostness" of modern man. . . . The monk confronts his own humanity and that of his world at the deepest and most central point where the void seems to open out into black despair. The monk confronts this serious possibility, and rejects it. . . . The option of absolute despair is turned into perfect hope by the pure and humble supplication of monastic prayer. The monk faces the worst, and discovers in it the hope of the best. From the darkness comes light. From death, life. From the abyss there comes, unaccountably, the mysterious gift of the Spirit sent by God to make all things new, to transform the created and redeemed world, and to re-establish all things in Christ.[39]

Thomas Merton Center 448. Untitled.
(image size: 8 ½ " h x 5" w, on gray card)

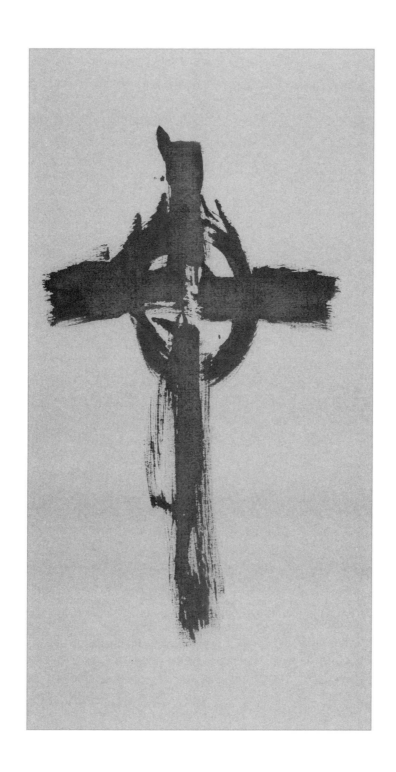

Signs *not of* idea *but of movement*

The following is a further passage from the notes drafted by Merton in 1964 toward his essay on his art.

Propitious forms and signs, ciphers of energy not as controlled by art but as moving in unconscious harmony—or disharmony.

Signs therefore not of *idea* but of movement

Footprints of the unconscious (as a child might make deliberate footprints in snow)
But difference—not a sign that "I" passed this way.
Footprints *divested of ego and yet not anonymous*
This I do not know how to explain.

That movement of the world was thus registered on paper was due to my decision—and it is important only in so far as my brushstrokes are not those of a machine. But neither are they "mine," nor are they those of a particular artist. Nor of a medium or shaman.[40]

Thomas Merton Center 454. Untitled.
(image size: 3" h x 2½" w)

19

The world runs by rhythms

The whole world runs by rhythms I have not yet learned to recognize, rhythms that are not those of the engineer.[41]

1965. The following texts were transcribed by Merton into his notes from a remarkable book on the Taoist spirit in Chinese art:

"The painter has to experience the rhythm of life to be able to express it in his works by means of the rhythm of the brush."

"One must scratch the ancients, then scratch oneself. If with this brush one composes poems and essays, and writes characters, and people look at the result and feel no ache, no itch, nothing at all, one might as well break one's arm. What use is it?"[42]

"Ch'i yun [rhythmic vitality] may be expressed by ink, by brushwork, by an idea, or by absence of ideas. . . . It is something beyond the feeling of the brush and the effect of ink, because *it is the moving power of Heaven, which is suddenly disclosed. But only those who are quiet can understand it.*"[43] (emphasis added by Merton)

Thomas Merton Center 702. Untitled.
(image size: 11" h x 8" w)

Sorcerer, soothsayer, alchemist

ca. 1963. To those who ask what I think about art, there are a couple of essays on the subject. . . . I like modern art. I have always liked such painters as Picasso, Chagall, Cézanne, Rouault, Matisse, and so on. I like expressionists and impressionists and post-impressionists and abstract expressionists and most of the other "-ists" but I don't like social realism. Nor do I like candy-box art or the illustrations in the *Saturday Evening Post.* I am not prepared to enter into an argument in defense of these preferences.[44]

October 29, 1964. Next month in Louisville I astound the population with an exhibit of incomprehensible abstract drawings which will cause the greatest possible amount of perplexity on all sides and will perhaps bring everyone into a state of inarticulate stupor in which all things and especially the drawings will immediately be forgotten and everyone will rush to indulge in something else that is capable of being advertised.[45]

It is conceivable that the artist might once again be completely integrated in society as he was in the Middle Ages. Today he is hardly likely to find himself unless he is a non-conformist and a rebel. To say this is neither dangerous nor new. It is what society really expects of its artists. For today the artist has, whether he likes it or not, inherited the combined functions of hermit, pilgrim, prophet, priest, shaman, sorcerer, soothsayer, alchemist, and bonze. How could such a man be free? How can he really "find himself" if he plays a role that society has predetermined for him? The freedom of the artist is to be sought precisely in the choice of his work and not in the choice of the role as "artist" which society asks him to play.[46]

Thomas Merton Center 442. Untitled.
(image size: 10 ¼" h x 7 ½" w)

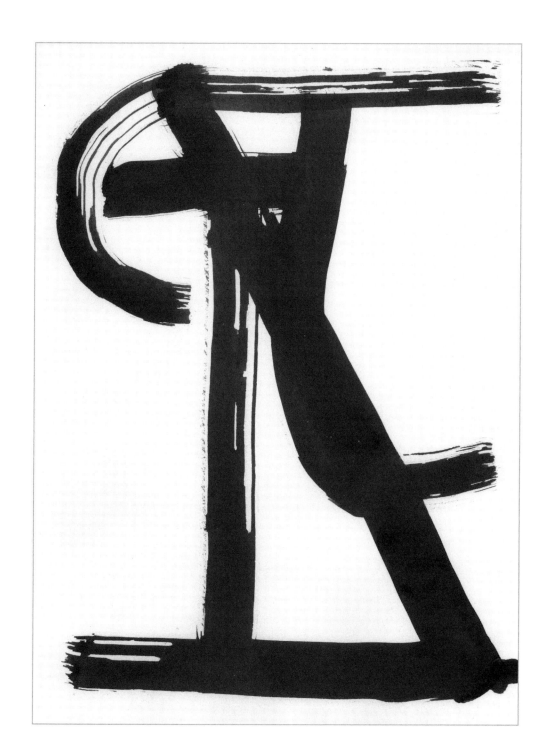

Not thoughts, but hours of silence

December 10, 1960. It is not thoughts that matter, but hours of silence and the precious dimension of existence which is otherwise completely unknown, certainly unknown when one thinks, or mentally speaks . . . or even writes. It must simply be seen, and is not seen until one has been sitting still, alone, in its own utter obviousness.[47]

The peculiar quality of Chinese and Japanese art that is influenced by Zen is that it is able to suggest what cannot be said, and, by using a bare minimum of form, to awaken us to the formless. Zen painting tells us just enough to alert us to what is *not* and is nevertheless "right there." Zen calligraphy, by its peculiar suppleness, dynamism, abandon, contempt for "prettiness" and for formal "style," reveals to us something of the freedom which is not transcendent in some abstract and intellectual sense, but which employs a minimum of form without being attached to it, and is therefore free from it.[48]

Transcribed by Merton from Mai-Mai Sze's study of the Taoist spirit in art:

"Painting, guided by the heart-mind through the means of skillful handling of brush and ink, should thus exhibit thought and reflection, sensibility and intuition. And it is the proper balance of these factors that can produce the harmonious results worthy of being described as expressions of the harmony of Heaven and Earth."[49]

Thomas Merton Center U004. *Emblem,* 1964.
(image size: 3 ¼" h x 2 ¼" w)

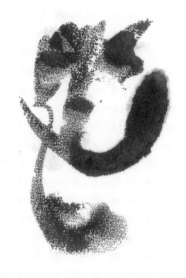

Emblem. ✝Martin '64.

22

It is more than silence

August 17, 1960. We should in a way fear for our perseverance because there is a big hole in us, an abyss, and we have to fall through it into emptiness, but the Lord will catch us. Who can fall through the center of himself into that nothingness and not be appalled? But the Lord will catch us.[50]

There is a silent self within us whose presence is disturbing precisely because it is so silent: it *can't* be spoken. It has to remain silent. To articulate it, to verbalize it, is to tamper with it, and in some ways to destroy it.[51]

June 30, 1965. The best approach is existentialist, and the existentialist approach, in theology, is not through abstract dogmas but through direct personal confrontation, not of a subject with an object but of a person with an inner demand.[52]

April 13, 1967. The silence that is printed in the center of our being. It will not fail us. It is more than silence. Jesus spoke of the spring of living water, you remember.[53]

Thomas Merton Center U011. *Personal or not, 1964.*
(image size: 4" h x 4" w)

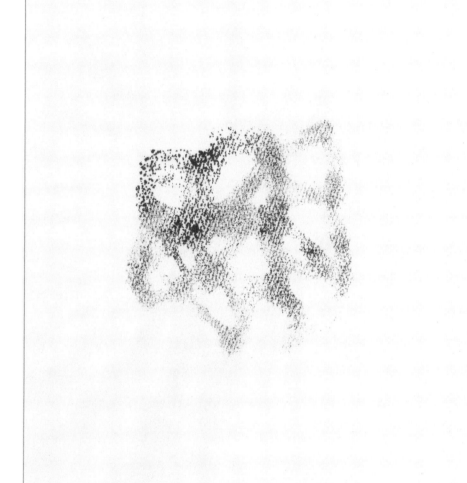

Personal or not.

tm. '64

23

The three doors (they are one door)

The three doors (they are one door).

 1. The door of emptiness. Of no-where. Of no place for a self, which cannot be entered by a self. And therefore is of no use to someone who is going somewhere. Is it a door at all? The door of no-door.

 2. The door without sign, without indicator, without information. Not particularized. Hence no one can say of it, "This is *it*! This is *the door*." It is not recognizable as a door. It is not led up to by other things pointing to it: "We are not it, but that is it—the door." No signs saying "Exit." No use looking for indications. Any door with a sign on it, any door that proclaims itself to be a door, is not the door. But do not look for a sign saying "Not-door." Or even "No Exit."

 3. The door without wish. The undesired. The unplanned door. The door never expected. Never wanted. Not desirable as door. Not a joke, not a trap door. Not select. Not exclusive. Not for a few. Not for many. Not *for*. Door without aim. Door without end. Does not respond to a key—so do not imagine you have a key. Do not have your hopes on possession of the key.

 There is no use asking for it. Yet you must ask. Who? For what? When you have asked for a list of all the doors, this one is not on the list. When you have asked the numbers of all the doors, this one is without a number. Do not be deceived into thinking this door is merely hard to find and difficult to open. When sought it fades. Recedes. Diminishes. Is nothing. There is no threshold. No footing. It is not empty space. It is neither this world nor another. It is not based on anything. Because it has no foundation, it is the end of sorrow. Nothing remains to be done. Therefore there is no threshold, no step, no advance, no recession, no entry, no nonentry. Such is the door that ends all doors; the unbuilt, the impossible, the undestroyed, through which all the fires go when they have "gone out."[54]

Thomas Merton Center 496. Untitled.
(image size: 6½" h x 8" w)

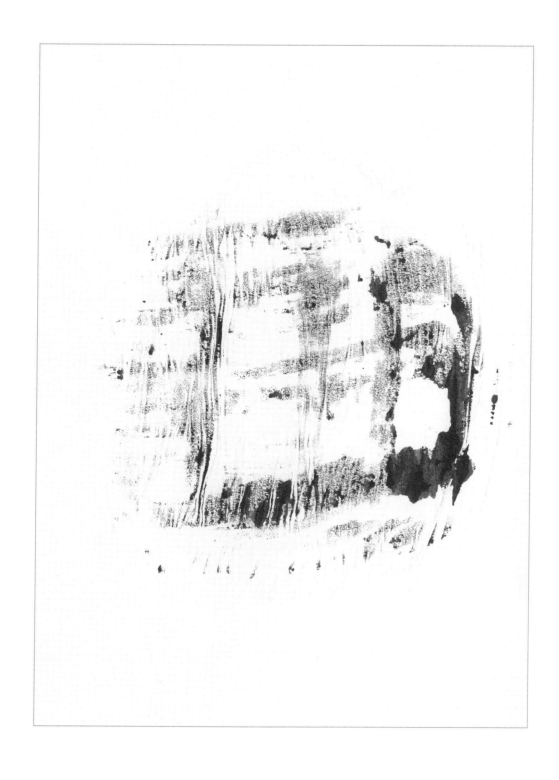

How like despair hope is

August 21, 1967. Can I tell you that I have found answers to the questions that
torment the man of our time? I do not know if I have found answers. When I
first became a monk, yes, I was more sure of "answers." But as I grow old in
the monastic life and advance further into solitude, I become aware that I
have only begun to seek the questions. And what are the questions? Can man
make sense out of his existence? Can man honestly give his life meaning
merely by adopting a certain set of explanations which pretend to tell him why
the world began and where it will end, why there is evil and what is necessary
for a good life? My brother, perhaps in my solitude I have become as it were
an explorer for you, a searcher in realms which you are not able to visit. . . .
I have been summoned to explore a desert area of man's heart in which
explanations no longer suffice, and in which one learns that only experience
counts. An arid, rocky, dark land of the soul, sometimes illuminated by
strange fires which men fear and peopled by specters which men studiously
avoid except in their nightmares. And in this area I have learned that one
cannot truly know hope unless he has found out how like despair hope is.[55]

Flogge Collection, on loan to the Thomas Merton Center. Untitled, 1967.
(image size: 8½" h x 6½" w)

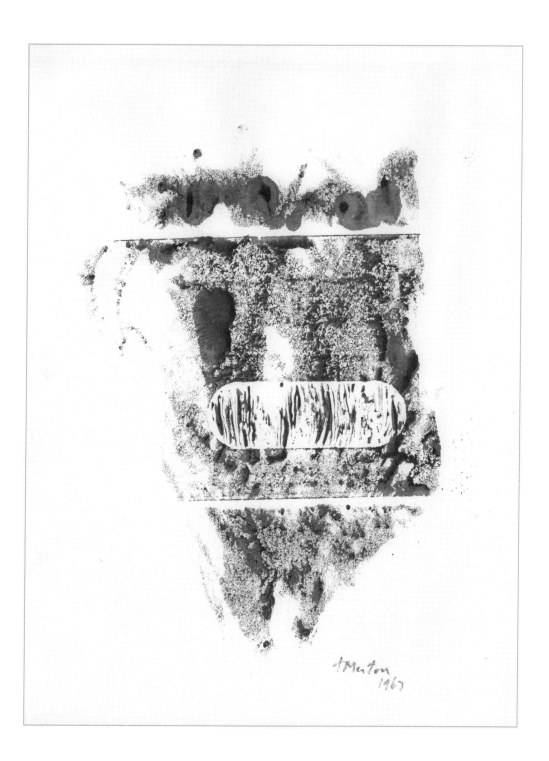

25

Beyond philosophy

He who is called to be a monk is precisely the one who, when he finally realizes that he is engaged in the pure folly of meeting an impossible demand, instead of renouncing the whole thing proceeds to devote himself even more completely to the task. Aware that, precisely because he cannot meet it, it will be met for him. And at this point he goes beyond philosophy.[56]

November 13, 1966. Today, for a certain type of person, to "listen" is to be in a position where hearing is impossible—or deceptive. It is the wrong kind of listening: listening for a limited message, an objective sound, a sensible meaning. Actually one decides one's life by responding to a word that is *not* well defined, easily explicable, safely accounted for. One decides to love in the face of an unaccountable void, and from the void comes an unaccountable truth. By this truth one's existence is sustained in peace— until the truth is too firmly grasped and too clearly accounted for. Then one is relying on words—i.e., on his own understanding and his own ingenuity in interpreting existence and its "signs." Then one is lost—has to be found once again in the patient Void.[57]

Thomas Merton Center 392. Untitled.
(image size: 7¾" h x 5½" w)

26

The law of risk and struggle

Much more to the point: the prayer that struggles toward God in obscurity, in trial, beating down the phantoms.[58]

September 20, 1962. At this, one need not be surprised, because the law of all spiritual life is the law of risk and struggle, and possible failure.[59]

January–March, 1966. God reveals Himself in the middle of conflict and contradiction—and we want to find Him *outside* all contradictions.[60]

Thomas Merton Center 394. Untitled.
(image size: 10½" h x 8½" w)

27

An act for which there can be found no word

April 10, 1965. The religion of our time, to be authentic, needs to be the kind that escapes practically all religious definition. Because there has been endless definition, endless verbalizing, and words have become gods. There are so many words that one cannot get to God as long as He is thought to be on the other side of the words. But when he is placed firmly beyond the other side of the words, the words multiply like flies and there is a great buzzing religion, very profitable, very holy, very spurious. One tries to escape it by acts of truth that fail. One's whole being must be an act for which there can be found no word. This is the primary meaning of faith. On this basis, other dimensions of belief can be made credible. Otherwise not. My whole being must be a yes and an amen and an exclamation that is not heard. Only after that is there any point in exclamations and even after that there is no point in exclamations. One's acts must be part of the same silent exclamation. . . . If only [we] could realize that nothing *has to be* uttered. Utterance makes sense only when it is spontaneous and free.[61]

Thomas Merton Center 480. Untitled.
(image size: 7¾" h x 10" w)

28

The prayer life of a flexible instrument

April 3, 1965. To be a flexible instrument in the hand of God is a great and sometimes terrible vocation. . . . We are all in some way instruments. And we all have to be virtuosos at taking a back seat when necessary. Way back. The prayer life of a flexible instrument cannot be well ordered. It has to be terribly free. And utterly responsive to a darkly, dimly understood command.[62]

October, 1968. You have to see your will and God's will dualistically for a long time. You have to experience duality for a long time until you see it's not there. In this respect I am a Hindu. Ramakrishna has the solution. Don't consider dualistic prayer on a lower level. The lower is higher. There are no levels. Any moment you can break through to the underlying unity which is God's gift in Christ. In the end, Praise praises. Thanksgiving gives thanks. Jesus prays. Openness is all.[63]

Thomas Merton Center 487. Untitled.
(image size: 10" h x 8½" w)

29

A *deep wisdom and* admiratio

Sometimes it is given to children and to simple people (and the "intellectual" may indeed be an essentially simple person, contrary to all the myths . . .) to experience a direct intuition of being. Such an intuition is simply an immediate grasp of one's own inexplicable personal reality in one's own incommunicable act of existing! One who has experienced the baffling, humbling, and liberating clarity of this immediate sense of what it means to *be* has in that very act experienced something of the presence of God.[64]

September 27, 1964. Underneath all the apparent ambiguities of Buddhism about suffering (they do in some cases seek to avoid it) there is actually a deep wisdom and *admiratio* at the mystery of truth and love which is attained only when suffering is fully accepted and faced. I think that the reality of Buddhism is missed when this deeply delicate *admiratio* and wonder is missed at the heart of it. It is also amazingly humorous. In this I think that what one encounters is what Pope John spoke of: the remnant of the "primitive revelation." And this remnant can be detected really by one note beyond all others, I think precisely its sapiential beauty and wonder, as when Buddha held up a flower and smiled, and his disciple understood the whole thing.[65]

Thomas Merton Center 726. Untitled.
(image size: 8 ½" h x 9 ¾" w)

30

Le point vierge

Again, that expression, *le point vierge,* (I cannot translate it) comes in here. At the center of our being is a point of nothingness which is untouched by sin and by illusion, a point of pure truth, a point or spark which belongs entirely to God, which is never at our disposal, from which God disposes of our lives, which is inaccessible to the fantasies of our own mind or the brutalities of our own will. This little point of nothingness and of *absolute poverty* is the pure glory of God in us. It is so to speak His name written in us, as our poverty, as our indigence, as our dependence, as our sonship. It is like a pure diamond, blazing with the invisible light of heaven. It is in everybody, and if we could see it we would see these billions of points of light coming together in the face and blaze of a sun that would make all the darkness and cruelty of life vanish completely. . . . I have no program for this seeing. It is only given. But the gate of heaven is everywhere.[66]

Thomas Merton Center 475. Untitled.
(image size: 4¾" h x 6½" w)

Everybody will come to their senses

December 20, 1962. They cannot silence either Chuang Tzu or this Child,
in China or anywhere. They will be heard in the middle of the night saying
nothing and everybody will come to their senses.[67]

Thomas Merton Center 697. Untitled.
(image size: 6" h x 7½" w)

32

The same hills as always, but now catching the light

May 21, 1963. Marvelous vision of the hills at 7:45 A.M. The same hills as always, as in the afternoon, but now catching the light in a totally new way, at once very earthly and very ethereal, with delicate cups of shadow and dark ripples and crinkles where I had never seen them, and the whole slightly veiled in mist so that it seemed to be a tropical shore, a new discovered continent. And a voice in me seemed to be crying, "Look! Look!" For these are the discoveries, and it is for this that I am high on the mast of my ship (have always been) and I know that we are on the right course, for all around is the sea of paradise.[68]

February 13, 1968. Two [crows] sat high in an oak beyond my gate as I walked on the brow of the hill at sunrise saying the Little Hours. They listened without protest to my singing of the antiphons. We are part of a ménage, a liturgy, a fellowship of sorts.[69]

Thomas Merton Center 665. Untitled.
(image size: 6" h x 8" w)

33

That is what it means to be a Christian

March 25, 1960. In emptying Himself to come into the world, God has not simply kept in reserve, in a safe place, His reality and manifested a kind of shadow or symbol of Himself. He has emptied Himself and is *all* in Christ. . . . Christ is not simply the tip of the little finger of the Godhead, moving in the world, easily withdrawn, never threatened, never really risking anything. God has acted and given Himself totally, without division, in the Incarnation. He has become not only one of us but even our very selves.[70]

That is what it means to be a Christian: not simply one who believes certain reports about Christ, but one who lives in *a conscious confrontation with Christ* in himself and in other men. This means, therefore, the choice to become empty of one's self, the illusory self fabricated by our desires and fears, the self that is here now and will cease being here if this or that happens.[71]

March 29, 1968. Christ not as object of seeing or study, but Christ as center in whom and by whom one is illuminated.[72]

Thomas Merton Center 813. Untitled.
(image size: 6⅛" h x 4¼" w)

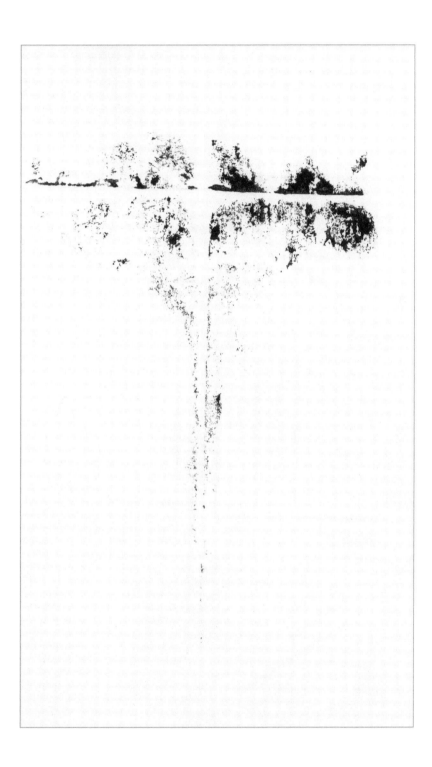

34

The fruit of that place

The Christian is, I believe, one who sacrifices the half truth for the sake of the whole truth, who abandons an incomplete and imperfect concept of life for a life that is integral, unified, and structurally perfect. Yet his entrance into such a life is not the end of the journey, but only the beginning. A long journey must follow: an anguished and sometimes perilous exploration. Of all Christians the monk is, or at least should be, the most professional of such explorers. His journey takes him through deserts and paradises for which no maps exist. He lives in strange areas of solitude, of emptiness, of joy, of perplexity and of admiration.[73]

One of the elders said: If a man settles in a certain place and does not bring forth the fruit of that place, the place itself casts him out, as one who has not borne its fruit.[74]

Thomas Merton Center 560. Untitled.
(image size: 6½" h x 6½" w)

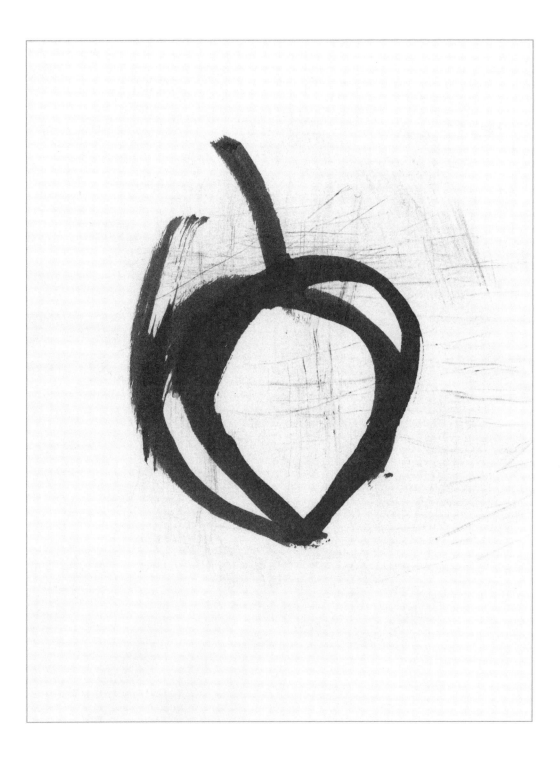

Three Studies

The long essay that opens this book encounters certain issues, people, and events of importance to Merton's work as a visual artist but, in the interest of a balanced narrative, doesn't stop at length to explore them. The studies that follow return to those topics.

Friends

> How good it has been to have seen His play in the friend-
> ships and influences that brought us all together in this
> world and this century.
>
> —Merton in a letter to Jacques Maritain,
> June 11, 1963[1]

Was it Merton's view, or is it just my own netted over him, that to live well is to live among friends? Though he was geographically remote from many of his friends, his correspondence must be one of the largest in sheer number and most searching in content among twentieth-century writers. Even at the hermitage he received no end of visitors—too many, he would periodically complain, but gains from the meetings exceeded losses. Apart from quiet meetings recorded only in Merton's journals, the photo archive from the hermitage years shows a fair number of picnics, with friends from near and far enjoying a Kentucky afternoon as blurry children race past. The journals also reflect small gatherings for lunch in Louisville, casual in form yet exercises in contact and conversation that often left large traces in all concerned. Against the sustained background of his chosen solitude—which was sometimes a struggle, sometimes a joy, sometimes plain—Merton in the 1960s nonetheless lived among friends. Writing in 1968 to Czeslaw Milosz, the Polish writer (and later Nobel laureate) who had recently accepted a post at the University of California, Berkeley, Merton assured him that a letter had not, as Milosz

feared, been wounding: "You are part of my 'Church' of friends who are in many ways more important to me than the institution."[2]

Friends crucial to the development of Merton's art in the 1960s can be mapped in a simple but helpful way:

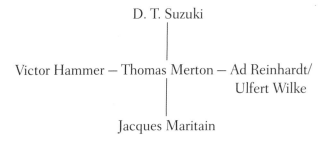

D. T. Suzuki

Victor Hammer — Thomas Merton — Ad Reinhardt/
Ulfert Wilke

Jacques Maritain

It is a map not just of names but of tensions and resolutions. The most astonishing and luminous resolution was along the vertical axis, between D. T. Suzuki as Merton's principal teacher of Zen Buddhism and Jacques Maritain (1882–1973), perhaps Merton's most eminent Catholic friend, a highly respected author on religious philosophy, the arts, and social issues. To the best of my knowledge, Suzuki and Maritain never met, but they met in Merton and found in him a profound

and creative reception. The tension between Victor Hammer and Ad Reinhardt, on the other hand, was beyond resolution—it simply had to be lived with suitable grace and separate appreciation for what each person was. Victor Hammer (1882–1967) was a painter, printmaker, and handpress printer and type designer long in Lexington, Kentucky, although he was born and educated in Vienna and in earlier years had created a fine press in Florence. A proud anachronism, he embodied Old World values of craftsmanship, quality, and broad culture in the arts and literature. He brought to Kentucky—and there it remains to this day in certain small presses—much of the view of craftsmanship and life that guided the founding of the Bauhaus in Weimar, Germany, just after World War I. As we shall see, he was fiercely dismissive of the innovations of twentieth-century art. Ad Reinhardt, whom we have come to know in earlier pages, was no less sober and rigorous in his approach to art, but fully an artist of his time. Both Hammer and Reinhardt were Merton's close friends. The two never met, though Hammer would have liked a "high noon" encounter with Reinhardt. "I am very sorry we missed your friends Lax and Reinhardt," he wrote to Merton in spring 1959.

> I would have liked to talk to Reinhardt as I am still unable to see anything in abstract art or understand it. These triangles, squares, dashes, and moving lines ought to *underlie* a work of art (as it is the case in all classic art), they ought to be hidden and *not to be shown*. They are the hard core, the skeleton of a work of art. If we were insects with the hard crust outside, abstract art would be appropriate. To me abstract art is pure perversion. Reinhardt may be sincere, but as an abstractionist he is a sinner against the Holy Ghost.[3]

It is almost certainly no accident that Merton omitted during that particular visit to invite Victor Hammer and his wife, Carolyn, to tea.

Ulfert Wilke (1907–1987), sent by Reinhardt to look in on Merton's art activity and perhaps lend a hand, is somewhat familiar from earlier pages. An enabler at just the right moment in Merton's development, he was a skilled artist of deep culture and wide friendships in the art world, who provided companionship, encouragement, and technical pointers and beyond that gave Merton a whiff of the avant-garde.

Other friends nourished Merton's explorations of art: John Howard Griffin, Ralph Eugene Meatyard, and Shirley Burden, all of whom encouraged Merton's photography and some of whom supplied equipment and materials (Griffin developed and printed Merton's negatives); Edward Rice, a Columbia classmate, editor, photographer, and early biographer of Merton; and Robert Lax (1915–2000). Lax was almost always distant geographically—from 1962 he lived on the island of Patmos as a hermit and unpublicized sage—but he was probably closest in spirit among all the friends, and ironically a more apt, natural hermit than Merton. Lax does not seem to have played a central role in the development of Merton's art in the 1960s, but when he received drawings from Merton, his letters of encouragement in response must have meant a great deal. "Now as to the calligraphies," Lax wrote in March 1964,

> Wow! . . . i am like all the calligraphies, all, all, and especially the one with my name on it: it is some calligraphy: zaup! do not stand in your own way when it comes to making calligraphies: do thousands; they are all great calligraphies.[4]

This was their language together: hugely inventive, maniacally inventive at times, and Reinhardt the artist

could go at it nearly as well as the two writers. There was a narrow circuit or racetrack among these three: Merton, Reinhardt, and Lax. By correspondence, one tended to know what the other was doing, and even when there were no letters for a time, they seemed to keep one another in mind. Biographers will surely wrestle with the uncanny parallels among these undergraduate classmates as they pursued their lives: Merton the formally dedicated monk and hermit, Reinhardt the Black Monk of contemporary art, and Lax the recluse on St. John's island of Patmos.

When Lax and Reinhardt were planning their spring 1959 trip together to Gethsemani, Lax's description of Reinhardt in a letter to Merton is uniquely affectionate and admiring:

> At the mention of any sacred thing he becomes entirely illuminated, and at whatsoever worldly, dims. he had thought of coming to see you (around the 26th of june) and wondered (eagerly) if there would be much flagellation. . . . reinhardt's latest painting (dark brown on dark blue) is a cross, a greek one, unimaginably beau.[5]

After their visit, Merton wrote to yet another friend, Sister Thérèse Lentfoehr, that they had had "a good talk. It was a pleasure for which I thank God."[6] Reinhardt, on his side, sent off a superb thank-you note to Merton:

> Good to see you and you look great. I expected you to look old, sick, holier. . . . I expected more caves, more eleventh and twelfth century stones and places, more seductively "contemplative" niches. Your Romanesque garments and singing were not disappointing in any way. . . . I wrote to Ulfert Wilke, art dept., University

of Louisville, who spent a couple of months in a Zen Buddhist temple and study center in Kyoto, where I found him last summer and made a tourist out of him for a couple days. He was "ink painting" like any eccentric monk, and not seeing any sights. . . . I told him to invite you to his next Kentucky cocktail party or university tea, probably around Derby time. . . . Let's argue about art and religion some more. If you're doing a book on it, and you have a world-wide audience, can I help you say what's right, instead of saying things people want to hear and agree with? You just make people happy if you don't say what's right, true (beautiful?). . . . Thanks for the weekend.[7]

Reinhardt's reference to an art book concerns *Art and Worship,* the failed manuscript discussed in earlier pages. The overall attitude—funny, disputatious, in love with truth—is pure Reinhardt.

It is proving difficult to disentangle these friends long enough to look at any one of them separately. We can know something more of the texture of Merton's experience as an artist through his freewheeling commentaries in letters to Lax and Reinhardt. For example, at the time Merton was first placing his calligraphic drawings in literary journals, at the end of 1963, he reported to Lax in their carefree style: *"El Corno Emplumado* [is] printing seven calligraphies of mine one on top of the other just like they should be, in a series. This is very fine, because you can generally whistle yourself silly before you can find someone to print your calligraphies in a *series*."[8] The following week, Merton wrote again and promised to send some drawings Lax's way: "Pretty soon there will be a blizzard of calligraphies. Ad says all calligraphies have to be large but in that case I am the father of the small calligraphy, and

the father of the microscopic calligraphy."[9] This letter takes us back, in turn, to Merton's exchanges with Reinhardt, who had mocked him not long before for making such small calligraphy. To which Merton responded that some large, fine sheets of paper, received from Reinhardt's endless stock, would be a strong first step in that direction. "Always small calligraphies down here," Merton wrote to Reinhardt,

> I am the grandfather of the small calligraphy because I don't have a big brush and because I no longer run about the temple barefoot in the frosts. But I am amiable and the smaller they get the more mysterious they are, though in fact it is the irony of art when a calligrapher gets stuck with a whole pile of papers the same size and texture, why don't friends from New York who received all kinds of expensive samples of paper send me samples of exotic and costly materials I invite you to pretend you are about to print a most exotic book and get samples of papers from distant Cathay and all over and then send them to your dusty old correspondent who is very poor and got no papers any more except toilet papers for the calligraphy.[10]

Reinhardt didn't miss his cue. Within a few months, Merton could record in his journal that "Ad Reinhardt has sent all kinds of fine paper, especially some thin—almost transparent—Japanese sheets on which I have found a way of crudely printing abstract calligraphies which in some cases turn out exciting, at least to me."[11]

Merton's earlier mention to Lax of a "blizzard of calligraphies" points to a theme as evident in his journals as in his correspondence with the oldest of friends. Merton's bursts of work as a calligraphic artist seem to have left him of two minds: pleased to be so productive, yet sometimes appalled by his work style. In earlier pages we have heard him tell Lax that "with calligraphies it is always a great storm of creative action and the calligraphies pile ten miles high and I am buried and smother under the dam calligraphies there is so much action and creation"[12]—words that include a self-mocking reference to Action Painting. But he is basically pleased. On the other hand, some months later he recorded in his journal an incident that he took as a warning to be wiser:

> This afternoon I made myself a cup of coffee (after dinner) strong enough to blow the roof off the hermitage, and then as a result got into an orgy of abstract drawings. Most of the drawings were awful—some were even disturbing. So that now I see that I cannot afford to play with this either, in solitude. But perhaps I will do some careful and sane drawings, based perhaps on Romanesque sculpture, until I get some better ideas.[13]

We know nearly enough now of Reinhardt and Lax as Merton's friends, making with him a dispersed but potent troika. Reinhardt predeceased Merton; Lax lived to the year 2000 and even in old age was a marvelous source of reflection about Merton. In letters of mourning written in their coded language but with undisguised grief, Merton and Lax shared the misery of Reinhardt's untimely death in 1967. "Do you know the great sorrows?" Merton asked his friend.

> Just heard today. . . . Reinhardt he daid. Reinhardt done in. He die. Last Wednesday he die with the sorrows in the studio. Just said he died in a black picture he daid. . . . The sorrows is true, the surmises is no evade. It is too true the

sorrows. Reinhardt he dead. . . . Tomorrow the solemns. The requiems alone in the hermit hatch. Sorrows for Ad in the oblation quiet peace request rest. . . . Just old black quiet requiems in hermit hatch with decent sorrows good bye college chum.[14]

Merton's more public memorial to Reinhardt was to publish in the first issue of his literary magazine, *Monks Pond* (spring 1968), and as its first article, a chantlike text by Reinhardt, dating to 1962. Merton's regard for this text, which has something of the rhythm of Buddhist liturgy, measures the distance he had traveled as an artist in the course of the 1960s. The text, of which the following is only one *shloka* (one verse—the Indian term forces its way in), captures the unforgettable sound of Reinhardt, telling what he knew of art:

> The one object of fifty years of abstract art is to present art-as-art and as nothing else, to make it into the one thing it is only, separating and defining it more and more, making it purer and emptier, more absolute and more exclusive—non-objective, non-representational, non-figurative, non-imagist, non-expressionist, non-subjective. The only and one way to say what abstract art or art-as-art is, is to say what it is not.[15]

Ulfert Wilke

Born in Germany in 1907, a refugee from Nazi Germany and a U.S. citizen since 1943, Ulfert Wilke was an artist of skill and elegance at the time he first met Thomas Merton in September 1963.[16] As a young man Wilke received a thorough education in art, both in his native Germany and in Paris, and his circle of friends after the Second World War (when he served in the U.S. Army) included artists in the United States and overseas who created some of the most influential works of twentieth-century art: Ad Reinhardt, Lyonel Feininger, Mark Tobey, Mark Rothko, Robert Motherwell, Julius Bissier, and still others. In 1948, Wilke joined the art department of the University of Louisville, and he retained that post until 1962. Unquestionably aware of Gethsemani soon after his arrival in Louisville, he recorded in his journal for 1950 two pages of sketches of the monks of Gethsemani, no doubt just after a first visit to the monastery. There is no sign of Merton in the sketches or written entry. Wilke's verbal comments focus on monastic styles of clothing (intriguing) and monastic discipline (off-putting). But intrigue must have prevailed over upset: the Thomas Merton Center has a record of works in ink and gouache, dated 1950, entitled "Trappists Converse," presumably exploring the shapes of Cistercian sign language, which was still in use at that time. There is no evidence that Wilke met Merton until much later.

Taking a leave of absence from the university in 1958 to study and work as an artist in Japan, Wilke refined his approach to brush-drawn calligraphy and explored Zen and Japanese culture. We have already heard Reinhardt boast to Merton about meeting Wilke in Kyoto and extracting him from the constraints of temple-bound practice to air him out by visiting the sights. Thereafter, Wilke moved on. In 1958–1959, benefiting from successive Guggenheim fellowships, he renewed his European roots by working in studios in Rome and Munich. But he still had Louisville on his mind, and even when he joined the faculty of Rutgers, in New Jersey, in the years 1962–1968, he would periodically return to a home and studio in Louisville. A collector by nature, throughout these years he amassed on a shoestring—but he seemed to have shoestring after

shoestring—an exquisitely thoughtful private collection of world art of many periods.[17] On the strength of his breadth of experience, creative talent, and collector's knowledge of the art market, in 1968 he was offered the position of museum director at the University of Iowa, where he flourished. A somewhat overlooked member of the abstract expressionist school, Wilke deserves reappraisal; his art was strong. The man who came to meet Merton in September 1963 was a familiar, accepted participant in the most sophisticated art circles of the United States and Europe. Merton encountered in Wilke a mature contemporary view and practice of art, enriched by study in Japan.

Like Merton a journal keeper, Wilke recorded their first meeting in an entry dated September 6, 1963:

> I visited Gethsemani and Thomas Merton, who is a friend of Ad Reinhardt's. Ad had suggested my seeing him. I brought him my book *One, Two and More.* . . . He looked a bit pale but not emaciated as one assumes somebody given to *Askese* might look. He was natural, frank and candid and we spoke very freely. He mentioned when I asked him about his travels as a child, the constant travels, that he wished he had even traveled more, and he mentioned Greece which he wished to have seen. He can go to Louisville but under the present Abbot he will not get permission to even visit New York. He doesn't put up with the "nonsense" of the church and says he is clear of that. And he refers to dogma and hairsplitting evaluations of being right, which he abhors. He guided me through the basement of the church and whenever he met some of the novices who are his students there was a ray of love meeting their eyes. "Well wishing can't breed but the same," I thought. I was talkative and he very generous. He showed me some of his own calligraphies and I could help him with [them] by indicating continuity by not refilling [his brush]. He spoke of having written about "sacred art" and that Ad had not liked what he wrote. Later he showed some Russian icons to illustrate his thoughts.[18]

There is a second entry in Wilke's journal for the day immediately following:

> A full day. Thomas Merton and Jim Wygal were sitting outside the library and we went for lunch to Cunningham's. Father Louis as he is called ate a hearty meal. Sardines fish lunch, a "planter's punch" for his entertainment. He is without the masochistic urge to chastise himself and enjoys the full meal. When Jim asked me whether I wished a drink, I said I would better wait with a drink til the evening. Father Louis pointed to his "planter's punch," said he would not have a chance for a drink in the evening so he took one now. We continued speaking about the conservative elements ruling the church and sticklers about dogma. He mentioned having read in a book a scribble made by someone saying that "no Protestant could ever go to heaven." . . . I mentioned [an] unimaginative image of the Virgin, just the Virgin surrounded by flowers. "That's only a sign to tell you that you are at the right place; that's just like a hamburger telling you there is a place to eat!"[19]

Some ten months passed until their next meeting. Wilke wrote in July 1964 that he was working nearby for the summer and would welcome another meeting. His offer fell providentially well for Merton, who, as

we know, would soon be preparing the first public exhibition of his art at Catherine Spalding College in Louisville. Sister Mary Charlotte, responsible for the Spalding art department, had caught wind of Merton's creative activity and wrote in late August to ask whether he would care to exhibit his work.[20] While there is no direct evidence that Wilke dropped a hint to Sister Mary Charlotte, unlike the cloistered Merton he moved freely in Louisville art circles and may well have made the connection. If this is so, Wilke was Merton's second godfather in art, Reinhardt the first.

It is difficult to sort out paternities here. In his letter accepting her invitation, Merton willingly acknowledged to Sister Mary Charlotte that the drawings he planned to exhibit resembled Wilke's art at a somewhat earlier stage—in fact, at the stage Merton could revisit whenever he wished in the portfolio-style publication *One, Two and More,* which Wilke had given him at their first meeting. The very beautiful Merton print of 1964, *Emblem* (here portfolio 21), recalls a similar work in Wilke's publication (fig. 17).[21] On the other hand, Merton had not waited for Wilke to reach a level of substantial skill and sophistication as a visual artist. He had been meditating on the art of the Zen priest Sengai for some years; he had come to appreciate abstract expressionism and enjoyed the counsel and friendship of Ad Reinhardt; and he had been working new terrain in his own art since late 1960. But there is no reason to sort out influences too carefully. Both Wilke and Reinhardt offered much to the birth of Thomas Merton as a visual artist.

When they met again in the summer of 1964, Wilke proved to be generously helpful. He sent a note to a prominent museum director, James J. Sweeney, to interest him in Merton's drawings. He advised Merton on framing the drawings for the Spalding exhibition, but beyond that seems to have made himself available

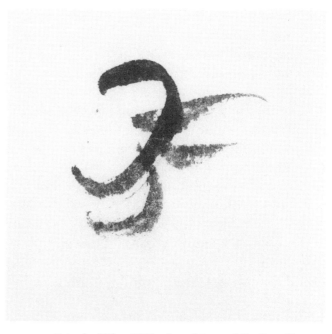

FIG. 17 Print by Ulfert Wilke; from his portfolio *One, Two, and More,* 1960.

when and as needed. "Ulfert Wilke was out the other day," Merton recorded in his journal, "and discussed some of the abstract drawings I have been doing; we talked about ways of mounting and framing them. I want to see his new paintings."[22] And soon he did see them. A journal entry for August 29 records his visit to Wilke's studio:

This afternoon—worked on abstract calligraphies—perhaps too many. Some seemed good. I took a batch to the Frame House on Thursday with Ulfert Wilke, who was a big help in showing how they should be framed. Afterward we had lunch and went out to his studio in Pee Wee Valley, in a garage next to a gambling club. Some fascinatingly calm, large abstractions which I

cannot describe. A calligraphic economy of points and small white figures on large black or maroon background (some lively red and yellow ones but the somber were more serious and profound).[23]

Wilke shared with Merton some fine paper he had on hand in the studio and gave him hints about pulling prints cleanly with the use of that paper. But perhaps the most important kindness offered by Wilke was simply the encouragement, advice, and companionship of a serious artist at a time when Merton was still finding his way with native confidence and some uncertainty. When Merton brought the framed drawings to the exhibition space in the fall, his journal entry again reflects Wilke's generosity:

> I went to Catherine Spalding College with the twenty-six abstract drawings of mine that are to be exhibited there in November. They are well framed, thanks to Ulfert Wilke's advice. They look pretty good, at least to me. I gave them names and prices not without guilt feelings. (Am I perpetuating a hoax?) But the drawings themselves, I think, are very good with or without names and prices. Wilke says, "They are real."[24]

These words, obviously much appreciated, live in a different world than the medieval philosophy of art from which Merton had tried in earlier years to construct an approach to contemporary art. *Id quod visum placet*—beauty is "that which pleases when seen," Maritain's influential rephrasing of St. Thomas Aquinas —is worlds distant from Wilke's simple and gratifying acknowledgment: "They are real." In the little Merton later wrote about his art, his language would be light, paradoxical, and richly evocative. And this too owed

something to Wilke, who had written as follows in his introduction to the portfolio of prints on Merton's shelf: "The drawings in [this] portfolio are unknown symbols. Painted with Far Eastern brushes and inks, they were printed in Japan, by Japanese hands and on their paper, but should one of the symbols have a known meaning, its reading must change and result at best in a 'grace,' an unintended gift. . . . [The drawings] are your melodies—not mine." Merton might have written much of this.

When the exhibition closed and moved on to Catholic colleges in other cities, Merton sent a note to Sister Mary Charlotte at Spalding: "I would like, by the way, to send one of the unsold drawings to Ulfert Wilke."[25] Wilke must have taken the drawing with him, as he soon departed for the University of Iowa. There is just one further recorded communication between Merton and Wilke, in early 1965, when Wilke wrote from New York that he was about to take a workshop with a master Japanese calligrapher and hoped to be able to share with Merton any insights gained. That does not appear to have taken place, and the two lost touch with one another. Wilke went on to a distinguished career at the University of Iowa Museum of Art, where the exhibitions and catalogs he sponsored were models of what a regional museum can accomplish. His work is represented in major collections both in the United States and abroad, including the Guggenheim and Whitney museums and the Hannover Museum (Germany).

Ulfert Wilke entered into and departed from Thomas Merton's life as a messenger from worlds physically remote from Gethsemani but spiritually within reach: the world of Zen and the worlds of American and European art in that great era when Reinhardt, Rothko, Tobey, and others of enduring accomplishment were still working.

Victor Hammer

There is a certain way to be an artist, now nearly lost, though I think always preserved and valued somewhere, even if not in plain sight. Its foundation is in craft tradition. Artists of this kind revere manual dexterity, technical processes, recipes passed down through generations of studio work. Typically, they have apprenticed with an expert in their field, and, circumstances permitting, they in turn provide apprenticeships. They are filled with memories and do their remembering as a kind of prayer, a request for the continued excellence of their own work. They honor the great artist-craftsmen of the past, gratefully view themselves as part of a succession, and preserve established styles and techniques in their own work. They may be sparing of words or outgoing, but in both cases they know their tradition cold. They innovate—within boundaries of proven style, taste, order, and need. If, despite their dedication to tradition, their work is recognizably of their own time, they may not quite know that this is so or prefer to leave the topic untouched.

Victor Hammer was an artist-craftsman of this kind. He and his wife and co-worker, Carolyn, were fast friends of Merton's from the mid-1950s (fig. 18). At their home and studio in Lexington, Kentucky, Merton found an atmosphere and conversations available nowhere else. The Hammers, in turn, were among his most frequent visitors at the abbey and later in the hermitage. Merton spoke of those visits in the kindest terms: "[Victor's] visits were always something reassuring, stabilizing—because of his intelligence and European culture. All the things we could talk about—from cave art to Pavese, from Austrian rococo to Berenson. I never felt distracted and restless after one of his visits with Carolyn here: we belonged together."[26]

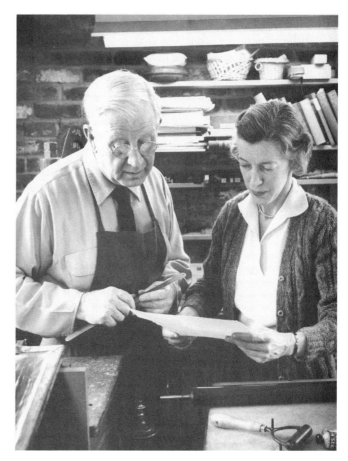

FIG. 18 Victor and Carolyn Hammer at the Stamperia del Santuccio in Lexington, Kentucky, ca. 1960.

We need some biographical facts to know who it was that Merton so cared for.[27] Born in Vienna in 1882, Victor liked to boast—gently—that he had played as a child in front of University Hall, where Beethoven's Seventh Symphony was first performed. Made for the arts, he enrolled at the Vienna Academy of Fine Arts in 1898, and by 1910 was earning his living as a portrait painter. In 1913 he joined the famed Vienna Secession, an art movement that had been furiously innovative at

the height of its energies some years earlier, but I suspect he joined without much conviction—his own art was quite different, classical and restrained. Serving in the war both in combat and as a war artist, he returned to Vienna in 1917 to study architecture for a time and resumed earning his living through portraiture. He was by now a master draftsman, capable of finely descriptive portraits and of extraordinarily sensitive use of simple tools such as the graphite pencil. On the other hand, his printmaking technique tended toward the most difficult and demanding—for example, the mezzotint process, capable of rendering extremely nuanced detail. Somewhere along the way he fell in love with the fine craft of type design and printing, and in 1921 he took the first steps toward establishing a small press in Florence, where he felt at home. There he built a wooden press in 1927, and he produced his first book in 1930 under the imprint long associated with him, the Stamperia del Santuccio—a name he brought with him years later to Kentucky. While retaining his Viennese roots, he and his family spent many months each year in Florence in a home not far from the residence of Bernard Berenson, the art connoisseur and dealer, with whom he had good relations.

The Nazi annexation of Austria in 1938 marked the end of Victor's life in his native country and in Europe. Although in 1937 he had become a professor at the Vienna Academy where he had studied, soon after the Nazis' arrival he was not permitted to continue teaching. By 1939, he was in the United States and teaching at Wells College in Aurora, New York, where he is still warmly remembered. A decade later, he became artist-in-residence at Transylvania College, now a university, in Lexington. This was his niche in life for many years.

Victor Hammer was famous among book people. He was directly responsible for the Stamperia del Santuccio, reestablished in Lexington; indirectly respon-

sible for the Anvil Press, started by friends and guided by his book sense; and an inspiration for the King Library Press at the University of Kentucky in Lexington, founded by his wife and still extant today. Every press Hammer touched produced books, pamphlets, and so-called broadsides or single-sheet formats of various kinds at an awesome level of quality, often using typefaces he himself had designed and cut by hand, usually with decorative letters or illustrations from his hand. Editions were limited, prices were high, clientele was elite. Wallace Stevens, thought by many to be the greatest American poet of the twentieth century, purchased a copy of the 1950 Stamperia del Santuccio edition of poems by Friedrich Hölderlin (just fifty-one copies printed), and wrote to Victor after receiving the book:

. . . one gets out of such a book what the printer has put into it. Aside from the knowledge about the job that has gone into the job and about which I am not competent to speak, I feel the constancy of a man who in the exile at the bottom of his heart cries If I forget thee, Jerusalem— and then works for years at a task of this sort with all the cunning of his love.[28]

Such feedback is rare; it tells one who one is.

Hammer's typefaces remain commercially available, among other sources from the famed Linotype company, whose Web site in 2005 described Victor Hammer as "a printer, painter, graphic artist, architect, type designer, sculptor, teacher, and publisher."

We must explore just two further matters before looking at the lively links between this distinguished person and Thomas Merton: we should see something of Victor Hammer's art, and we need a clearer notion of his overall perspective on art. Toward the end of

1961, Merton was persuaded to sit for his portrait by Victor (fig. 19). "The patient, human work of sitting and talking and being understood on paper. How different from the camera!"[29] So Merton recorded in his journal. The drawing Victor made that day and its elaborate title give us Merton as the archetypal monk—neither young nor old, reflective, elsewhere. The panel painting, unfortunately lost in a fire, for which this drawing was a preliminary study could nearly have been created in sixteenth-century Germany: lines hardened, colors brightened, an emblem of monastic collectedness emerged from the gentle drawing.

Virtually all of Hammer's work conveys both his technical mastery and his lifelong preference for clarity. Especially in the paintings, there is a prevailing mood of sobriety, a kind of sternness not just in the characterization of his subjects but in the quality of line, which serves as a strict, slightly brittle boundary. Though Hammer has been compared, not unwisely, to Jean-Auguste-Dominique Ingres, the mid-nineteenth-century painter who endowed his subjects with a porcelain-like, hard clarity, ingeniously combined with a singing quality of line, he is actually much closer to some of his own German contemporaries who participated after World War I in the so-called *Neue Sachlichkeit* or New Objectivity movement—for example, the painter Christian Schad. Hammer was inevitably a man of his own time, however much he insisted that he was an anachronism. We all breathe the same air. "I am certainly not a revolutionary artist," he wrote in 1965, "rather I am a recluse who 'fits' into the role of an *artiste maudit,* unknown, an individualist, an anachronism if you will; I belong to no school, have not founded one, do not 'belong' to my time, my century, work only *ad maiorem dei gloriam.*"[30] On another occasion he wrote, "I do not go with the times, nor do I go against them, for this would mean that I consider ephemera

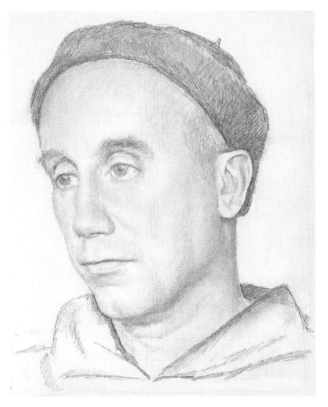

FIG. 19 *Thomas Merton (Father Louis, O.C.S.O.), Novice Master at the Abbey of Gethsemani, Trappist, Kentucky.* Study by Victor Hammer, 1961, for a lost panel painting.

worth refuting."[31] About the art all around him, he could hardly have been more contemptuous: "These 'doodlings' these 'scrawls' these meaningless blobs and patches and streaks. . . . Despair is manifest in them.— We should not be tempted to imitation; it may be unsafe/even dangerous."[32]

And yet he was a gentleman, and a gentle man. He played the lute, he built clavichords (a keyboard instrument retired in the late eighteenth century), he designed and printed some of the most beautiful books

one will ever see, he created typefaces that continue to be valued in the unsentimental commercial world, he set an example of attentive craftsmanship that still serves as an inspiration in the world of small presses—and he knew how to be a friend.

The bonds between Victor and Carolyn Hammer and Thomas Merton could not have been firmer. They delighted in working together; the celebrated writer and celebrated private press team knew how to draw on one another. Merton appreciated the opportunity to publish some of his shorter works beautifully and obscurely, in editions that would reach only a handful of people. "Nice printing," he commented in his journal at an early stage in their collaboration, "and no one inquiring about publicity or money or sales or anything. Doing something good for the sake of its own worth and therefore for the glory of God."[33] There are several limited-edition books and broadsides,[34] the earliest dating to 1958 and perhaps the most important published in 1960, an edition of Merton's much-appreciated prose-poem, "Hagia Sophia": "There is in all visible things an invisible fecundity, a dimmed light. . . ." Hagia Sophia, the female figure of Holy Wisdom (deriving from a passage in Proverbs 8 that Merton especially loved), was also the topic of coaching on Merton's part. Victor Hammer had painted her image without quite knowing who it was he was painting. During one of his visits to their home, Merton recognized her, so to speak, and later sent Victor a wonderfully searching letter about her place in religious thought. "I am sure Hagia Sophia herself was guiding you in the process, for it is she who guides all true artists, and without her they are nothing."[35]

The atmosphere among these excellent people had the steady magic of *agape*, of unconditional love. "Victor is more of a monk than anybody I know," Merton recorded in his journal,

because he is rooted in his own solitude, his integrity and his work which receives no publicity. And he does not rebel uselessly, he is content; yet maintains his true honor in simplicity. There's therefore in him a humility and honor together, a kind of monastic silence. Not a passive self-effacement but a quietness that speaks to anyone who can listen, for it is full of honest reality.[36]

For all the love among these people, one can't help noticing where the difficulty might lie. Merton had to talk himself into appreciating Victor's art, and, as we shall soon see, Victor lavished no effort whatever on talking himself into appreciating Merton's art. Unquestionably, Victor's art was created *ad maiorem dei gloriam,* for the greater glory of God. Unquestionably, there was no traditional method, no workshop secret in any of the many arts he had mastered that Victor wouldn't know and teach with clarity and love—one only had to ask. Nevertheless, there was something tight in his art that distanced Merton, though he never disclosed his feelings. In the spring of 1959, for example, Merton took note of the problem in his journal: "The Hammers came over and we had a lively conversation about his leaflet on art which, I realize, I had read too superficially. He demands to be met on completely classical grounds and I am unwilling to meet him there. But the fact is he is a very sane and humble person and his refusal to be carried away by contemporary fashions is in reality a mark of genuine and deep integrity."[37] Some months later, the same issue came up in another form. "Victor wants to print a dialogue on art between him and myself but I am not sure we would be talking about the same thing."[38]

These differences, hardly grave in 1959 when Merton had not yet found his art, could not help but

surface when Merton was preparing his first public exhibition in the fall of 1964. The potential problem caused him no little anxiety. "One thing saddens and embarrasses me," he confided to his journal,

> that [Victor] will be shocked at my exhibition of drawings or calligraphies or what you will. There is no way to explain this to him, and in a way I am on his side, on principle. And yet they have a meaning, and there is a reason for them: an unreasoned reason perhaps. I feel like writing to him and saying: if you heard I had taken a mistress you would be sad but you would understand. These drawings are perhaps worse than that. But regard them as a human folly. Allow me at least, like everyone else, at least one abominable vice, etc.[39]

A day earlier, he had actually written to Victor an equivocating sort of letter, through which he hoped to disarm his friend in advance: "If you should hear news," he had written,

> of my exhibiting strange blobs of ink in Louisville, ignore the information: it is not worthy of your notice. As always, my feelings about it are very mixed, but it was something that presented itself in such a way that I thought I could do it without harm to anyone. I think I have made plain to all concerned that I do not regard it as "art" and that they are not supposed to either.[40]

This was the best he could do: white lies and equivocation. Yet for a long while it seems to have solved the problem. There is no record of Victor or Carolyn visiting the exhibition, and Merton deliberately left their names off the guest list for a small private viewing of critics, the press, and special friends.[41] There is just one tart word from Victor, written well into 1966: "It is a mad world we live in and I am afraid you are not fully aware of it with the things you draw as an artist. Or are you?"[42]

Naturally, the Hammers asked Merton to contribute as a writer to a very exciting event and publication, a retrospective exhibition of Victor's art in April 1965 at the North Carolina Museum of Art, with accompanying catalog. Merton's foreword, the opening element in that richly informative catalog, is uncomfortable, a little awkward, although he clearly gave his all in terms of length and intricacy in the thoughts he shared. At one point he ventured onto the terrain where they could not meet:

> [T]hough [Victor Hammer] has devoted himself to making *explicit* the content of his paintings, I must confess that I still find more that is implicit and therefore mysterious, and in fact I think he is sometimes more enigmatic, at least to me, than much abstract painting.[43]

But as so often among true friends, they left the battle unfought.

Victor's final illness and death in July 1967 occasioned one of Merton's longest reflections about mortality and the basis—what is it, really?—for confidence that our lives have a metaphysical dimension, untouched by our physical fragility. "Death is shocking in anyone," he wrote in part in his journal,

> but most shocking in the case of someone of real genius and quality and someone you know and love well. The blunt fact is that it is just not conceivable that Victor Hammer should cease to exist. . . . Instead of facing the inscrutable

fact that the dead are no longer there, and that we don't *know* what happens to them, we affirm that they are there, somewhere, and we *know* . . . But we don't know, and our act of faith should be less facile; it should be rooted in our unknowing, not just a further construction of a kind of instinctive feeling for survival. Yet what is man that his life instinct should translate itself into a conviction that he cannot really altogether die? Where is it illusory and where not?[44]

Through their long relationship, Merton came in touch with the way of the artist-craftsman. Values he had encountered in the essays of Ananda K. Coomaraswamy, admired in the English artists Eric Gill and Peter Watts, and intuited in the infinitely layered sensibility of Paul Klee came to life and were part of his life through Victor Hammer. Alongside this were the taste and mind of Europe, left behind so long ago. Victor Hammer could not and did not directly support Merton's work as a visual artist. But his example and friendship were enough.

Daisetz T. Suzuki

"I sat with Suzuki on the sofa and we talked of all kinds of things to do with Zen and with life. . . . For once in a long time I felt as if I had spent a few moments with my own family. The only other person with whom I have felt so much at home in recent years is Victor Hammer, with his wife Carolyn."[45] So wrote Merton in the summer of 1964, after meeting D. T. Suzuki at Columbia University in New York (see fig. 5, p. 11). Because Suzuki has been a presence throughout this book, there is no need here for an extended discussion. The task that remains, a pleasant one, is to evoke something of the texture of their direct encounter and its aftermath.

Since the mid-1950s, Suzuki's writings had drawn and inspired Merton. Very largely in Suzuki's version, Zen Buddhism became the mirror of his Christian faith and practice. It showed him the goodness and depth of Christianity but also alternative principles and insights, and an alternative teaching/learning style preserved in the baskets of Chinese and Japanese writings. Suzuki's Zen teachings gave Merton a new way to think about the inner life, a new sacred history composed of the sayings and doings of the early Chinese masters, and new forms of practice. "Zen is not kerygma, but realization," Merton wrote toward the end of his life, "not revelation but consciousness, not news from the Father who sent his Son into this world, but awareness of the ontological ground of our own being here and now, right in the midst of this world."[46] And he went on to write that Zen and Christianity complement each other. That was overwhelmingly his experience. Merton's hunger to be real, to experience his inner and outer life vividly and without self-deception, needed the practice and perspectives of Zen.

> Buddhist meditation, but above all that of Zen, seeks not to *explain* but to *pay attention,* to *become aware,* to be mindful, in other words to develop a certain *kind of consciousness that is above and beyond deception* by verbal formulas. Deception in what? Deception in its grasp of itself as it really is. Deception due to diversion and distraction from what is right there—consciousness itself. (emphasis added by Merton)[47]

Released from the monastery with the permission and blessing of Dom James Fox, Merton traveled by air

for the second time in June 1964 and found himself again in New York City after an absence of some twenty-three years. He joined Dr. Suzuki and his secretary, Mihoko Okamura, at the simple apartment where Suzuki was staying.

> One had to meet this man in order to fully appreciate him. He seemed to me to embody all the indefinable qualities of the "Superior Man" of the ancient Asian, Taoist, Confucian, and Buddhist traditions. Or, rather in meeting him one seemed to meet that "True Man of No Title," that Chuang Tzu and the Zen Masters speak of. And of course this is the man one really wants to meet. Who else is there? In meeting Dr. Suzuki and drinking a cup of tea with him I felt I had met this one man. It was like finally arriving at one's own home.[48]

As Merton wrote to a friend in religion several months later, "Without contact with living examples, we soon get lost or give out."[49] Over the years, he had neither gotten lost nor given out, but his experience of monasticism had lacked a living example. It was this void, this unoccupied place, which Suzuki filled not through any deliberate action on his part but simply by the way he was and by virtue of the knowledge he had feelingly mastered. "He really understands what interior simplicity is all about and really lives it. This is the important thing," Merton reported in the same letter. As the next section of this exploration of friends will suggest, there was a second living example, endowed with another sort of wisdom and so close to Merton in the 1960s that he was not so much an example as a family member ahead on the path.

Merton was struck by Suzuki's regard for his writings on Zen. He sent to Robert Lax a burlesque account of the moment when Suzuki paid him a compliment:

> I was to visit Suzuki, yes Suzuki, you heard me right. I was to visit with him very old, but secretary young and spry make the tea ceremony and Suzuki with the ear trumpet propose many koans from a Chinese book and in the middle they gang up on me with winks and blinks and all kinds of friendly glances and assurances and they declare with one voice: "Who is the western writer who understand best the Zen IT IS YOU" they declare. You in this connection means me. It is I in person that they have elected to this slot and number of position to be one in the west. First west in Zen is now my food for thought.[50]

This, too, is Merton. He experienced in multiple ways. From his heart of hearts, he could write of his meeting with Suzuki: "I was speaking to someone who, in a tradition completely different from my own, had matured, had become complete, and had found his way. One cannot understand Buddhism until one meets it in this existential manner, in a person to whom it is alive."[51] And he could also tell Lax, privately and in fun, that he had been named the number one Zen in the West.

The encounter between Merton and the elderly sage focuses the concern that eventually prompted Merton's journey to Asia: the need for an authentic teacher. A talk that he gave to fellow monastics in Alaska, on his way to Asia in the fall of 1968, directly addressed the issue. Transcribed from tape and scarcely edited, the talk lacks the polish of his finished writings but its meaning is unmistakable. "We used to have in

monastic life a sort of guru-disciple relationship," he said,

> something like the idea of a spiritual father in the Desert tradition and in the Russian tradition, someone who knows intuitively how to bring out what is deepest in a person and, believe me, that is what we really need. But it is very hard. It is a charism. You have to have someone special who can do it, but really that is what we need.[52]

In the aftermath of the meeting in New York, there were exchanges. Merton dared to send Suzuki a calligraphic drawing (it would be good to recover it, but that is for another day), and Suzuki reciprocated by sending the calligraphic scroll discussed in earlier pages (fig. 7, p. 12). "Your calligraphy," Merton responded to the gift, "[is] a presence of great beauty and strength which I have given a place of honor in the hermitage. It transforms all around it."[53] There are records through 1965 that Merton received the annual Sengai calendar, produced under Suzuki's auspices and with his commentaries.[54] Merton published two books on Zen, in part collecting essays that had already seen the light of day in magazines and journals. And with the curious fatality that we have been following without quite noticing, Merton again had to write a memorial for the passing of a friend; this time for *The Eastern Buddhist* (2:1, 1967), a journal founded and edited in his lifetime by Suzuki and, in earlier years, by his American wife, Beatrice Lane Suzuki.[55]

There would have been no significant art from Merton without Suzuki's immense impact on him—or in any case a very different art. More important still, Merton would not have been the person he was in the 1960s without Suzuki as a source and friend. I wrote many pages ago that there would have been no art without the hermitage. These two themes, Zen and the hermitage, coincide in a passage from Merton's journal in 1966. Perhaps in those words is the sound needed to conclude this evocation of a friendship that keeps asking for more time, more remembrance:

> Beauty and *necessity* (for me) of solitary life—apparent in the sparks of truth, small, recurring flashes of a reality that is beyond doubt, momentarily appearing, leading me further on my way. Things that need no explanation and perhaps have none, but which say: "Here! This way!" And with final authority!
>
> It is for them that I will be held responsible. Nothing but immense gratitude! They cancel out all my mistakes, weaknesses, evasions, falsifications.
>
> They lead further and further in that direction that has been shown me, and to which I am called.[56]

Jacques Maritain

Words must not set a boundary around the boundless friendship of Thomas Merton and Jacques Maritain. Between these two men, from whom one would expect intensive religious dialogue, towering metaphysics, searching examinations of society, there was before all else a gathering warmth, strongest in the 1960s. The rest—rich thought, shared problem solving—was evident from the beginning, but that's not what one sees with the mind's eye when one looks at the whole. One sees or feels warmth.

In point of fact, they met just twice, in 1939 at an early stage of Merton's conversion,[57] and again in the

fall of 1966 when at Merton's invitation Maritain spent several days at Gethsemani (fig. 20). "Our journey is in common, though we are very much alone," Merton wrote in 1963 to his friend.[58] Little more than a year later, Maritain echoed those feelings as he planned a trip to the United States but knew that he could not join Merton in Kentucky: "How I will regret being unable to see you! But little by little one acquires the habit of the invisible, and to tell the truth I always have the feeling of being close to you."[59] Although they saw each other little, their exchange of letters and reading of one another's works filled the years so richly after they began to correspond in 1949 that one has the impression they were constantly in touch, as if neighbors in nearby towns.[60] As well, they were able to help one another in practical ways. Maritain used his formidable influence in the Catholic Church to persuade the censors of Merton's order to allow publication of *The Sign of Jonas* (1953)—they thought it too frank and disedifying. Had that battle not been won, Merton's writing in later years would surely have been different and harmed. On his side, Merton was one of few chosen, early readers of the journal of Jacques's late wife, Raïssa, and was trusted to advise on whether and how to make the journal, an intimate record of religious striving, available to a wider audience. Merton also provided an introduction in English to Raïssa's remarkable short book on the Lord's Prayer and, to Maritain's delight, he translated and published some of her poetry. By all these means and others he comforted Jacques in the years after the death of Raïssa Maritain (1883–1960), a misfortune that Jacques never put behind him, nor did he wish to, in the thirteen years that remained to him.

Jacques Maritain was a key intellectual and humanist in the twentieth-century Catholic Church. Loyal to his church but never blind to the human fail-

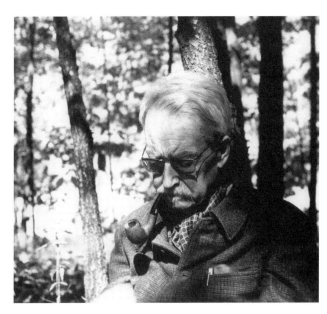

FIG. 20 Jacques Maritain at Gethsemani, October 7, 1966. Photograph by Thomas Merton.

ings of human institutions, he took from Catholic teaching its intrinsic dignity but gave in return an extraordinarily dignified, searching voice by which others, Catholic and non-Catholic, could know with certainty that the church was a community of seekers, of questioners, of men and women with doubts, fears, and hope. Teaching at a prestigious French Catholic institution until just after World War I and later creating with Raïssa a salon and seminars at their home near Paris, where some of the great writers and artists of the era were regular participants, Jacques took refuge with his wife in 1940 in the United States, where they came to feel so at home and welcome that he continued to teach periodically at Princeton University until 1960.

Together with another outstanding French scholar, Etienne Gilson (1884–1978), Maritain was responsible

for the enduringly fruitful revival and reinterpretation of the thought of St. Thomas Aquinas, known as Neo-Thomism. Maritain's book *Art and Scholasticism* (1920, with later revisions) not only remains in print but is now available in a digital edition, a sure sign of continuing use. On the basis of this book and few others—above all, the writings of Ananda K. Coomaraswamy—Merton formed the views on art that he felt called to rework but never wholly abandon at the beginning of the 1960s.

Maritain's scope as an author could not have been wider: there are works on the theory of knowledge and many phases of religious philosophy, studies of the just society and human rights, works coauthored with Raïssa on contemplative prayer and the inner dimensions of Christian life, works created under prestigious auspices (the A. W. Mellon Lectures at the National Gallery of Art, Washington, D.C.),[61] and works published in miniature editions, as if whispered to the world (*De la vie d'oraison,* an essay on the life of prayer, coauthored with his wife and published in 1933). And there were works in more than one sense. Asked by Charles de Gaulle at the end of World War II to accept the post of French ambassador to the Vatican, Maritain served with notable distinction. He also served on the committee that drafted the charter for UNESCO, to which he brought an astutely reasoned approach to reconciling religious and national differences. His negotiating strategy later influenced the process that led to the United Nations' Universal Declaration of Human Rights (1948).[62] Maritain's long years of work on the meticulous philosophy of St. Thomas Aquinas did not fix him in place; on the contrary, he seems to have learned breadth and flexibility.

That was true of his approach to art. Although the Neo-Thomist view of art can be embraced as a flaw-less doctrine and divider of sheep from goats, he didn't mean it to be taken that way and didn't practice anything of the sort. He was too sensitive to the warmth and movement of art, too aware of its challenges, too much a poet himself to allow rigidity. He and Raïssa had friends among French artists, particularly Marc Chagall. Their approach to art was in part an approach to artists. It remained alive. In his Mellon lectures of 1952, Maritain returned again and again to the notion of "creative intuition," a term that leaves the field open for surprises and much goodness.

Art and Scholasticism was Merton's master text on Christian art, but for a time in the late 1950s and very early 1960s—the period of his struggle to write *Art and Worship*—Merton allied its light and clarity with his own confusions.[63] That was an unhappy thing to do, and he got over it. But even in the summer of 1964, a high point for his practice as a calligraphic artist, he organized his talks on art for the novices around the text he called in his notes "A&S"—*Art and Scholasticism*. By then, he had come to the balanced, creative attitudes we have experienced and explored. One of many passages from Maritain he recorded in those notes has precisely the warmth and openness, the invitation to spontaneity, that he had come to value. Under the heading of "Art and Kairos"—art and the moment of great, life-giving insight—Merton transcribed: "In the end, all the rules having become connatural to him, the artist seemingly has no other rule than to espouse at each moment the living contour of a unique and dominating emotion that will never recur."[64] The word *connatural* is part of Thomist heritage; today we might say "second nature." But it couldn't be clearer that Merton was finding, now, in traditional Catholic thought the basis for freedom he had discovered through his exploration of Zen Buddhism.

Merton felt that Maritain was one of the voices that "sang him" into the Church, as he beautifully put it—not only Jacques but Raïssa also, and she more than he, perhaps owing to Merton's affinity for her dedication to contemplative prayer.[65] Who really was Maritain to Merton, as their relation developed? He was Merton's heart-abbot, one of two elders in religion to whom Merton offered unconditional regard. Maritain was also France. And he was the Church thinking and searching while retaining its sacred foundation in faith, prayer, Gospel, and the Holy Mass—the Church to which Merton deeply belonged. As their relation warmed through the 1950s and became a zone of trust and love in the 1960s, a dismissive observer might say that Maritain came to occupy the place of the lost father. But to narrow the relation in that way, as if he were only a "father figure," misses a great deal. It is true that Merton signed a letter of 1966, written just after Maritain's visit to Gethsemani, in words that leave no doubt of his feeling: *Avec toute mon affection filiale*— with all my filial affection.[66] Consider also that Merton addressed Dom James Fox, the abbot at Gethsemani through most of Merton's years there, as "Reverend Father." But Dom James was not his heart-abbot, not an *abba* or Desert Father whom he revered. That place in his inner life was occupied and fulfilled by Maritain, the Christian, and Suzuki, the Buddhist.

At some point Merton sent Maritain a copy of his 1964 essay on his art, and Maritain replied in September 1965: "I was very happy with the invaluable studies you had the goodness to send me, and read them with joy. I especially like the 'Notes by the Artist' . . . I'm delighted by what you say about the great freedom of Zen calligraphy; how I would like to see your drawings!"[67] There is no further preserved discussion between them about Merton's art, and no sign that Merton

showed his work to Maritain when he visited Gethsemani in 1966. Maritain's influence on Merton's art had occurred long before and stayed with him as an interior factor, a way of seeing and valuing.

Maritain was the heart-abbot, and he was also France. "I envy you in France!" Merton once wrote to Maritain. "Oh lovely France. Pray for me there."[68] Merton had spent a key part of his boyhood in France, and he was thoroughly fluent in French. To write in French from time to time, to Maritain, and to receive Maritain's letters in French must have been a homecoming. That Merton chose to join the Cistercian Order, founded in twelfth-century France by the man later known as St. Bernard of Clairvaux, renewed in seventeenth-century France by the redoubtable abbot Armand de Rancé, and established in central Kentucky in the mid-nineteenth century by French monks who built in a French style and worked the land like French peasants, was not a random choice. Though the austere life of the Cistercian Order in the 1940s, still medieval for all intents and purposes, appealed to Merton as a young monk, he also recovered France in Kentucky. That must have been a comfort, a familiarity.

By joining the Cistercian Order, Merton adopted Cistercian memory as his own. In a journal entry for Christmas Day, 1948, he toured that long memory:

> I wonder how Christmas was at Tintern in 1248, at Clairvaux in 1148, at Cîteaux in 1108? How was it at Bellevaux and Rosières and Châtillon, at Bonport, at all the places where there were saints: Villers, Heisterbach, Tamié, Bonnevaux, Poblet, Santes Creus, Heiligenthal, Ter Doest, Rievaulx, Fossanova.[69]

The names of the great Cistercian abbeys make an anthem across a map that extends from England through

France, Belgium, Spain, and Germany to Italy. Burgundy was the center, Gethsemani the far edge of the Cistercian world. Some years later, writing to Dom Jean Leclercq, a Benedictine friend of great and beneficent influence in the monastic world, Merton returned to his theme: "The forest here is very lonely and quiet," he wrote, "and covers about a thousand acres, and there is much woodland adjoining it. It is as wild as any country that would be found in the Ardennes or the Vosges, perhaps wilder."[70]

It is irresistible to enrich this collection of letters with a passage from 1967, in which Merton reveals himself as the guardian of certain memories:

> The area of Bardstown, Kentucky . . . was a refuge for French Catholics, hence the Trappists came here twice, both times seeking a hideout. Gethsemani is full of stories that will never be told because forgotten, of people who wandered here from France. They are all dead now, but I remember some. And let me remark in passing that this is Bourbon country and that Bourbon is the name of a French Royal House.[71]

Maritain's letters in French, warm and effortlessly intelligent, must each have been an event for Merton.

There is one further note to be discovered in this friendship: Merton's love for Raïssa. Although he never met Raïssa, he knew her published poetry and contemplative writings, and he knew the depth of Jacques's love and concern for her—she was never very healthy. It was as if Merton were a member of the household, a participant in the unity and religious aspiration that had signed that household for more than fifty years. Raïssa came to represent for Merton, more fully than any other woman, the feminine figure of Holy Wisdom, Hagia Sophia, who visited the best of his dreams

and entered the best of his poetry. He did not make a great fuss over this—he was well aware that Raïssa was real, not a symbol or an ideal. But after her death, Maritain found in Merton one who could share his grief at the level where it was felt, in darkness and pain, and share also his slow, judicious path toward publishing the heart of Raïssa's work, her journal. Merton turned with particular joy and attention to the challenge of translating some of her verse:

> Deeply forgetful of the evil by our side
> We sail above our strange agony
> Chained utterly Mary to your joy[72]

Maritain finally had the opportunity to visit Merton at Gethsemani in the fall of 1966. Merton had sent him what he might have heard as a call for help. "Jacques, there are moments when I feel a thousand years old, and so old that I cannot get excited about what the Church is doing. . . . I give up. I cut wood. The woods are marvelous."[73] But more likely Maritain just found it possible to make the long-awaited visit. He was feeling reasonably well despite the health problems of old age that now beset him, and a mutual friend, the photographer and author John Howard Griffin, facilitated the journey. In his superb biography of Merton, Michael Mott provides a short account of the visit. Maritain arrived on October 6, gave a talk to the monastic community, and on the morning of the seventh joined Merton with other friends at the hermitage. Photographs of the occasion (fig. 20 is one of them) attest to many of the details Mott captured:

> Merton insisted his guests should come up to the hermitage. Here he banked the fire with logs, led Jacques Maritain to the rocker before the fire, and wrapped Maritain's legs with a

blanket. Merton made coffee for everyone, a strain on the hermitage supply of cups and glasses. His attempt to get the others to agree that Bob Dylan was the American François Villon was not a great success, and Maritain obviously thought good time was being taken up listening to a record when they could have been talking. However, they enjoyed Merton's reading of his own poems.[74]

After the visit, Merton wrote a brief account to Robert Lax: "Also was here Maritain, very fine, very noble, back from the old days when there used to be people."[75] And on his side, Jacques wrote to Merton of "the pure atmosphere in your beloved hermitage, where I breathed *freely,* with a sort of joy unknown to me for a long time."[76]

It is time to assemble in full the passage from a letter of Merton to Maritain that has presided over this exploration of friends. These were the friends without whom Merton's art could not have been what it was: Reinhardt and Wilke, Victor and Carolyn Hammer, Suzuki and Maritain. A fragmentary passage from that letter opens this study, but readers unfamiliar with Jacques and Raïssa Maritain would not until now have grasped the force of Merton's words in the completed passage. Merton wrote:

I want to come after you and Raïssa by the road you have taken, since our journey is in common, though we are very much alone. How good it has been to have seen His play in the friendships and influences that brought us all together in this world and this century.[77]

Unlikely Peers

When nothing is securely possessed one is free to accept
any of the somethings. How many are there? They roll up at
your feet.

—John Cage in the mid-1950s

Questions. Did Merton have peers in a broader circle of artists of his time? Did his developed art draw on the work of artists other than those few already encountered? Did his art converge toward some center because he saw enough contemporary art journalism to know what was going on and experience its pull? Were there other forces at work, on the model of identical discoveries by scientists looking in the same direction although unaware of one another's work? Responses to these questions could shed new light.

At this point, we are not beginners. We know of Merton's fast friendship with Ad Reinhardt, and we have taken note of that influence both in his art and in his perspective on art. We know, as well, of Ulfert Wilke's timely intervention, and we have compared Wilke's calligraphic art to Merton's. We have found in Merton's approach to printmaking a practice of collage or assemblage drawn from mainstream twentieth-century art. We have also speculated about Merton's reading, his forays to public and university libraries in Louisville. Some of his reading is documented in his journal—for example, Coomaraswamy's essays, Klee's notebooks. From the same source we know what he was avid to see in New York museums when he visited

Suzuki: Klee, Miró, van Gogh, Rajput painting, Zen drawings. But we don't know and may never know whether he was aware of projects such as Mark di Suvero's impressive metal sculpture of the mid-1960s in St. Louis. Perhaps an influence passed across; perhaps Merton responded by experimenting with that sort of massive yet lyrical design; and, then again, perhaps not. Portfolio image 20 argues for some connection, but no confirming evidence bears it out.

The plot thickens considerably when we consider the work of prominent American artists, some of whom were friends of Ulfert Wilke's: Mark Tobey, Robert Motherwell, Philip Guston, Jackson Pollock. Mark Tobey (1890–1976) wrote a warm introduction to one of Wilke's finely printed portfolios[78] and they remained in touch for many years, but Wilke's closeness with Tobey may not be significant for our theme. I have seen no evidence that Merton looked at Tobey's work. And yet there is a relation. A participant in the Baha'i faith with a lifelong commitment to spirituality, Tobey had trained in Japan in the discipline of brush calligraphy. Several phases of his work could have impressed Merton, had he seen them. Tobey's "white writing," the fine, nearly evanescent calligraphic layer-

ing for which he is best known, would have been *congenial* in the root meaning of the word—sharing in the same "genius" or root sense of things. Similarly, Tobey's *sumi* ink works on paper from the 1950s could have struck Merton as belonging to much the same world as his own work.[79]

Merton once wrote, "The monk is a bird who flies very fast without knowing where he is going. And always arrives where he went, in peace, without knowing where he came from."[80] This leaves little hope of tidy documentation. In any event, the same undocumented generalities apply to some of the works on paper by Robert Motherwell (1915–1991). Had Merton seen them, he might well have found them congenial. For example, Motherwell's *Lyric Suite*, works in ink on rice paper from the mid-1960s, would have made sense to Merton; so too a slightly earlier series of drawings, *Beside the Sea.* A Motherwell series based on calligraphic marks and apparently initiated in 1967, *Samurai,* could easily have connected with Merton's love of primal emblems.

Much the same could be said of Philip Guston's lyrical abstract expressionist paintings of the mid-1950s, and of Pollock's classic drip paintings. To the best of my knowledge, Merton never mentions Philip Guston (1913–1980), yet he would have found in those durably beautiful works something to think about and value. Of Jackson Pollock (1912–1956) he wrote often enough, though never at length, and we have had reason to speculate about Pollock's symbolic role in Merton's initial revulsion against the art of his time. Pollock was occasionally a target, for example in a letter of late 1963 to Victor Hammer that is full of discomfort: the discomfort of addressing Victor about contemporary art, his own discomfort over being both attracted to abstract expressionism and wary of it. "After all, one has to be able to say," he wrote to Victor,

that abstract expressionism is *not* art, and I think that clarifies most of what needs to be said about it, both for and against. That is precisely what is "for" it: that it is not art, though it seems to be. I know this statement is scandalous, and I think the ambiguities are bad ones in the long run (it should not pretend to be art, which in fact it does). I do not think that throwing paint on canvas and saying "This is art" merits twenty thousand dollars. It is too obvious. However, even the obvious has its place.[81]

This is not his settled thought on the subject—we will soon come to that settled thought. Merton was right to note at this stage in his reflections that "the ambiguities are bad ones." The ambiguities are entirely his own.

How noticeable it is that most of the abstract expressionists were Merton's age peers. This art was his generation's work. And there is something more, far-fetched but worth considering: Merton's kinship, surely unknown to both parties, with the French writer and artist Henri Michaux (1899–1984). I'm thinking of Michaux's pen and ink drawings of the late 1950s and thereafter, which he called "Mescalines," created while under the influence of the psychoactive drug mescaline.[82] Merton had no trust whatever in drug-induced spiritual trips, and no experience. Keenly attuned to French literary culture, he might well have been aware of Henri Michaux as an author, but it's unlikely that he ever saw Michaux's "Mescalines." Yet those nervous calligraphic works, with their Tobey-like intensity of fine rhythmic line, bear some resemblance to Merton's most evanescent, immaterial images, such as portfolio images 29 and 30. I cannot interpret this resemblance, which is not so much a visual similarity as a kinship in sensibility. It is

as if two independent scientists, by different means, reached parallel findings about a subtle structure.

Perhaps enough has been said, though more could be added, to make the point that Merton's art was more deeply couched in the art of his time than we have so far noticed. He spoke as his generation spoke; he belonged to it. His attraction to Far Eastern calligraphic forms was not unusual. His comfort with abstraction was, obviously, not unusual. He made from the shared language of his time an art of his own. He used that language to support and further his search in religion—and in this respect he parted ways with his generational peers, for whom art and art making were, at least on the surface, secular activities. Yet many of them recognized in their art a spiritual dimension that could not be calculated or manipulated. It found its way in. Merton was acutely aware of this enigma. "The artist should preach nothing," he once wrote, "not even his own autonomy. His art should speak its own truth, and in so doing it will be in harmony with every other kind of truth—moral, metaphysical, and mystical."[83] What he writes here from the best of his understanding would have been clear in meaning and welcome to many in his generation of artists.

By the mid-1960s, Merton's view of contemporary art was far warmer and more accepting than he had conveyed to Victor Hammer in 1963. In the notes he took toward a midsummer 1964 seminar on art for the monastery's novices, there are two carefully composed and surprising passages, nearly a credo, addressing the art of his generation:

In spite of the fact that the majority of people have derided modern non-representative art, have attacked it, and have taken for granted that it was all a fraud, all complete nonsense, have been frightened, shocked, scandalized by it, this art has gone its own way and has established itself as one of the most important expressions of man's intellectual and spiritual life in the world today—it flourishes everywhere, not only in extremely sophisticated circles in Europe and North America, but also in Latin America, in former colonial countries, and in Soviet Russia, Poland, etc., where it is opposed and suppressed by the Communists. . . . It has thus become a *universal language of experience,* a common idiom of the spirit in which artists all over the world share in the development of new attitudes and new views of the world, even when they cannot speak each other's language. . . .

Man's religious condition, his predicament as a being no longer capable of understanding and accepting religion in familiar terms, also manifests itself in art It is necessary to deepen and fulfill the inner potentialities of our lives. Art is a deeply fulfilling immanent activity of the intellect which heightens the quality of our life and of all our vital experience. Therefore to be able to enjoy artistic experience is to have ways of deepening our capacity for other expe-rience, particularly religious. . . . Through an understanding of art, we can enter into communion with the world of our time on a deep and significant level and can therefore come to a knowledge of its needs and its problems. We can be more in communion with our own time. We have to be men of our time.[84]

We can move now onto surer ground to complete this exploration of unlikely peers. The least likely of all was

among the closest in fact: John Cage (1912–1992), the composer, author, artist, expert mushroom collector, *puer aeternus,* and wise old man. Again, I know of no mention of Cage in Merton's writings public or private, and Cage as a man of broad culture would have known of Merton and might well have read his books on Zen and much else, but they did not meet. Still, there is a nexus: Dr. Suzuki.

I will not seriously try here to encapsulate Cage's complex creative life—there were too many strands. But we should recall something of his happy turbulence. A composer associated with all things avantgarde in America in the 1930s and for the following five decades, he was rejected as a hopeless case by Arnold Schoenberg after two years of music study (he didn't mind). Over a long period of time he wrote music, infinitely avant-garde, for the Merce Cunningham dance troupe. He invented the "prepared piano" and wrote for the instrument (it was a piano with all kinds of things stuck into the strings to modify their sound). He probably created the very first "happening" while he was at Black Mountain College in the company of Buckminster Fuller and other pioneering artists and designers. He published books of collected essays and literary experiments from 1961 forward, some of which are simply remarkable, others annoyingly opaque. He became an able graphic artist who produced suites in lithography and other media, and the playful notation of some of his published musical scores makes them fascinating works of visual art in their own right. This was a bubbling, intensely creative and independent spirit, a serious artist who incarnated the spirit of play. He was Pan-like. That explains his interest in mushrooms.

John Cage studied with D. T. Suzuki. In the preface to his first book of essays, he wrote, "Critics frequently cry 'Dada' after attending one of my concerts or hearing one of my lectures. Others bemoan my interest in Zen. . . . What I do, I do not wish blamed on Zen, though without my engagement with Zen (attendance at lectures by Alan Watts and D. T. Suzuki, reading of the literature) I doubt whether I would have done what I have done."[85] Suzuki taught at Columbia University annually between 1951 and 1957. Cage was among those attending his seminars in 1951–1952, and he also wrote that he twice visited Suzuki in Japan. "I have never practiced sitting cross-legged nor do I meditate," he felt constrained to state in a late autobiographical essay. "My work is what I do and always involves writing materials, chairs, and tables. Before I get to it, I do some exercises for my back and I water the plants, of which I have around two hundred."[86] But even this statement is cross-legged, full of Zen spirit. Watering two hundred plants is nothing if not a meditation.

Dr. Suzuki did not teach something that students learned from him. I know of no better way to put this odd thought. He did teach in its fullness the Zen perspective on human identity and possibility. One element of that perspective—the one we need to pursue this exploration—is classically formulated in the opening lines of a poem by an early Zen patriarch, Seng-Ts'an:

> The great way isn't difficult
>> for those who are unattached to their
>> preferences.
> Let go of longing and aversion,
>> and everything will be perfectly clear.
> When you cling to a hairbreadth of distinction,
>> heaven and earth are set apart.
> If you want to realize the truth,
>> don't be for or against.[87]

The frame of reference here is primarily internal: the verses teach a way to be free and awakened. Though there are always external occasions and reasons for letting go—for letting life be what it is, without clinging or protest—the freedom to which the verses point is primarily worked out within oneself.

There can be no doubt that John Cage, like Thomas Merton, heard this teaching and was moved by it. For Merton, it fused inwardly with all that he knew, all that he had experienced of the Christian monk's practice of simplicity and acceptance. Scarcely a month before his death, he recorded in his journal insights that recall Seng Ts'an's teaching:

> The contemplative life must provide an area, a space of liberty, of silence, in which possibilities are allowed to surface and new choices—beyond routine choice—become manifest. It should create a new experience of time, not as stopgap, stillness, but as "*temps vierge*"—not a blank to be filled or an untouched space to be conquered and violated, but a space which can enjoy its own potentialities and hopes—and its own presence to itself. One's *own* time. But not dominated by one's own ego and its demands. Hence open to others—*compassionate* time, rooted in the sense of common illusion and in criticism of it.[88]

Cage's expression of something like these insights has much the same flavor, although his frame of reference differs. Merton is speaking primarily of the inner life and of meetings with others. Cage speaks of a receptive, choiceless inner state that eliminates personal preference and judgment from the process of musical composition. The text is from the mid-1950s:

> When nothing is securely possessed one is free to accept any of the somethings. How many are there? They roll up at your feet. How many doors and windows are there in it? There is no end to the number of somethings and all of them (without exception) are acceptable. If one gets suddenly proud and says for one reason or another: I cannot accept this; then the whole freedom to accept any of the others vanishes. But if one maintains secure possession of nothing (what has been called poverty of spirit), then there is no limit to what one may freely enjoy. In this free enjoyment there is no possession of things. There is only enjoyment. What is possessed is nothing. . . . When in the state of nothing, one diminishes the something in one: Character. At any moment one is free to take on character again, but then it is without fear, full of life and love. For one's been at the point of the nourishment that sustains in no matter what one of the something situations.[89]

We know thinking and language of this kind—we have heard it in Merton. We also know something of its source: Zen, Suzuki.

Pursuing his visceral need to liberate musical composition from the operations of personal choice, which he experienced as egoistic, culturally conditioned, and unfree, Cage adopted what he once summarized as "a complicated composing means using *I Ching* chance operations, making my responsibility that of asking questions instead of making choices."[90] On another occasion he wrote more explicitly:

> Those involved with the composition of experimental music find ways and means to remove

themselves from the activities of the sounds they make. Some employ chance operations, derived from sources as ancient as the Chinese Book of Changes, or as modern as the tables of random numbers used also by physicists in research. Or, analogous to the Rorschach tests of psychology, the interpretation of imperfections in the paper upon which one is writing may provide a music free from one's memory and imagination.[91]

Here is what Dr. Suzuki did not teach, yet some of his students learned it as if from him. Freedom was always internal for Suzuki, and the free act of the artist, monk, or swordsman was free by virtue of an inner freedom for which years of practice had been necessary. Cage understood this; he could never have written so evocatively of living without fear had he not understood. But he was a man of the West in search of a valid music. Impressed not only by Zen but also by the Dada and surrealist practices of automatic writing and chance pictorial composition, Cage *displaced* the act of composition away from the choosing self to elaborate chance operations. It is true, as others have commented, that his music sounds like John Cage's music, not the music of anyone else. He did eliminate passages and whole compositions because they were not, as he put it, "interesting."[92] Nevertheless, his primary focus was on external procedures, rigorously free from personal choice until a subsequent stage of editing. What Suzuki and Zen tradition taught as wholly internal was partially displaced into an external, mechanical, or chance procedure.

When we look across to Merton with Cage in mind, we find him at grips with the same issue and coming to a comparable solution. Merton also wished to banish egoistic preference and all trace of pride from his work as an artist and to open it to other currents. His adoption of printmaking, which we know to have been a crucial decision, removed him somewhat from the image-making process and allowed "a space of liberty, of silence, in which possibilities are allowed to surface"—a space that he could not fully control and had no wish to fully control. The chanciness of the outcome, when he flattened a sheet of fine paper onto what he called his "negative" and then pulled the print, was not so very different from Cage's use of the *I Ching* and other computational strategies to drive musical composition. Cage spoke of chance operations; Merton had no specific name for the collaborator beyond his control, but we have spoken in earlier pages of chance/providence.

Both Merton and Cage loved freedom passionately and sought to be free as artists—free from their own inevitable pettiness and free to give to others in large measure without self-concern. "Zen calligraphy," Merton wrote, "by its peculiar suppleness, dynamism, abandon, contempt for 'prettiness' and for formal 'style,' reveals to us something of the freedom which is not transcendent in some abstract and intellectual sense, but which employs a minimum of form without being attached to it, and is therefore free from it."[93] Cage's version of much the same thought would have pleased Merton: "[W]hat is the purpose of writing music? One is, of course, not dealing with purposes but dealing with sounds. Or the answer must take the form of paradox: a purposeful purposelessness or a purposeless play. This play, however, is an affirmation of life—not an attempt to bring order out of chaos nor to suggest improvements in creation, but simply a way of waking up to the very life we're living, which is so excellent once one gets one's mind and one's desires out of its way and lets it act of its own accord."[94]

These were two of the spiritual sons of D. T. Suzuki. Both were very fond of the old sage, and perhaps that fondness shows how to bring this study of unlikely peers to a conclusion. Fondness beams through an anecdote that Cage deposited in one of his more patterned writings. "Once when Daisetz Teitaro Suzuki was giving a talk at Columbia University," Cage recalled, "he mentioned the name of a Chinese monk who had figured in the history of Chinese Buddhism. Suzuki said, 'He lived in the ninth or tenth century.' He added, after a pause, 'Or the eleventh century, or the twelfth or thirteenth century or the fourteenth.'"[95] The same warmth radiates from Merton's description to Robert Lax of a moment in conversation with Suzuki. We must again see Merton and Suzuki seated together on that sofa in the summer of 1964 (fig. 5, p. 11). It is hard to believe, but Merton claimed to have told Suzuki the following mad story:

[O]ne monk he is walking on the water and he meets another monk in a boat and the one in the boat says what you doing walking on the water and the other one says this is no water this is the meadows and for proof here is a flower so he bends down and picks a flower and throws it at the guy so the other one says nothing he reaches into the water and picks up a salmon and throws it at the other guy. After that the other guy was called by everybody "Salmon" in memory of this occasion.

Who won?

This I tell Suzuki expecting him to be very happy but all he did was ask where the first one got that flower. Not a wink about salmon, no siree.[96]

Exhibitions

> Do you know of some group, club, clique, cell or cultural enclave that would dare to associate its name with these drawings?

> —Thomas Merton in a letter to
> Ethel Kennedy, 1965

In nearly everything we do there is a plain side and people, however great, do plain things. Plainness is reassuring; it means there is no emergency. Such a moment is reflected in one of just two preserved photographs of Merton handling his drawings (fig. 21). The date is July 14, 1967; the scene is the embankment alongside Dom Frederic's Lake at Gethsemani. Merton's guest is Martha Schumann, a volunteer from the Merton Room, the kernel of today's Thomas Merton Center at Bellarmine University. In his journal entry for the day, Merton mentions that Mrs. Schumann and a colleague would be dropping by to "settle 'problems' of cataloguing."[97] Mrs. Schumann has in hand what appears to be portfolio image 7 in this book.

This photograph walks us into the topic of exhibitions of Merton's art. For once, the topic is not taxing. We will not have to interpret works of art and texts, not have to become seekers alongside Thomas Merton. Like Merton himself as he oversaw the development of his first exhibition and its tour to various cities across the United States, we will be involved for the most part with day-to-day matters. But Merton's comments as events move along and his mail from people involved in exhibiting the work reveal his attitudes toward his art and its reception in the world. This is the larger value of the exploration.

The idea for an exhibition was surely Wilke's but, owing to a nun's proper discretion, we may never know

FIG. 21 Thomas Merton with Martha Schumann, July 14, 1967, Gethsemani. Photographer unknown.

with certainty if this was so. When Sister Mary Charlotte, of the art department at Louisville's Catherine Spalding College, sent Merton a note of inquiry, she passed over the identity of her informant: "It was my pleasant experience today to learn of your activities in the field of art and of the existence of a collection of your recent works. . . . We are writing to request your permission to show your work in an exhibit to be held early this fall. . . ."[98] Merton was pleased. Within less than a week he had made needed arrangements and replied with firmness and enthusiasm:

> I am grateful for your kind letter. . . . I have discussed this matter with Father Abbot and he has no objections, so I am glad to accept your offer. The drawings are being framed. . . . It seems to me that the exhibition could be held at any time convenient for you in October or November. . . . Naturally I would not be able to be there myself at any time, though if I do happen to be in town I hope I might sneak in and get a quick look to see how they are on a wall. But there could *not* be any planned "public" appearances. A minimum of *personal* publicity is desirable . . . But of course the drawings would be open to any interest or comment. . . . [99]

Merton offered in the same letter to provide titles for the works and to write the gallery notes published here on pp. 60–61. He recognized that visitors might find his art difficult. "I am enclosing a draft of notes I wrote to help people look at the drawings," he wrote some weeks later to his friends at Catherine Spalding. "I think they will be of some help. Mimeographed together with a list of the drawings, they could help

many people find their way through the mysterious collection. . . ."[100]

In point of fact, Merton had been thinking months earlier about an exhibition of some kind, somewhere. In March 1964, he had made a suggestion along these lines to his friend in the peace movement, Jim Forest:

> . . . how about an exhibition in some gallery, small back alley, or something? Or in a place where they drink espresso and look at calligraphies, or something of the sort? If you think this is a good idea and anything gets sold you can have half. Someone would have to be interested enough to mount the pictures in some way, and I could take care of any expenses involved in that. If you think this is a good idea I will send the best and subtlest of the calligraphies which are all on a kind of very thin Japanese paper.[101]

The offer from Catherine Spalding College would lead to a more formal exhibition than this letter suggests. Events quickly marched forward. Wilke advised Merton on the style of framing that would suit his art, the exhibition was scheduled to open just before Thanksgiving and to run for several weeks, and a private preview for the press, arts people, and personal friends was organized. Merton was looking forward to the exhibition. "Next month in Louisville," he wrote to a friend in Latin America, "I astound the population with an exhibit of incomprehensible abstract drawings which will cause the greatest possible amount of perplexity on all sides and will perhaps bring everyone into a state of inarticulate stupor. . . ."[102] He did manage on several occasions to sneak in and get a quick look. One of those occasions was preparatory: "I certainly enjoyed my brief visit and the opportunity to get

the pictures named. I am glad you are going ahead with the printing of the Notes and the plans for a private showing. . . ."[103] A month later, he found his way to the exhibition proper and was delighted. "I was able to see the drawings as they are now hung at Catherine Spalding. A very attractive exhibit."[104]

The titles he provided have not been published since they appeared in those gallery notes. As mentioned in earlier pages, only a few can be matched to works for which either the original or a print or photograph is preserved. But the roster of titles is provocative (fig. 22).[105] It offers a compact tour of Merton's mind. Some titles evoke a primal era and his concern for fundamentals: "Ancient Signal I," "More Ancient Signal," "Beginning of Speech." Others reflect his deep interest in Zen. Several reflect the metaphor of dance, which we have seen him use well in other contexts. All reflect his broad culture, none loudly states that the artist is a Catholic monk and priest of long years' experience. Somewhere in the exhibition was a drawing, "Signature III," which Merton considered "best of show," but I have been unable to identify it.[106]

Just before the exhibition, he fired off a joyful letter to Robert Lax to report the news:

Now I tell you I have a big exhibit of puns and calligraphies and soup spoons and artifacts and mobiles in Louisville I am in all the junk shops from November on with works of harp and artificials. I have made the picture, I have scooped the ink into a ball and flung it upon newsprnps and in pieces of picture. I have assailed the public conscience. It is the scandal of the evening according to all the prints of the borough. It should never have been allowed growls Juniper Johnson and the fiftieth plank of Coldbottle's

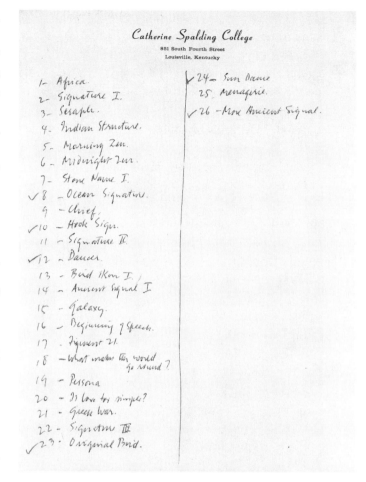

FIG. 22 Thomas Merton's handwritten list of titles for works in the exhibition at Catherine Spalding College, November–December 1964.

platform is to decry the works of art by the Seven Stirring Mousewhip.[107]

The Seven Stirring Mousewhip—more commonly known as Thomas Merton, author of *The Seven Storey Mountain*—was pleased.

Public response to the exhibition was more moderate than his letter predicted. Newspaper articles both in Louisville and in cities to which the exhibition later traveled tended to quote from Merton's "Notes by the Artist" rather than respond directly. "Reviewers are rather speechless," he heard as the exhibition traveled, "and can only quote you (but maybe that's best)."[108] This was surely a measure of the difficulty of the art: Zen-influenced abstract expressionism would have been unfamiliar in visual language and overall purpose to many gallery visitors. Only a handful of works sold in Louisville and elsewhere; Abbot James Fox generously raised funds to round out the scholarship for an African-American girl at Spalding, which Merton had in mind. Sister Mary Charlotte was nonetheless reassuring when the exhibition closed. "The exhibit attracted a great deal of attention," she wrote as Christmas approached, "was enjoyed by many and provided excellent publicity for us. A little freshman has just stopped by the office to tell me how much she liked the pictures. . . ."[109]

Despite this modest initial success, offers came in the mail. Sister Lurana, at Xavier University in New Orleans, caught wind of the exhibition and asked for it.[110] Her inquiry prompted Merton to begin thinking practically about how to tour the exhibition from place to place without huge gaps in time and geography. He had no illusions about taking the art world by storm. "They are not the popular type of thing," he wrote to one of his closest friends in religion, "and may scandalize some. Still, people seem to like them. . . ."[111]

He became his own tour manager with the willing help of staff members at the colleges and other venues where the exhibit toured. The show in New Orleans took place in February 1965. Replenished with additional work, it moved on to Marquette University in Milwaukee for an exhibition now of forty-three works,

in March. In April, it moved on again to Webster College, St. Louis. There was a gap at that point—a plan to show the work in Atlanta fell through—and then a September showing at a museum in Santa Barbara, owing to the influence and organizational capacity of Merton's friend Jim Forest. As we had reason to discuss in earlier pages, in 1966 the exhibition (refreshed yet again) reached a Catholic bookstore in New York City with the help of James Laughlin, Merton's friend and publisher at New Directions. And in 1967 it finally washed ashore at a coffeehouse and gallery in Washington, D.C., from whence it did not return. There are gaps in the tour, times when the works were put in storage, and a better overall knowledge of the tour can almost certainly be teased out of Merton's correspondence. But for present purposes we have a clear enough notion of the pattern.

Touring the exhibition at all, let alone over a three-year period, was an astonishing feat for a hermit with a typewriter, letter paper, and little else. Logically, one would suppose that Merton received help from the monastery's administrative center, but there is no evidence that this was so. The touring exhibition seems to have been entirely his own concern, and he had the normal anxieties of any tour manager. "It is a relief," he wrote to an administrator at Marquette University, "to learn that the exhibit arrived safely."[112] That he undertook this large task so willingly gives another measure of Merton's commitment to his art.

In the course of the tour, Merton wrote a number of revealing, often funny letters, none more so than one in early 1965 to Ethel Kennedy, wife of Robert Kennedy and sister-in-law of the late president. He had felt for some years a sense of kinship with the Kennedy family, well-known Catholics struck by tragedy. He wrote, "Now to the question of the works of 'art?'" And continued:

Here is the scoop on that. I have forty-three extremely way-out and abstract drawings going around the country causing senators to believe that there is yet another Red plot afoot to addle the American mind. They are at the moment, I hope, at Marquette in Milwaukee and from there they go to St. Louis, and then in Atlanta in June. Now they are to be at St. Louis in April and Atlanta in June. . . . So I am looking for a place to subvert the nation with these drawings in the month of May. At first thought, what better place than Washington. Or does that make no sense at all? So far, they have been exhibited at colleges. But they don't have to be exhibited only in educational institutions. However, as you can now see, I am trying to enlist you in this: do you think maybe Trinity would want them? . . . Or do you know of some group, club, clique, cell or cultural enclave that would dare to associate its name with these drawings? If you do and if you could get on the phone to them, then they could contact me and all the rest would be simple (in theory). (I know what it is in practice.)[113]

In the event, it was not through Mrs. Kennedy but through other friends two years later that the exhibition found its way to Washington. By that time, December 1967, Merton had tired of his role as tour manager and was ready to abandon it. In correspondence with a young theologian of great promise, Rosemary Radford Ruether, who had kept an eye on the exhibition in Washington, he suggested closing off the cycle. He was confident that she would use the remaining drawings to raise money for good purposes—and not confident at all that the exhibition in Washington had been well handled by those primarily responsible for it. "The drawings are yours," he wrote to Rosemary. "Unfortunately, I don't have an inventory of them, but there must be about twenty available still. But get whatever you can. As to the rest, I don't really care."[114]

The dejected tone of a weary tour manager is not a fair stopping place for this study of Merton's art on exhibition. Merton was rarely dejected for long. Turning back in time a few years, to the early spring of 1965, we come upon him responding with interest to a follow-up thought from Sister Mary Charlotte at Catherine Spalding. She had been well pleased by the exhibition of Merton's drawings. Further, she knew that he had become very interested in photography and that some of his photographs had already been set aside for posterity in the Merton Room. Would he care to mount an exhibition of photography? "You mentioned exhibiting photographs," he replied. "Naturally I would be glad to let you do this. The ones at Bellarmine can be borrowed at any time, I am sure. I have some others here that we are working up, and perhaps later there would be enough for a small exhibit. . . ."[115] This exchange was a link to the future. Merton's photography, permanently exhibited in a fine selection at the Thomas Merton Center, has been the focus of several exhibitions since his passing. A substantial selection, first exhibited in Louisville in the winter of 2004–2005, took to the road for a tour.[116]

APPENDIX

Thomas Merton, Printmaker: Reconstructing His Technique

By John Begley, Adjunct Professor of Critical and Curatorial Studies and Gallery Director,
 University of Louisville
James Grubola, Professor and Chairman, Department of Fine Arts, University of Louisville
John Whitesell, Professor of Printmaking, University of Louisville

Artists typically use printmaking techniques to produce multiples of images, either for commercial reasons or in response to egalitarian ideas about distribution and access to art. As well, the graphic and physical nature of the materials and methods of printmaking may attract artists to the medium for its intrinsic aesthetic pleasures. Great printmaking often reflects all of these motivations and joys. Thomas Merton's attraction to printmaking seems to have been for aesthetic and philosophical, rather than commercial or democratic, reasons.

Merton's printmaking techniques were bare and simple, yet effective. In what appears to have been an effort to find the minimum necessary means and draw on the most basic of found materials, Merton used printmaking techniques to distance and remove traces of his hand from his art. His methods removed autographic traces (therefore, individual ego) by inserting a process between the artist's hand and the finished work. This self-effacement was consistent with Merton's values as a monk and religious seeker. Printmaking proved to be an elegant solution for what we can surmise to have been some of his art-making issues. It allowed him to approach a spiritual plane in his art making, which echoed his larger search. For Merton, printmaking appears to have been a means to higher ends.

Only under close examination does it become apparent that Merton often used printmaking techniques. When his methods do become apparent, it also becomes clear that he did not use them for the usual reasons—the usual reasons apparently did not interest him at all. Instead, he used printmaking as a means of image development, typically a single image never repeated again. The following is a discussion of what he did and why we believe that he turned printmaking on its head: in Merton's hands, a reproductive method became a unique drawing tool.

Typically, the printmaker develops a matrix that carries a common image, which is then transposed and transformed into multiple originals through the printing process. The copper plate in etching, the stone in lithography, wood block, and stencil are common matrix materials. Merton used none of these traditional materials. Instead, he adapted some nontraditional innovations in printmaking that suited the materials

available in his environment and connected with philosophical ideas of importance to him.

In the mid twentieth century, artists influenced by cubism and surrealism explored the use of glued and collaged objects as a printmaking matrix. A matrix of this kind could be printed by combining intaglio (etching) and relief or block printing techniques, and the resulting prints were often called collographs.[1] This technique is closely associated with Boris Margo (1902–1995), an early, enthusiastic practitioner and advocate, who was artist-in-residence at the University of Louisville at some point during Ulfert Wilke's years there. As Margo generally worked in Provincetown (Cape Cod), where many artists came and went, he may have had contact with Ad Reinhardt, thus providing a further possible link to Merton. Through either Wilke or Reinhardt, Merton may have been introduced to Margo's collographic technique.

However he learned or devised it, this modernist approach with its nontraditional and hybrid use of objects obviously appealed to Merton. The objects he used as matrices for image making were materials he had at hand in his cloistered situation. They were essentially found objects joined together in collages—objects such as ordinary mailing envelopes received in the course of his voluminous correspondence. Other types of envelopes, perhaps billing envelopes with cellophane window cutouts (no doubt easily found in the monastery print shop), can be recognized in some of his more elaborate images. His printing plates, the carriers of his images, were simple materials such as these, which, as he discovered, have just enough relief to convey an almost intangible image.

Careful observation shows that these humble materials were the basis for some of his most striking prints. Once this becomes apparent, many other simple materials become evident, as well: grass stems gathered in fields near the hermitage, crinkled paper, ends of wood veneers, and similar materials at hand. Merton's matrices range from brushed ink patterns, often applied to textured cardboard, to fairly elaborate collages of found objects, which could be inked and printed.

In the typical printmaking process, the application of ink to the matrix and the selection of a final substrate for the image (paper, fabric, or other material) are choices made by the artist to complete a print. Usually, though not always, the ability to repeat the process and create an edition of multiple originals is an important consideration. As noted earlier, Merton had no apparent interest in this idea. Instead, the transfer of ink from one object (the matrix) to another (drawing paper) was similar, in his practice, to a transfer of ideas, as if in conversation. The simple way he evidently applied India ink directly with a brush to the paper and/or objects serving as his matrix and his straightforward method of transferring the image to complete a print point to the immediacy, openness, and truthfulness to materials and methods that mark his general attitude toward art making.

His printing method was to press by hand a sheet of paper to the paper matrix he had developed. This simple method typically produces one print—in the language of twentieth-century art practice, a monoprint. Like the collograph, the monoprint or monotype was a popular method in mid-twentieth-century art. The artist could achieve unique effects through the adsorption of ink on paper. As well, ink could be smeared on a nonabsorbent matrix such as metal or plastic. The approach generates some of the aesthetic characteristics of a print but typically can't be used to create multiples.

While Merton did on rare occasions pull a number of prints from a single matrix, he appears to have been generally content to pull just one. For this reason we describe his printmaking as a form of drawing. There is a further point: the uniqueness of each transfer in the monotype method promotes and encourages chance effects, related to such techniques as automatic writing cultivated in surrealism and, with a different scale and intensity, in abstract expressionism. Automatic techniques that court chance or unknown outcomes, including rubbing, stamping, and other quasi-printing techniques, have an affinity with Asian ideas and aesthetics, as Merton well knew. Monotype printing—just one image each time, controlled by the artist only up to a point and thereafter subject to chance effects as the print is made—seems to have provided a method for Merton to free himself from Merton. It must have been in this sense that he once described his art as "signatures of someone who is not here."

Merton was exposed to various types of printing. Through his friendship with Victor Hammer, described earlier in this book, he was aware of the techniques of letterpress printing as a fine craft. He was also familiar with the higher-volume printing methods of the monastery print shop. He must have used that shop as one source of paper for his work, would have observed there the process of offset printing, and very possibly learned from it. Offsetting images from the matrix to a carrier plate, such as a rubber blanket—in effect, a secondary matrix—developed in the early part of the century. Offset printing became the primary commercial printing technique because it allowed longer runs of printed materials. The paper in an offset press does not abrade the matrix as quickly as in direct printing and therefore allows more impressions. While this ob-viously was not a goal of Merton's, he may have taken an interest in the idea of an intermediary carrier of images. Even simple, inexpensive forms of printing or copying, such as mimeographing, which substituted a paper plate for the rubber transfer blanket, had evolved to the point that offsetting the image was central to producing and transferring an image or text. Merton relied on mimeographs from the monastery print shop to duplicate his *Cold War Letters* for distribution to friends in the peace movement.

Merton occasionally seems to have used a simple adaptation of offsetting technique for his own image making, sometimes in a serial manner to create a linked group of images. He also explored making multiple impressions of a secondary matrix within the same image by folding it over in some way or repeating it as a mirror image. Each time the transfer is fainter as the pigment available for transfer diminishes. The aesthetic impact of this method of image making is very different from the strike on paper of a metal block in a letterpress or the marks left by more physically rigorous methods of printmaking that use rollers, presses, and oil-based inks to make the impression. Merton's work exhibits a lightness of touch: the hand as the press, the brush as the inking source, and almost a "kiss" of papers to transfer his marks. While the everyday world of the monastery print shop was perhaps not the primary influence on his methods, what he must have seen among the offset presses and mimeo machines would have reinforced other methods of image making that he practiced.

Merton extended, modified, and played with all of these techniques in combination. He made calligraphic drawings on textured papers—cardboards, for example—and used them as matrices to create monoprints or as intermediary matrices for experiments with offset

printing. He would transfer the original drawings by blotting, wiping, or stamping to create images that represented further distillations or reflections of his original marks. One eyewitness source reported that he "slapped" inked grass directly onto paper as a means of image making. Many of his later images must have been made by layering uninked grass stems on top of a brush-drawn image, which then served as a matrix for printing. The grass stems left fine stencil-like streaks and channels in the resulting image. Every time he printed, he distanced the source—his own creative choices and touch—through the steps of printmaking he employed, and he opened the process to chance but welcome effects.

Experimental Validation

To validate that our observations about Merton's printmaking are essentially correct, we experimentally created a number of samples by what we believe to have been his techniques. In figure 1, you will see a brush-drawn calligraphic mark at the left, followed by two successive prints made by hand-pressing a sheet of paper directly onto the still-wet mark. The texture of the paper used to receive the image shows up in the first print. Some drier areas in the original brush-drawn image have not transferred. The second print, at the far right, echoes but changes the first. Further abstraction and refinement have occurred.

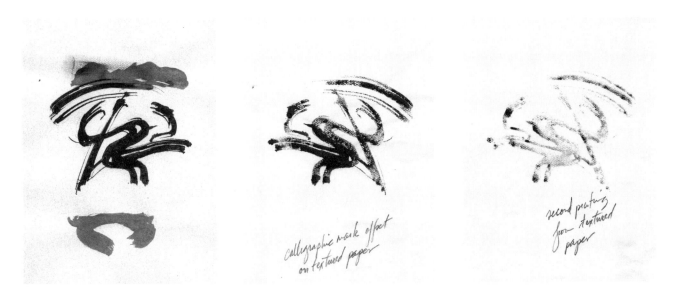

FIG. 1 Duplicating Merton's printmaking methods:
A brush-drawn matrix (at left) and two successive prints pulled by hand.

In figure 2, we laid grass onto a brush-inked sheet and again hand-pressed a sheet of paper onto this matrix. This method produced an effect very similar to a number of Merton's images: positive edges of the grass where ink pooled created lines, while negative areas where the grass resisted the ink produced a stencil-like effect of blocked-out areas. Spatters and dots of ink from two sources—the brush and the process of positioning grass on the matrix—appear in the printed image.

In figure 3, common window envelopes were inked with a calligraphy brush, and we made the impression by hand (the roughly oval shape of the hand is evident in the print on top). The different absorption characteristics of the envelope paper and window cellophane (actually plastic, in our case) create different ink textures in the print, and the crisp negative line generated by the slight difference in relief appears quite clearly. The result is very similar to Merton's work.

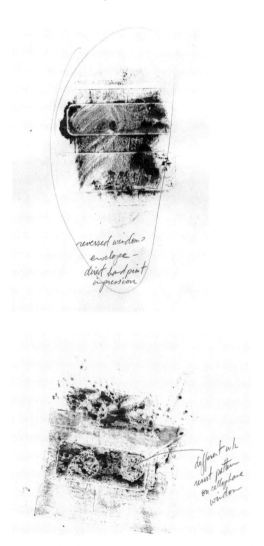

FIG. 2 Duplicating Merton's printmaking methods: A grass stencil print.

FIG. 3 Duplicating Merton's printmaking methods: More complex matrices including window envelopes.

Figure 4 demonstrates the collage effects achieved through printing stamped envelopes. Again, the results are very similar to Merton's. The second printing reduced the amount of ink transferred and allowed textures, edges, and additional chance marks to reveal themselves.

In the final test of these ideas (fig. 5) about how Merton used printmaking techniques to draw, we combined several of the preceding methods. Stamps, envelopes, grass stencils, wetter and drier matrices, reversed and second-image transfers, splatters and blobs again produced results reminiscent of Merton's.

FIG. 4 Duplicating Merton's printmaking methods: Two successive prints from the same matrix, which included a stamped envelope.

The utter simplicity of Merton's techniques is impressive. The resulting images, at best, are inspiring and masterful. Simplicity was necessary; it reflected circumstances in which only the most minimal materials were available. But it also connected with and surely supported his spiritual quest to find the most essential, common, universal points and components of his world.

In summary, Merton did not use printmaking as a method for multiplying or disseminating his work. In his practice, it was an image-making technique that could yield certain aesthetic and spiritual results—primarily light textures with fine detail and an evanescent quality—while distancing himself as the maker or ego-focused artist by introducing the opportunity for chance effects. It would have been difficult if not impossible to achieve the light textures and other expressive features that interested him, had he continued to create images directly with the brush in the calligraphic style of his first years of art practice in the 1960s. By nontraditional methods, he seems to have found a way to put printmaking at the service of spirit.

FIG. 5 Duplicating Merton's printmaking methods: Complex matrices that include many of Merton's found object.

NOTES

The Invisible Art of a Highly Visible Man

In the following notes, TMC refers to the Thomas Merton Center.

1. Merton letter to James Forest, November 16, 1966, in Thomas Merton, *The Hidden Ground of Love: The Letters of Thomas Merton on Religious Experience and Social Concerns,* ed. William H. Shannon (New York: Farrar, Straus and Giroux, 1985), p. 299.

2. See Katarzyna Bruzda, "Thomas Merton—An Artist," *Studia Mertoniana* 2, 2003, pp. 177–96; Christine M. Bochen, "Calligraphies" and Patrick F. O'Connell, "Drawings, Representational" in *The Thomas Merton Encyclopedia,* ed. William H. Shannon, Christine M. Bochen, and Patrick F. O'Connell, eds., (Maryknoll, N.Y.: Orbis, 2002), pp. 38–40, 119–20; Jonathan Montaldo, "A Gallery of Women's Faces and Dreams of Women from the Drawings and Journals of Thomas Merton," *The Merton Seasonal* 14, 2001; Thomas Merton, *Dialogues with Silence: Prayers and Drawings,* ed. Jonathan Montaldo (San Francisco: HarperSanFrancisco, 2001), a selection predominantly predating 1960; and Margaret Betz, "Merton's Images of Elias, Wisdom, and the Inclusive God," in *The Merton Annual: Studies in Culture, Spirituality, and Social Concerns,* vol. 13 (Trowbridge, U.K.: Sheffield Academic Press, 2000). Prof. Dorothy Keller (St. Joseph College) has explored Merton's methods and materials, and other topics, at Merton conferences, and Dr. Paul M. Pearson has addressed various topics, including connections between Merton's poetry and visual art, in conferences.

3. Thomas Merton, Notebook 14, 1964, TMC collection. With the permission of the Merton Legacy Trust.

4. Thomas Merton, *The Wisdom of the Desert: Sayings from the Desert Fathers of the Fourth Century* (New York: New Directions, 1960).

5. Merton letter to Sister M. Emmanuel, December 2, 1960, in *The Hidden Ground of Love,* op. cit., p. 184.

6. *Turning Toward the World: The Pivotal Years (The Journals of Thomas Merton, vol. 4, 1960–1963),* ed. Victor A. Kramer (San Francisco: HarperSanFrancisco, 1996), entry for October 28, 1960, p. 60.

7. Ibid., entry for November 9, 1960, p. 63.

8. Merton letter to Eloise Spaeth, November 23, 1960, in the Eloise Spaeth Papers, the Archives of American Art. With the permission of the Merton Legacy Trust and the Archives of American Art. Merton's playful description, "animated fragments" and so on, echoes the famous mocking phrase applied by an American art critic in 1913 to Marcel Duchamp's *Nude Descending a Staircase*— "an explosion in a shingle factory." Merton's echo, even if not deliberate, is a sign of his familiarity with twentieth-century art.

9. Cited in Steve Theodore Georgiou, *The Way of the Dreamcatcher: Spirit Lessons with Robert Lax, Poet, Peacemaker, Sage* (Ottawa: Novalis, 2002), p. 127.

10. Merton letter to Thomasine O'Callaghan, October 17, 1967, in *The Road to Joy: The Letters of Thomas Merton to New and Old Friends*, ed. Robert E. Daggy (New York: Farrar, Straus and Giroux, 1989), p. 266.

11. Readers looking for occurrences of these three terms ("edifying," "disedifying," "scandal") will find them in the following places, among others: *Learning to Love: Exploring Solitude and Freedom* (*The Journals of Thomas Merton, vol. 6, 1966–1967*), ed. Christine M. Bochen (San Francisco: HarperSanFrancisco, 1997), pp. 109, 274; and *When Prophecy Still Had a Voice: The Letters of Thomas Merton and Robert Lax*, ed. Arthur W. Biddle (Lexington: University Press of Kentucky, 2001), p. 283. This last passage relates directly to Merton's art: "Now I tell you I have a big exhibit of puns and calligraphies and soup spoons and artifacts and mobiles in Louisville. . . I have assailed the public conscience. It is the scandal of the evening according to all the prints of the borough." In a letter to a college administrator concerning preparations for the Catherine Spalding College exhibition of Merton's art in the late fall of 1964, Merton noted that he did not often come to Louisville: "My trips to town are few and far between and Father Abbot is very insistent that when I am out of the monastery I should keep as far as possible out of sight, hearing and contact with the rest of the human race for fear that I give serious disedification." Merton letter to Aloys Landes, October 19, 1964, TMC collection. With the permission of the Merton Legacy Trust.

12. Merton letter to James Forest, October 19, 1963, in *The Hidden Ground of Love*, op. cit., p. 277.

13. Merton letter to James Laughlin, February 16, 1955, in *Thomas Merton and James Laughlin: Selected Letters*, ed. David D. Cooper (New York and London: Norton, 1997), p. 108.

14. See Laura Swan, *The Forgotten Desert Mothers: Sayings, Lives, and Stories of Early Christian Women* (New York: Paulist Press, 2001), and John Chryssavgis, *In the Heart of the Desert: The Spirituality of the Desert Fathers and Mothers* (Bloomington, Ind.: World Wisdom, 2003).

15. *The Other Side of the Mountain: The End of the Journey* (*The Journals of Thomas Merton, vol. 7, 1966–1967*), ed. Brother Patrick Hart (San Francisco: HarperSanFrancisco, 1998), p. 98. Theophane the Recluse was a nineteenth-century monastic pioneer in gathering and translating into contemporary language the traditions of the Desert Fathers.

16. Merton letter to D. T. Suzuki, March 12, 1959, in *Encounter: Thomas Merton and D. T. Suzuki*, ed. Robert E. Daggy (Monterey, Ky.: Larkspur Press, 1988), pp. 5–6.

17. Merton letter to D. T. Suzuki, April 11, 1959, Ibid., p. 18.

18. Merton letter to Paul Sih, January 2, 1962, in *The Hidden Ground of Love*, op. cit., p. 551.

19. Merton letter to a woman religious, March 27, 1968, in Thomas Merton, *Witness to Freedom: The Letters of Thomas Merton in Times of Crisis*, ed. William H. Shannon (San Diego: Farrar, Straus and Giroux, 1994), p. 197.

20. Thomas Merton, *Day of a Stranger* (Salt Lake City: Gibbs M. Smith, 1981), p. 41 (written in 1965).

21. Thomas Merton, Notebook 14, op. cit. (see note 3, above). Merton's phrase "Zen Catholicism" refers to a book he valued: Dom Aelred Graham, *Zen Catholicism: A Suggestion* (New York: Harcourt, Brace and World, 1963).

22. The Sengai calendars were available in a scroll-like form—this is what Merton had—and also as small publications in book form, now rare. I have seen two of the latter, *Sengai Calendar 1961* and *Sengai Calendar 1963*, published by Idemitsu Kosan Co., Ltd., Tokyo, with the full texts by Suzuki and the illustrations for that particular year. Many of Suzuki's commentaries found their way into the book documented in the next note.

23. Daisetz T. Suzuki, *Sengai, The Zen Master* (London: Faber and Faber, 1971), p. 26.

24. Isshu Miura and Ruth Fuller Sasaki, *The Zen Koan: Its History and Use in Rinzai Zen* (New York: Harcourt, Brace and World, 1965), p. xiii.

25. Ad Reinhardt letter to Merton, n.d. but soon after Reinhardt's May 1959 visit to Gethsemani. With the permission of the Columbia University Libraries Rare Book and Manuscript Library and Anna Reinhardt.

26. Thomas Merton, *Conjectures of a Guilty Bystander* (Garden City, N.Y.: Doubleday, 1966), p. 204. (All citations

from this first edition, which differs in pagination from the later paperback.)

27. *Run to the Mountain: The Story of a Vocation (The Journals of Thomas Merton, vol. 1, 1939–1941)*, ed. Brother Patrick Hart (San Francisco: HarperSanFrancisco, 1995), pp. 53–54.

28. Thomas Merton, *The Sign of Jonas* (New York: Harcourt Brace, 1953), p. 247.

29. Thomas Merton, *Entering the Silence: Becoming a Monk and Writer (The Journals of Thomas Merton, vol. 2, 1941–1952)*, ed. Jonathan Montaldo (San Francisco: HarperSanFrancisco, 1997), p. 469.

30. Merton letter to Father Kilian McDonnell, O.S.B., March 14, 1958, in *The School of Charity: The Letters of Thomas Merton on Religious Renewal and Spiritual Direction*, ed. Brother Patrick Hart (New York: Farrar, Straus and Giroux, 1990), p. 109.

31. Merton letter to Father Kilian McDonnell, August 22, 1959, Ibid., p. 122.

32. Readers will find a thorough discussion of the rise and fall of this manuscript, *Art and Worship*, in David D. Cooper, *Thomas Merton's Art of Denial: The Evolution of a Radical Humanist* (Athens and London: University of Georgia Press, 1989), chap. 4.

33. Thomas Merton, jacket copy for William Congdon, *In My Disc of Gold: Itinerary to Christ of William Congdon* (New York: Reynal & Co., n.d., but ca. 1962). William Congdon's life and work are richly presented on the Web site of the William Congdon Foundation, www.congdon.it.

34. Ad Reinhardt letter to Merton, 1962, in Joseph Masheck, "Five Unpublished Letters from Ad Reinhardt to Thomas Merton and Two in Return," *Artforum*, December 1978, p. 25.

35. Merton letter to Ad Reinhardt, February 1962, *The Road to Joy*, op. cit., p. 280.

36. Thomas Merton, Notebook 14, 1964, op. cit.

37. Jacques Maritain, *Creative Intuition in Art and Poetry*, Bollingen Series 35.1 (New York: Pantheon Books, 1953); Maritain, *Georges Rouault* (New York: Abrams, 1954).

38. Thomas Merton, *Turning Toward the World*, op. cit., pp. 60–61.

39. Katsuki Sekida, trans. and commentary, *Two Zen Classics: Mumonkan and Hekiganroku* (New York and Tokyo: Weatherhill, 1977), pp. 128–31. See also R. H. Blyth, *Mumonkan: Zen and Zen Classics*, vol. 4, (Tokyo: Hokuseido Press, 1966), pp. 295–300. *Mumonkan* translates as *The Gateless Gate,* the title under which this koan collection from the early centuries of Zen (Ch'an) practice in China is now better known in English.

40. Thomas Merton, *The Other Side of the Mountain*, op. cit., pp. 211–12.

41. Thomas Merton, *The School of Charity*, op. cit., p. 271 (here slightly reedited on the basis of the original in the Burns Library, Boston College).

42. Katsuki Sekida, *Two Zen Classics*, op. cit., p. 128; R. H. Blyth, *Mumonkan*, op. cit., p. 297.

43. Merton letter to Mark Van Doren, February 16, 1961, in *The Road to Joy*, op. cit., p. 40.

44. Thomas Merton, *Turning Toward the World*, op. cit., p. 73.

45. Thomas Merton, Notebook 14, 1964, op. cit.

46. Robert E. Daggy, ed., *Encounter*, op. cit., n. 10, p. 95.

47. Merton letter to Sister M. Emmanuel, December 2, 1964, in *The Hidden Ground of Love*, op. cit., p. 194.

48. Thomas Merton, *The Climate of Monastic Prayer* (Kalamazoo: Cistercian Publications, 1969), p. 53.

49. Merton letter to Robert Lax, August 21, 1957, in *When Prophecy Still Had a Voice*, op. cit., p. 135.

50. Merton letter to Ad Reinhardt, November 23, 1957, in Joseph Masheck, "Five Unpublished Letters," op. cit., p. 24. Merton salvaged the deliciously rare word *latreutic* from the depths of older Catholic literature. It means "pertaining to divine worship."

51. *Owen Merton: Expatriate Painter,* (Christchurch, New Zealand: Christchurch Art Gallery, 2004).

52. Merton letter to Ernesto Cardenal, August 17, 1959, in *The Courage for Truth: The Letters of Thomas Merton to Writers*, ed. Christine M. Bochen (New York: Farrar, Straus and Giroux, 1993), p. 112.

53. Merton letter to Dom Gabriel Sortais, May 26, 1962, in *The School of Charity*, op. cit., p. 144. Merton's reference to a "juggler," in a letter almost certainly written in French, is somewhat misleading as translated; he is referring to the medieval *jongleur*, a multitalented, itinerant bard.

54. *Dancing in the Water of Life: Seeking Peace in the Hermitage (The Journals of Thomas Merton, vol. 5, 1963–1965),* ed. Robert E. Daggy (San Francisco: HarperSanFrancisco, 1997), p. 125.

55. The years 1962–1965 saw the meetings known as Vatican II at the highest level of the Catholic Church. Merton was a keen observer of the events and consequences, for good and ill, of this period of opening and change, initially under the guidance of Pope John XXIII, whom Merton regarded as a saintly individual. Merton cared enormously about two topics raised in the course of Vatican II: the church's attitudes toward peace and war, and the ecumenical movement that began to embrace not only other Christian confessions but also the religions of Asia.

56. Thomas Merton, *Conjectures of a Guilty Bystander,* op. cit., p. v.

57. Merton letter to Father Ronald Roloff, O.S.B., September 26, 1962, in *The School of Charity,* op. cit., p. 146.

58. Thomas Merton, *Introductions East and West: The Foreign Prefaces of Thomas Merton,* ed. Robert Daggy (Greensboro, N.C.: Unicorn Press, 1981), p. 43.

59. Thomas Merton, *Turning Toward the World,* op. cit., p. 69.

60. Merton letter to J. R., December 1961, in *Witness to Freedom,* op. cit., pp. 24–25.

61. Merton letter to Rosemary Radford Ruether, February 14, 1967, in *At Home in the World: The Letters of Thomas Merton and Rosemary Radford Ruether,* ed. Mary Tardiff, O.P. (Maryknoll, N.Y.: Orbis Books, 1995), p. 23.

62. Thomas Merton, "A Letter on the Contemplative Life," in Thomas Merton, *The Monastic Journey,* ed. Brother Patrick Hart (Garden City, N.Y.: Doubleday [Image Books], 1978), pp. 218–23.

63. Merton letter to John Howard Griffin, March 30, 1965, in *The Road to Joy,* op. cit., p. 133.

64. Consider, for example, figs. 41 and 49, both dating to 1948, in the classic monograph on Reinhardt: Lucy R. Lippard, *Ad Reinhardt* (New York: Abrams, 1981). As well, the thickly brushed lines of portfolio images 19 and 20 in this book are akin to Reinhardt's art of 1950, e.g., figs. 63–64 in Lippold, although I am unsure how to date these Merton works.

65. Thomas Merton, *Turning Toward the World,* op. cit., p. 311.

66. Three works dated 1963 in the collection of the Burns Library, Boston College, document this stage of Merton's developing art. A fourth, undated work in that collection is published here as portfolio 16.

67. Merton letter to Ernesto Cardenal, September 26, 1964, in *The Courage for Truth,* op. cit., p. 147.

68. Merton letters to Ad Reinhardt, October 31, 1963 and January 12, 1964, in *The Road to Joy,* op. cit., pp. 281–83. Please note that the next letter cited, Merton to Reinhardt, September 28, 1963, is available on microfilm at the Archives of American Art.

69. Ulfert Wilke, *One, Two and More* (Kyoto: Kuroyama Collotype Printing Company, 1960); large-scale, boxed portfolio of collotype prints.

70. Merton letter to Sr. Mary Charlotte, August 28, 1964, TMC collection. With the permission of the Merton Legacy Trust.

71. Merton letter to Sr. Mary Charlotte, September 7, 1964, TMC collection. With the permission of the Merton Legacy Trust.

72. Thomas Merton, *Dancing in the Water of Life,* op. cit., p. 149.

73. *At Home in the World,* op. cit., p. 96. See also Merton's letter of July 7, 1967, p. 78.

74. Documentation of the Paraclete Book Center exhibition will be found in *Thomas Merton and James Laughlin: Selected Letters,* op. cit., pp. 282, 303–4.

75. See "The Drawings of Thomas Merton," in the Washington, D.C. literary magazine *Voyages* 1:1, Fall 1967, pp. 53–60. The dated work is on p. 55; the text is a reprint of Merton's essay on his art.

76. Joost Baljeu, "The Problem of Reality with Suprematism, Constructivism, Proun, Neoplasticism and Elementarism," *The Lugano Review* 1, 1965, pp. 105ff.

77. W. H. Ferry, ed., *Letters from Tom: A selection of letters from Father Thomas Merton, monk of Gethsemani, to W. H. Ferry, 1961–1968* (Scarsdale, N.Y. Fort Hill Press, ca. 1983). A letter from Merton to Ferry, December 5, 1964, reveals Merton in the rare attitude of an art critic commenting on the expressiveness of abstract imagery.

"Thanks for your letters and geometric swirls," he wrote in response to a letter that must have had interesting sketches or doodles. "I like the ones that lead you into a funnel. There's where you have been putting your secret spirituality, you old Christian."

78. Merton letter to John Pick, March 30, 1965, TMC collection. With the permission of the Merton Legacy Trust.

79. Thomas Merton, *Day of a Stranger,* op. cit., p. 31.

80. Thomas Merton, *Dancing in the Water of Life,* op. cit., p. 255, referring to Mai-Mai Sze, *The Tao of Painting: A Study of the Ritual Disposition of Chinese Painting,* Bollingen Series 49 (New York: Pantheon Books, 1956).

81. Mai-Mai Sze, op. cit., p. 104.

82. Ibid., p. 102.

83. Merton letter to William Claire, June 14, 1967, TMC collection. With the permission of the Merton Legacy Trust. The evidence in this letter needs to be weighed against Merton's reference, in a letter of March 25, 1967, to "the abstract drawings I still do" (TM letter to Margaret Randall, in *The Courage for Truth,* op. cit., p. 218).

84. Published in *Voyages* 1:1, 1967, p. 60.

85. Thomas Merton, *Learning to Love,* op. cit., passim; see also *In the Dark Before Dawn: New Selected Poems of Thomas Merton,* ed. Lynn R. Szabo (New York: New Directions, 2005), which includes a selection from the original limited edition of Merton's poems from that period, *18 Poems* (New York: New Directions, 1985).

86. *Voyages,* 1:1, 1967, where this image appears on p. 58.

87. Thomas Merton, "The Solitary Life," in *The Monastic Journey,* op. cit., p. 207.

88. Ralph Eugene Meatyard, *Father Louie: Photographs of Thomas Merton,* ed. Barry Magid, with an essay by Guy Davenport (New York: Timken, 1991), p. 101.

89. Merton letter to Ad Reinhardt, January 12, 1964, in Joseph Masheck, "Five Unpublished Letters," op. cit.

90. Merton letter to Sr. Gabriel Mary, April 28, 1965, TMC collection. With the permission of the Merton Legacy Trust.

91. The exception is a series of images, probably created on a nonabsorbent matrix and perhaps with an atypical ink, and then printed off. The images have a gelatinous, spreading appearance, somewhat like watery sea plants.

92. Thomas Merton, *Turning Toward the World,* op. cit., p. 106.

93. Merton letter to Ulfert Wilke, October 19, 1964, TMC collection. With the permission of the Merton Legacy Trust.

94. Ralph Eugene Meatyard, *Father Louie,* op. cit., p. 25.

95. Merton letter to Jacques Maritain, April 10, 1956, in *The Courage for Truth,* op. cit., p. 27.

96. Thomas Merton, *Turning Toward the World,* op. cit., p. 135.

97. Thomas Merton, *Dancing in the Water of Life,* op. cit., p. 178.

98. Thomas Merton, Introduction to John C. H. Wu, *The Golden Age of Zen: Zen Masters of the Tang Dynasty* (1967; reprint, Bloomington, Ind.: World Wisdom, 2003), p. 18.

99. See William H. Shannon, *Thomas Merton's Dark Path: The Inner Experience of a Contemplative* (New York: Farrar, Straus and Giroux, 1981).

100. See note 90.

101. See pp. 82 and 96 for the full text.

102. Merton letter to Doña Luisa Coomaraswamy, February 12, 1961, in *The Hidden Ground of Love,* op. cit., p. 129.

103. See pp. 60–61 for the full text.

104. David Steindl-Rast, "Man of Prayer," in *Thomas Merton, Monk: A Monastic Tribute,* ed. Brother Patrick Hart (New York: Sheed and Ward, 1974), p. 89

105. Thomas Merton, "Theology of Creativity," in *The Literary Essays of Thomas Merton,* ed. Brother Patrick Hart (New York: New Directions, 1981), p. 364. This text was first published in 1960 in *The American Benedictine Review.* Readers familiar with the writings of Ananda K. Coomaraswamy will hear the echo of Coomaraswamy's thought in parts of this passage. Merton had in mind at one point to create a select anthology of Coomaraswamy's essays on art.

106. Merton letter to Robert Lax, October 3, 1963, in Arthur W. Biddle, ed., *When Prophecy Still Had a Voice,* op. cit., p. 251.

107. Thomas Merton, *Conjectures of a Guilty Bystander,* op. cit., p. 134.

108. *Cables to the Ace,* section 37, in *The Collected Poems of Thomas Merton* (New York: New Directions, 1977), p. 421.

109. Thomas Merton, *Turning Toward the World,* op. cit, p. 180.

110. Robert E. Daggy, ed., *Monks Pond: Thomas Merton's Little Magazine* (Lexington: University Press of Kentucky, 1989), where the fish appears on p. 24. See also p. 88.

111. The key passage on Paul Klee in Merton's journal: "I have an obligation to Paul Klee which goes deeper, even into the order of theology. An obligation about which I have done nothing. Knowing he is there in some museums or in the Skira [art] books is not enough. Nor is mimicry. My obligation is to seriously question him and reply to his question addressed to me, to justify in some sense the faith in me which he never knew he had (for how would he know *me*?). But he painted me, nevertheless, whether he wanted to or not." *Dancing in the Water of Life,* op. cit., p. 62.

112. Merton letter to Miguel Grinberg, May 11, 1964, in *The Courage for Truth,* op. cit., p. 198.

113. Some readers would want to know of two linked documents that help to substantiate this reading: (1) the birdlike image on p. 25 of *Raids on the Unspeakable* is illustrated in a newspaper clip in the Columbia University collection and identified by title as *Original Bird* (Sarah Lansdell, art editor, "Merton Drawings . . .", *The Courier-Journal,* n.d., late fall 1964); (2) The handlist of works and titles distributed at the Catherine Spalding College exhibition, preserved at the Thomas Merton Center and in other Merton collections (see fig. 22, p. 163), includes the title *Original Bird* and a work with a related title, *Bird Ikon I.* The Lansdell article also illustrates a drawing in the exhibition entitled *Ocean Signature.* This is the drawing on p. 7 of *Raids,* which I relate in this book to Merton's birdlike images. Further research on newspaper reviews of Merton's exhibition as it traveled from city to city might reconstitute additional elements of the exhibition. Just before this book went to press, photographs of three drawings in the traveling exhibition surfaced unexpectedly at the Thomas Merton Center: "Dancer II," "Sun-Dance," and "Outside Question," all dated 1964.

114. Thomas Merton, *New Seeds of Contemplation* (New York: New Directions, 1961), p. 297.

115. Thanks to Prof. Setsuya Kotani for translating the inscription.

116. Thomas Merton, *Dancing in the Water of Life,* op. cit., p. 62.

117. Thomas Merton, *The Climate of Monastic Prayer,* op. cit., p. 37.

118. A newspaper clipping (unfortunately mislaid) identifies this image in *Raids* as *Chief*; this title appears in the hand-list of the Catherine Spalding College exhibition.

119. Thomas Merton, "The Solitary Life," in *The Monastic Journey,* op. cit., p. 206.

120. Merton letter to Robert Lax, July 10, 1964, in *The Road to Joy,* op. cit., p. 176. Paul Pearson offered, in this connection, the observation that Merton gave three talks on Celtic monasticism in September 1964.

121. "I have been able to take a little time for reading in the woods, but have been trying to do too much especially with Richards' *Mencius* (getting excited about the ideograms and literal translations in the Appendix . . .)." Thomas Merton, *Turning Toward the World,* op. cit., p. 19. See I. A. Richards, *Mencius on the Mind* (London: Routledge and Kegan Paul, 1932), and later editions.

122. For example, *Artforum* 3:8, May 1965, pp. 36 ff., where di Suvero published photographs of new work, but perhaps even more likely as a model is a work at the St. Louis Art Museum, *Praise for Elohim Adonai,* 1965. See James K. Monte, *Mark di Suvero* (New York: Whitney Museum of Art, 1975), p. 49.

123. Merton letter to James Laughlin, February 3, 1965, in David D. Cooper, ed., *Thomas Merton and James Laughlin: Selected Letters,* op. cit., pp. 257–58.

124. Thomas Merton, "A Letter on the Contemplative Life," in *The Monastic Journey,* op. cit., p. 223; specified as written at the Abbey of Gethsemani, August 21, 1967.

125. See the text facing portfolio image 18 for fuller context.

126. Merton letter to Ludovico Silva, April 10, 1965, in *The Courage for Truth,* op. cit., p. 225.

127. *Cables to the Ace,* in *The Collected Poems of Thomas Merton,* op. cit., p. 452.

128. Thomas Merton, *The Other Side of the Mountain,* op. cit., p. 131.

129. The journal for this brief period of travel was published separately as Thomas Merton, *Woods, Shore, Desert* (Santa Fe: University of New Mexico Press, 1984).

130. Merton letter to Mother Myriam Dardenne, September 7, 1968, in *The School of Charity*, op. cit., p. 396.

131. Thomas Merton, *The Climate of Monastic Prayer*, op. cit., p. 94.

132. Thomas Merton, *The Other Side of the Mountain*, op. cit., p. 132.

133. Ibid., p. 325.

The Art of Thomas Merton: Thirty-four Images

All works cited in this set of endnotes are by Thomas Merton unless otherwise indicated.

1. *The Courage for Truth*, op. cit., p. 216.

2. Robert E. Daggy, ed., *Monks Pond*, op. cit., pp. 24, 88.

3. "Signatures: Notes on the Author's Drawings," in *Raids on the Unspeakable*, op. cit., pp. 179–82.

4. *The Monastic Journey*, op. cit., p. 30.

5. *Conjectures of a Guilty Bystander*, op. cit., pp. 81–82.

6. *Turning Toward the World*, op. cit., p. 27.

7. *Contemplation in a World of Action* (Garden City, N.Y.: Doubleday, 1971), p. 345.

8. *The Courage for Truth*, op. cit., p. 198.

9. "Answers on Art and Freedom," in *Raids on the Unspeakable*, op. cit., p. 171.

10. *Witness to Freedom*, op. cit., p. 73.

11. *The Literary Essays of Thomas Merton*, ed. Brother Patrick Hart, op. cit., p. 364. This text was first published in *The American Benedictine Review* in 1960.

12. *Dancing in the Water of Life*, op. cit., p. 67.

13. Ibid., p. 334.

14. *Conjectures of a Guilty Bystander*, op. cit., pp. 133–34.

15. "Answers on Art and Freedom," in *Raids on the Unspeakable*, op. cit., p. 175.

16. *Witness to Freedom*, op. cit., pp. 329–30.

17. *Conjectures of a Guilty Bystander*, op. cit., p. 134.

18. *The Courage for Truth*, op. cit., p. 198.

19. *Conjectures of a Guilty Bystander*, op. cit., p. 228.

20. *The Collected Poems of Thomas Merton*, op. cit., p. 245.

21. *Witness to Freedom*, op. cit., p. 276. Merton was reading Louis Massignon's French translation (1957) of writings by Husayn ibn Mansur al-Hallaj, the celebrated Sufi mystic and martyr (d. 922 C.E.).

22. *Thomas Merton in Alaska*, ed. Robert E. Daggy (New York: New Directions, 1988), p. 118.

23. *Dancing in the Water of Life*, op. cit., p. 178.

24. *Turning Toward the World*, op. cit., pp. 233–34.

25. *Dancing in the Water of Life*, op. cit., p. 319.

26. *Learning to Love*, op. cit., p. 10.

27. Ibid., p. 201.

28. *The Courage for Truth*, op. cit., pp. 216–17.

29. Notes toward the Catherine Spalding College exhibition, Notebook 14, 1964, TMC collection. With the permission of the Merton Legacy Trust.

30. *When Prophecy Still Had a Voice*, ed. Arthur W. Biddle, op. cit., p. 269.

31. *Witness to Freedom*, op. cit., p. 32.

32. *Contemplation in a World of Action*, op. cit., p. 230.

33. *Love and Living*, ed. Naomi Burton Stone and Brother Patrick Hart (New York: Farrar, Straus and Giroux, 1979), pp. 193–94.

34. *Witness to Freedom*, op. cit., p. 254.

35. *New Seeds of Contemplation* (New York: New Directions, 1961), pp. 296–97.

36. *The Climate of Monastic Prayer* (Kalamazoo, Mich.: Cistercian Publications, 1969), p. 90.

37. *Dancing in the Water of Life*, op. cit., p. 265

38. *The Collected Poems of Thomas Merton*, op. cit., p. 449.

39. *The Climate of Monastic Prayer*, op. cit., p. 25.

40. Notes toward the Catherine Spalding College exhibition, op. cit.

41. *Raids on the Unspeakable*, op. cit., p. 9.

42. Mai-Mai Sze, *The Tao of Painting*, op. cit., p. 31 (as transcribed by Merton).

43. Ibid., p. 55 (emphasis added by Merton).

44. *The Road to Joy*, op. cit., p. 90.

45. *The Courage for Truth*, op. cit., pp. 200–1.

46. "Answers on Art and Freedom," in *Raids on the Unspeakable*, op. cit., p. 173.

47. *Turning Toward the World*, op. cit., p. 73.

48. *Zen and the Birds of Appetite* (New York: New Directions, 1968), p. 6.

49. Mai-Mai Sze, *The Tao of Painting*, op. cit., p. 99.

50. *The Hidden Ground of Love*, op. cit., p. 138.

51. *Love and Living*, op. cit., p. 40.

52. *The Courage for Truth*, op. cit, p. 226.

53. *The Hidden Ground of Love*, op. cit., p. 116.

54. *The Asian Journal of Thomas Merton*, ed. Naomi Burton, Patrick Hart, and James Laughlin (New York: New Directions, 1973), pp. 153–55.

55. *The Hidden Ground of Love*, op. cit., p. 156. The version of this image published in the literary magazine *Voyages* 1:1, Fall 1967, now in the Albert Romkema collection of Merton materials, can be viewed online at www.merton-artifacts.com.

56. *Conjectures of a Guilty Bystander*, op. cit., p. 266.

57. *Learning to Love*, op. cit., pp. 160–61.

58. *Conjectures of a Guilty Bystander*, op. cit., p. 32.

59. *The Hidden Ground of Love*, op. cit., p. 37.

60. *Learning to Love*, op. cit., p. 354.

61. *The Courage for Truth*, op. cit., p. 225.

62. *The School of Charity*, op. cit., p. 271 (this entry slightly reedited from the original in the Burns Library, Boston College).

63. David Steindl-Rast, citing Merton in conversation, in *Thomas Merton, Monk: A Monastic Tribute*, op. cit., p. 89.

64. *Conjectures of a Guilty Bystander*, op. cit., p. 201.

65. *The School of Charity*, p. 241.

66. *Conjectures of a Guilty Bystander*, op. cit., p. 142.

67. *The Hidden Ground of Love*, op. cit., p. 624.

68. *Turning Toward the World*, op. cit, pp. 321–22.

69. *The Other Side of the Mountain*, op. cit., p. 56.

70. *A Search for Solitude: Pursuing the Monk's True Life* (*The Journals of Thomas Merton*, vol. 3, 1952–1960), ed. Lawrence S. Cunningham (San Francisco: HarperSanFrancisco, 1996), p. 381.

71. *Conjectures of a Guilty Bystander*, op. cit., p. 199.

72. *The Hidden Ground of Love*, op. cit., p. 643.

73. From a statement written by Merton for the jacket of *A Thomas Merton Reader*, ed. Thomas P. McDonnell (New York: Harcourt Brace and World, 1962).

74. *The Wisdom of the Desert*, op. cit., p. 45.

Three Studies

1. Merton letter to Jacques Maritain, June 11, 1963, *The Courage for Truth*, op. cit., p. 40.

2. Merton letter to Czeslaw Milosz, March 15, 1968, in *Striving Towards Being: The Letters of Thomas Merton and Czeslaw Milosz*, ed. Robert Faggen (New York: Farrar, Straus and Giroux, 1997), p. 175.

3. Victor Hammer letter to Merton, May 2, 1959, TMC collection. With the permission of the Estate of Victor and Carolyn Hammer and the Merton Legacy Trust.

4. Robert Lax letter to Merton, March 13, 1964, *When Prophecy Still Had a Voice*, op. cit., p. 270.

5. Robert Lax letter to Merton, n.d. but shortly before the May 1959 visit to Gethsemani. Cited with the permission of the Rare Book and Manuscript Library, Columbia University, and Anna Reinhardt.

6. Merton letter to Sr. Thérèse Lentfoehr, May 14, 1959, *The Road to Joy*, op. cit., p. 233

7. Ad Reinhardt letter to Merton, n.d. but soon after the May 1959 visit to Gethsemani. With the permission of the Rare Book and Manuscript Library, Columbia University, and Anna Reinhardt.

8. Merton letter to Robert Lax, October 17, 1963, *When Prophecy Still Had a Voice*, op. cit., pp. 254–52.

9. Merton letter to Robert Lax, October 23, 1963, ibid., p. 256.

10. Merton letter to Ad Reinhardt, October 31, 1963, *The Road to Joy*, op. cit., p. 281. In his funny line about toilet paper, Merton is either recalling or reliving an inscription on one of Sengai's calligraphic scrolls. Sengai's calligraphy was much sought after. "They seem to think/My study is a kind of toilet,/They each come/With a roll of paper." Daisetz T. Suzuki, *Sengai: The Zen Master*, op. cit., p. 26. Merton could not have seen this book but would have seen the Sengai scroll in one of the calendars sent him annually by Suzuki.

Merton's reference to bare feet responds to a letter from Ad Reinhardt, who teasingly reproved Merton for making his calligraphic drawings too small. "Don't you know," wrote Reinhardt, "them fellows way down East used brushes bigger than anyone's big head, a big pot of

paint size of a big sink, and in bare feet, dance over a piece of paper. . . ." Reinhardt to Merton, October 3, 1963, TMC. With the permission of Anna Reinhardt and the Thomas Merton Center.

11. Thomas Merton, *Dancing in the Water of Life,* op. cit., p. 58.

12. Merton letter to Robert Lax, March 5, 1964, *When Prophecy Still Had a Voice,* op. cit., pp. 268–69.

13. Thomas Merton, *Dancing in the Water of Life,* op. cit., p. 175.

14. Merton letter to Robert Lax, September 5, 1967, *When Prophecy Still Had a Voice,* op. cit., pp. 368–69.

15. *Monks Pond* 1, Spring 1968, p. 6, first published in *Art International,* December 1962. Merton must have seen something like this text before 1962, because he wrote to Mark Van Doren, his literature professor at Columbia, in February 1961: "I like Reinhardt's dogmatic definitions about abstract art." *The Road to Joy,* op. cit., p. 40. See Merton's own formulation in a passage tied to portfolio image 2 in this book.

16. Wilke's biography, excellent photographs of the artist and his work, and a stimulating appraisal of his art will be found in Gerald Nordland, *Ulfert Wilke: A Retrospective* (Salt Lake City: Utah Museum of Fine Arts, University of Utah, 1983).

17. See Ulfert Wilke, *An Artist Collects: Selections from Five Continents* (Iowa City: University of Iowa Museum of Art, 1975).

18. Journals of Ulfert Wilke, entry for September 6, 1963. With the kind permission of Nicholas Wilke and the Archives of American Art. Wilke's journal reflects his English-language usage, eloquent and free but sometimes straying from idiomatic English or back into his native German—as, for example, his use of German *Askese* for English asceticism.

19. Ibid., September 7, 1963.

20. Sr. Mary Charlotte letter to Merton, August 28, 1964, TMC collection. With the permission of the Merton Legacy Trust and Catherine Spalding University.

21. Ulfert Wilke, *One, Two and More* (Kyoto: Kuroyama Collotype Printing Company, 1960).

22. Thomas Merton, *Dancing in the Water of Life,* op. cit., p. 132.

23. Ibid., entry for August 29, 1964, p. 139.

24. Ibid., entry for October 25, 1964, p. 157.

25. Merton letter to Sr. Mary Charlotte, December 13, 1964, TMC collection. With the permission of the Merton Legacy Trust.

26. Thomas Merton, *Learning to Love,* op. cit., pp. 269–70.

27. Biographical sources for Victor Hammer include John Rothenstein, *Victor Hammer: Artist and Craftsman* (Boston: David R. Godine, 1978); *Victor Hammer: Artist and Printer,* ed. Carolyn R. Hammer (Lexington, Ky.: Anvil Press, 1981); *Victor Hammer: A Retrospective Exhibition,* April 4–25, 1965 (Raleigh: North Carolina Museum of Art).

28. *Letters of Wallace Stevens,* ed. Holly Stevens (New York: Alfred A. Knopf, 1966), p. 681.

29. Thomas Merton, *Turning Toward the World,* op. cit., p. 180.

30. *Victor Hammer: A Retrospective Exhibition,* op. cit., p. 75.

31. John Rothenstein, *Victor Hammer: Artist and Craftsman,* op. cit., p. 9.

32. Victor Hammer, *Some Fragments for C. R. H.* (Lexington, Ky: Stamperia del Santuccio, 1967), p. 16.

33. Thomas Merton, *A Search for Solitude,* op. cit., p. 178.

34. Thomas Merton, *Prometheus: A Meditation* (Lexington, Margaret I. King Library Press, University of Kentucky, 1958); Thomas Merton, *Hagia Sophia* (Lexington: Stamperia del Santuccio, 1962). Other publications of unusual beauty in the Merton/Hammer bibliography are *The Ox Mountain Parable,* with notes and text by Thomas Merton after the translation by I. A. Richards (Lexington: Stamperia del Santuccio, 1960); Thomas Merton, trans., *What Ought I to Do? Sayings from the Desert Fathers of the Fourth Century (Verba Seniorum)* (Lexington: Stamperia del Santuccio, 1959); and Thomas Merton, *The Solitary Life* (Lexington: Stamperia del Santuccio, 1960).

35. Merton letter to Victor Hammer, May 14, 1959, *Witness to Freedom,* op. cit., p. 5.

36. Thomas Merton, *Turning Toward the World,* op. cit., p. 69.

37. Thomas Merton, *A Search for Solitude,* op. cit., pp. 271–72.

38. Ibid., p. 383.

39. Thomas Merton, *Dancing in the Water of Life,* op. cit., p. 162.

40. Merton letter to Victor Hammer, November 3, 1964, *Witness to Freedom*, op. cit., p. 10.

41. "Out of town there is Victor Hammer, but he would not be able to come and would not like the drawings either." Merton letter to Aloys Landes, Director of Development, Catherine Spalding College, October 28, 1964, TMC collection. With the permission of the Merton Legacy Trust.

42. Victor Hammer letter to Merton, May 29, 1966, TMC collection. With the permission of the Estate of Victor and Carolyn Hammer and the Thomas Merton Center.

43. Thomas Merton, foreword, in *Victor Hammer: A Retrospective Exhibition*, op. cit., p. 5.

44. Thomas Merton, *Learning to Love*, op. cit., pp. 260–61.

45. Robert E. Daggy, ed., *Encounter*, op. cit., pp. 85–86.

46. Thomas Merton, *Zen and the Birds of Appetite*, op. cit., p. 47. The word *kerygma*, from the Greek meaning "herald," may be unfamiliar; it refers in the period of the early apostles to their dissemination of the new faith.

47. Ibid., p. 38.

48. Ibid., p. 61. This essay on D. T. Suzuki was first published in 1967.

49. Merton letter to an Anglican priest, Father Aelred, December 8, 1964, *The School of Charity*, op. cit., p. 254.

50. Merton letter to Robert Lax, July 10, 1964, *When Prophecy Still Had a Voice*, op. cit., p. 280.

51. Thomas Merton, *Zen and the Birds of Appetite*, op. cit., p. 62.

52. Thomas Merton, *Thomas Merton in Alaska: The Alaskan Conferences, Journals, and Letters*, ed. Robert E. Daggy, et al. (New York: New Directions), 1988, p. 122.

53. Merton letter to Daisetz T. Suzuki, March 4, 1965, *The Hidden Ground of Love*, op. cit., p. 570.

54. Ibid.

55. Merton's memorial for Suzuki has been cited here in its American edition, "D. T. Suzuki: The Man and His Work," in *Zen and the Birds of Appetite*, op. cit., pp. 59–66.

56. Thomas Merton, *Learning to Love*, op. cit., p. 367. The lives and work of highly influential people eventually undergo critical reexamination, and in recent years Suzuki's time has come. Some scholars in his field now question his presentation of Zen—was it biased in various ways, did it understate the importance of some elements? Further, one of Suzuki's essays in Japanese for the home audience during the Second World War has been reproached for suggesting that the entire Japanese people would be better off if it adopted the samurai code, the code of the warrior trained in Zen and indifferent to death. I have no doubt whatever that the contributions of this immensely creative and benevolent scholar-sage far outweigh errors in judgment, scholarly or moral. But it is no error to look closely. See Brian (Daizen) A. Victoria, *Zen at War* (New York and Tokyo: Weatherhill, 1997), and Brian Daizen Victoria, *Zen War Stories* (London and New York: RoutledgeCurzon, 2003). General biographical sources include A. Irwin Switzer III, *D. T. Suzuki: A Biography* (London: Buddhist Society, 1985), and Masao Abe, ed., *A Zen Life: D. T. Suzuki Remembered* (New York and Tokyo: Weatherhill, 1986).

57. For a very brief note on the first meeting, see Thomas Merton, *Run to the Mountain*, op. cit., p. 58.

58. Merton letter to Jacques Maritain, June 11, 1963, in *The Courage for Truth*, op. cit., p. 40.

59. Jacques Maritain letter to Merton, September 12, 1964, trans. R. Lipsey, TMC collection. With the permission of the Thomas Merton Center and the Estate of Jacques Maritain. The Jacques Maritain Center at the University of Notre Dame, Indiana, holds the English-language rights to the works of Jacques Maritain.

60. Merton's side of the correspondence will be found in Thomas Merton, *The Courage for Truth*, op. cit., pp. 22–53; Maritain's side is preserved at the Thomas Merton Center.

61. Jacques Maritain, *Creative Intuition in Art and Poetry*, The A.W. Mellon Lectures in the Fine Arts, 1952, National Gallery of Art, Washington, D.C. Bollingen Series 35.1 (New York: Pantheon Books, 1953).

62. See Michael Novak, "Human Dignity, Human Rights (Universal Declaration of Human Rights)," *First Things*, November 1, 1999 (available online at www.firstthings.com/ftissues/ft9911/articles/mnovak.html).

63. For Merton's views in 1960 on Maritain's approach to art, see his essay "Theology of Creativity," in *The Literary Essays of Thomas Merton*, ed. Brother Patrick Hart (New York: New Directions, 1981), pp. 355–70, esp. pp. 366 ff.

This essay, somewhat brittle and wordy, represents the closing phase of Merton's passage out of the difficulties he encountered in the *Art and Worship* project.

64. Merton transcribed this passage from Jacques Maritain, *Art and Scholasticism and The Frontiers of Poetry,* trans. Joseph W. Evans (New York: Scribner, 1962), p. 48. I want to use this note to signal the recent publication of a book by Rowan Williams, Archbishop of Canterbury, which takes as a recurrent point of reference the writings on art of Jacques Maritain (see bibliography for details).

65. See Thomas Merton, *Conjectures of a Guilty Bystander,* op. cit., p. 188.

66. Merton letter to Jacques Maritain, October 13, 1966, *The Courage for Truth,* op. cit, p. 48. The words cited, "Avec toute mon affection filiale," omitted in the letter as published, are cited from a copy of the handwritten letter in the collection of the Thomas Merton Center. With the permission of the Merton Legacy Trust.

67. Jacques Maritain letter to Merton, September 27, 1965, trans. R. Lipsey, TMC collection. With the permission of the Merton Legacy Trust and the Estate of Jacques Maritain.

68. Merton letter to Jacques Maritain, June 30, 1960, *The Courage for Truth,* op. cit., p. 30.

69. Thomas Merton, *Entering the Silence,* op. cit., p. 259.

70. Merton letter to Dom Jean Leclercq, *The School of Charity,* op. cit., p. 85.

71. Merton letter to "Frank," October 16, 1967, Boston College collection. With the permission of the Burns Library, Boston College, and the Merton Legacy Trust.

72. Thomas Merton, translation (last stanza) from Raïssa Maritain, "Mosaic: St. Praxed's," in *The Collected Poems of Thomas Merton,* op. cit., p. 965. See Thomas Merton, "Raïssa Maritain," in Brother Patrick Hart, ed., *The Literary Essays of Thomas Merton,* op. cit., pp. 307–8; also Raïssa Maritain, *Notes on the Lord's Prayer,* with a foreword by Thomas Merton (New York: P. J. Kennedy, 1964).

73. Merton letter to Jacques Maritain, March 7, 1966, *The Courage for Truth,* op. cit., p. 47.

74. Michael Mott, *The Seven Mountains of Thomas Merton* (Boston: Houghton Mifflin, 1984), p. 461.

75. Merton letter to Robert Lax, November 4, 1966, *When Prophecy Still Had a Voice,* op. cit., p. 347.

76. Jacques Maritain letter to Merton, November 10, 1966, trans. R. Lipsey, TMC collection. With the permission of the Thomas Merton Center and the Estate of Jacques Maritain.

77. Merton letter to Jacques Maritain, June 11, 1963, *The Courage for Truth,* op. cit., p. 40.

78. Mark Tobey, Introduction to Ulfert Wilke, *Music To Be Seen: A Portfolio of Drawings* (Louisville, Ky.: Erewhon Press, n.d., ca. 1957).

79. There is an extensive literature on the art and thought of Mark Tobey. See, for example, William C. Seitz, *Mark Tobey* (New York: The Museum of Modern Art, 1962), and Wulf Herzogenrath and Andreas Kreul, eds., *Sounds of the Inner Eye: John Cage, Mark Tobey, Morris Graves* (Tacoma: Museum of Glass, International Center for Contemporary Art, 2002).

80. Merton letter to Miguel Grinberg, May 11, 1964, *The Courage for Truth,* op. cit., p. 198.

81. Merton letter to Victor Hammer, November 9, 1963, *Witness to Freedom,* op. cit., p. 8.

82. See Henri Alexis Baatsch et al., *Henri Michaux* (Paris: Centre Georges Pompidou, Musée national d'art moderne, 1978), and Fred Jahn and Michael Krueger, eds., *Henri Michaux 1942–1984* (Munich: Verlag Fred Jahn, 1987).

83. Thomas Merton, "Answers on Art and Freedom," in *Raids on the Unspeakable,* op. cit., p. 171.

84. Thomas Merton, Notes on Art, Novitiate Conferences, Summer 1964, pp. 1–2, TMC collection. With the permission of the Merton Legacy Trust.

85. John Cage, *Silence: Lectures and Writings by John Cage* (Middletown, Conn.: Wesleyan University Press, 1961), p. xi.

86. John Cage, "Autobiographical Statement," *Southwest Review,* 1991; cited from www.newalbion.com/artists/cagej/autobiog.html.

87. Stephen Mitchell, ed., *The Enlightened Heart: An Anthology of Sacred Poetry* (New York: HarperPerennial, 1993), p. 26.

88. Thomas Merton, *The Other Side of the Mountain,* op. cit., p. 262.

89. John Cage, *Silence,* op. cit., pp. 132–33.

90. John Cage, "Autobiographical Statement," op. cit.

91. John Cage, *Silence,* op. cit., p. 10.

92. Wulf Herzogenrath, "John Cage: An Artist who Accepts Life," in *Sounds of the Inner Eye,* op. cit., p. 2.

93. Thomas Merton, *Zen and the Birds of Appetite,* op. cit., p. 6.

94. John Cage, *Silence,* op. cit., p. 12.

95. Ibid., p. 67.

96. Merton letter to Robert Lax, July 10, 1964, *When Prophecy Still Had a Voice,* op. cit., pp. 280–81.

97. Thomas Merton, *Learning to Love,* op. cit., p. 264.

98. Sr. Mary Charlotte letter to Merton, August 28, 1964, TMC collection. With the permission of the Thomas Merton Center and Catherine Spalding University.

99. Merton letter to Sr. Mary Charlotte, September 7, 1964, TMC collection. On the topic of personal publicity, see also Merton to Aloys H. Landes of Catherine Spalding College, October 10, 1964, TMC collection: "One point that I think we ought to anticipate is this: Father Abbot and I myself both feel that too much personal emphasis in publicity would *not* be desirable. To be concrete: we would like to avoid pictures of me in the *papers.*" Both letters cited with the permission of the Merton Legacy Trust.

100. Merton letter to Aloys H. Landes, October 10, 1964, TMC collection. With the permission of the Merton Legacy Trust.

101. Merton letter to James Forest, March 16, 1964, *The Hidden Ground of Love,* op. cit., pp. 279–80.

102. Merton letter to Miguel Grinberg, *The Courage for Truth,* op. cit., pp. 200–1.

103. Merton letter to Aloys H. Landes, October 28, 1964, TMC collection. With the permission of the Merton Legacy Trust.

104. Thomas Merton, *Dancing in the Water of Life,* op. cit., p. 170.

105. Among the works listed in fig. 22, reproduced from Merton's handwritten notes when he visited Catherine Spalding College some weeks before the exhibition, several are reproduced in Thomas Merton, *Raids on the Unspeakable,* op. cit., and within that published group several can be securely linked with these published titles.

106. See Merton letter to W. H. (Ping) Ferry, December 5, 1964, and Merton letter to Sr. Mary Charlotte, December 13, 1964, TMC collection.

107. Merton letter to Robert Lax, October 31, 1964, *When Prophecy Still Had a Voice,* op. cit., p. 283.

108. John Pick letter to Merton, March 11, 1965, TMC collection. With the permission of the Merton Legacy Trust and Catherine Spalding University.

109. Sr. Mary Charlotte letter to Merton, n.d. (Christmastide 1964), TMC collection. With the permission of the Merton Legacy Trust and Catherine Spalding University.

110. Merton letter to Sr. Lurana, December 14, 1964, TMC collection. With the permission of the Merton Legacy Trust.

111. Merton letter to Sr. Mary Luke Tobin, December 21, 1964, *The School of Charity,* op. cit., p. 255.

112. Merton letter to John Pick, March 3, 1965, TMC collection. With the permission of the Merton Legacy Trust.

113. Merton letter to Ethel Kennedy, February 26, 1965, *The Hidden Ground of Love,* op. cit., p. 448.

114. Mary Tardiff, ed., *At Home in the World,* op. cit., p. 97.

115. Merton letter to Sr. Mary Charlotte, March 27, 1965, TMC collection. With the permission of the Merton Legacy Trust.

116. The most recent exhibition of photography was "A Hidden Wholeness: The Zen Photography of Thomas Merton," December 2004–January 2005, Bellarmine University, Louisville, curated by Paul M. Pearson with a catalog including contributions by Paul M. Pearson, Deba P. Patnaik, and Bonnie B. Thurston, published by the Thomas Merton Center, 2004.

BIBLIOGRAPHY

Journals

Run to the Mountain: The Story of a Vocation. The Journals of Thomas Merton, vol. 1, 1939–1941. Edited by Brother Patrick Hart. San Francisco: HarperSanFrancisco, 1995.

Entering the Silence: Becoming a Monk and Writer. The Journals of Thomas Merton, vol. 2, 1941–1952. Edited by Jonathan Montaldo. San Francisco: HarperSanFrancisco, 1997.

A Search for Solitude: Pursuing the Monk's True Life. The Journals of Thomas Merton, vol. 3, 1952–1960. Edited by Lawrence S. Cunningham. San Francisco: HarperSanFrancisco, 1996.

Turning Toward the World: The Pivotal Years. The Journals of Thomas Merton, vol. 4, 1960–1963. Edited by Victor A. Kramer. San Francisco: HarperSanFrancisco, 1996.

Dancing in the Water of Life: Seeking Peace in the Hermitage. The Journals of Thomas Merton, vol. 5, 1963–1965. Edited by Robert E. Daggy. San Francisco: HarperSanFrancisco, 1997.

A Vow of Conversation: Journals 1964–1965. Edited by Naomi Burton Stone. New York: Farrar, Straus and Giroux, 1988.

Learning to Love: Exploring Solitude and Freedom. The Journals of Thomas Merton, vol. 6, 1966–1967. Edited by Christine M. Bochen. San Francisco: HarperSanFrancisco, 1997.

The Other Side of the Mountain: The Journals of Thomas Merton, vol. 7, 1966–1967. Edited by Brother Patrick Hart. San Francisco: HarperSanFrancisco, 1998.

The Asian Journal of Thomas Merton. Edited by Naomi Burton, Patrick Hart, and James Laughlin. New York: New Directions, 1973.

Woods, Shore, Desert: A Notebook, May 1968. Albuquerque: University of New Mexico Press, 1984.

Thomas Merton in Alaska. Edited by Robert E. Daggy. New York: New Directions, 1988.

Correspondence

At Home in the World: The Letters of Thomas Merton and Rosemary Radford Ruether. Edited by Mary Tardiff. Maryknoll, N.Y.: Orbis, 1995.

The Courage for Truth: The Letters of Thomas Merton to Writers. Edited by Christine M. Bochen. New York: Farrar, Straus and Giroux, 1993.

Encounter: Thomas Merton and D. T. Suzuki. Edited by Robert E. Daggy. Monterey, Ky.: Larkspur Press, 1988.

"Five Unpublished Letters from Ad Reinhardt to Thomas Merton and Two in Return." Edited with an introduction by Joseph Masheck. *Artforum,* December 1978.

187

The Hidden Ground of Love: The Letters of Thomas Merton on Religious Experience and Social Concerns. Edited by William H. Shannon. New York: Farrar, Straus and Giroux, 1985.

Letters from Tom: A selection of letters from Father Thomas Merton, monk of Gethsemani, to W. H. Ferry, 1961–1968. Edited by W. H. Ferry. Scarsdale, N.Y.: Fort Hill Press, ca. 1983.

The Road to Joy: The Letters of Thomas Merton to New and Old Friends. Edited by Robert E. Daggy. New York: Farrar, Straus and Giroux, 1989.

The School of Charity: The Letters of Thomas Merton on Religious Renewal and Spiritual Direction. Edited by Brother Patrick Hart. New York: Farrar, Straus and Giroux, 1990.

Striving Towards Being: The Letters of Thomas Merton and Czeslaw Milosz. Edited by Robert Faggen. New York: Farrar, Straus and Giroux, 1997.

Survival or Prophecy?: The Letters of Thomas Merton and Jean Leclercq. Edited by Brother Patrick Hart. New York: Farrar, Straus and Giroux, 2002.

Thomas Merton and James Laughlin, Selected Letters. Edited by David D. Cooper. New York and London: W.W. Norton, 1997.

When Prophecy Still Had a Voice: The Letters of Thomas Merton and Robert Lax. Edited by Arthur W. Biddle. Lexington: University Press of Kentucky, 2001. [Close students of Merton's writings will also want to be aware of Merton's own edition of selected correspondence with Robert Lax, now superseded by Biddle's larger edition: *A Catch of Anti-Letters,* with a foreword by Brother Patrick Hart. Kansas City: Sheed, Andrews, and McMeel, 1978.]

Witness to Freedom: The Letters of Thomas Merton in Times of Crisis. Edited by William H. Shannon. San Diego: Farrar, Straus and Giroux, 1994.

Books

The Climate of Monastic Prayer. Kalamazoo, Mich.: Cistercian Publications, 1969.

The Collected Poems of Thomas Merton. New York: New Directions, 1977.

Conjectures of a Guilty Bystander. Garden City, N.Y.: Doubleday, 1966.

Contemplation in a World of Action. Garden City, N.Y.: Doubleday, 1971.

Day of a Stranger. Salt Lake City: Gibbs M. Smith, 1981.

Dialogues with Silence: Prayers and Drawings. Edited by Jonathan Montaldo. San Francisco: HarperSanFrancisco, 2001. [The best source for Merton's art before 1960 at the monastery.]

Eighteen Poems. New York: New Directions, 1985.

Hagia Sophia. Lexington: Stamperia del Santuccio, 1962.

In the Dark Before Dawn: New Selected Poems of Thomas Merton. Edited by Lynn R. Szabo. New York: New Directions, 2005.

Introductions East and West: The Foreign Prefaces of Thomas Merton. Edited by Robert E. Daggy. Greensboro, N.C.: Unicorn Press, 1981.

The Literary Essays of Thomas Merton. Edited by Brother Patrick Hart. New York: New Directions, 1981.

Love and Living. Edited by Naomi Burton Stone and Brother Patrick Hart. New York: Farrar, Straus and Giroux, 1979.

The Monastic Journey. Edited by Brother Patrick Hart. Garden City, N.Y.: Doubleday (Image Books), 1978.

Monks Pond: Thomas Merton's Little Magazine. Edited by Robert E. Daggy. Lexington: University Press of Kentucky, 1968.

Mystics and Zen Masters. New York: Farrar, Straus and Giroux, 1967.

New Seeds of Contemplation. New York: New Directions, 1961.

Prometheus: A Meditation. Lexington: Margaret I. King Library Press, University of Kentucky, 1958.

Raids on the Unspeakable. New York: New Directions, 1966.

The Seven Storey Mountain. New York: Harcourt, Brace, 1948.

The Sign of Jonas. New York and London: Harcourt, Brace, 1953.

A Thomas Merton Reader. Edited by Thomas P. McDonnell. New York: Harcourt, Brace and World, 1962.

The Wisdom of the Desert: Sayings from the Desert Fathers of the Fourth Century. New York: New Directions, 1960.

Zen and the Birds of Appetite. New York: New Directions, 1968.

Articles

"The Drawings of Thomas Merton." *Voyages* 1:1, Fall 1967, pp. 53–60.

Introduction to John C. H. Wu, *The Golden Age of Zen: Zen Masters of the Tang Dynasty.* 1967. Reprint, Bloomington, Ind.: World Wisdom, 2003.

Books and Articles about Thomas Merton

Betz, Margaret. "Merton's Images of Elias, Wisdom, and the Inclusive God." In *The Merton Annual: Studies in Culture, Spirituality, and Social Concerns,* vol. 13. Trowbridge, U.K.: Sheffield Academic Press, 2000.

Bruzda, Katarzyna. "Thomas Merton—An Artist." *Studia Mertoniana* 2, 2003, pp 177–96.

Cooper, David D. *Thomas Merton's Art of Denial: The Evolution of a Radical Humanist.* Athens, Ga., and London: University of Georgia Press, 1989.

Cunningham, Lawrence S. "The Black Painting in the Hermit Hatch: A Note on Thomas Merton and Ad Reinhardt." *The Merton Seasonal,* 11/4, Autumn 1986.

Forest, James. *Thomas Merton: A Pictorial Biography.* New York: Paulist Press, 1980.

Furlong, Monica. *Merton: A Biography.* New York: Harper and Row, 1980.

Griffin, John Howard. *A Hidden Wholeness: The Visual World of Thomas Merton.* Boston: Houghton Mifflin, 1979.

Hart, Patrick, ed. *Thomas Merton, Monk: A Monastic Tribute.* New York: Sheed and Ward, 1974.

Montaldo, Jonathan. "A Gallery of Women's Faces and Dreams of Women from the Drawings and Journals of Thomas Merton." *The Merton Seasonal* 14, 2001.

Mott, Michael. *The Seven Mountains of Thomas Merton.* Boston: Houghton Mifflin, 1984.

Patnaik, Deba Prasad, ed. *Geography of Holiness: The Photography of Thomas Merton.* New York: Pilgrim Press, 1980.

Rice, Edward. *The Man in the Sycamore Tree: The Good Times and Hard Life of Thomas Merton.* Garden City, N.Y.: Doubleday, 1970.

Shannon, William H. *Silent Lamp: The Thomas Merton Story.* New York: Crossroad, 1996.

———. *Thomas Merton's Dark Path: The Inner Experience of a Contemplative.* New York: Farrar, Straus and Giroux, 1981.

———. Christine M. Bochen, and Patrick F. O'Connell, eds. *The Thomas Merton Encyclopedia,* Maryknoll, N.Y.: Orbis, 2002.

Other Sources

Abe, Masao. *A Zen Life: D. T. Suzuki Remembered.* New York and Tokyo: Weatherhill, 1986.

Baatsch, Henri Alexis, et al. *Henri Michaux.* Paris: Centre Georges Pompidou, Musée national d'art moderne, 1978.

Baljeu, Joost. "The Problem of Reality with Suprematism, Constructivism, Proun, Neoplasticism and Elementarism." *The Lugano Review* 1:1965, pp. 105 ff.

Blyth, R. H. *Mumonkan: Zen and Zen Classics,* vol. 4. Tokyo: Hokuseido Press, 1966.

Cage, John. "Autobiographical Statement." *Southwest Review,* 1991. Online at www.newalbion.com/artists/cagej/auto biog.html.

———. *Silence: Lectures and Writings by John Cage.* Middletown, Conn.: Wesleyan University Press, 1961.

Chryssavgis, John. *In the Heart of the Desert: The Spirituality of the Desert Fathers and Mothers.* Bloomington: World Wisdom, 2003.

Congdon, William. *In My Disc of Gold: Itinerary to Christ of William Congdon.* New York: Reynal & Co., n.d., but ca. 1962.

De Thieulloy, Guillaume. *Le Chevalier de l'Absolu: Jacques Maritain entre Mystique et Politique.* Paris: Editions Gallimard, 2005.

Georgiou, Steve Theodore. *The Way of the Dreamcatcher: Spirit Lessons with Robert Lax, Poet, Peacemaker, Sage.* Ottawa: Novalis, 2002.

Graham, Dom Aelred. *Zen Catholicism.* New York: Harcourt, Brace and World, 1963.

Hammer, Carolyn R., ed. *Victor Hammer: Artist and Printer.* Lexington: Anvil Press, 1981.

———. *Some Fragments for C. R. H.* Lexington: Stamperia del Santuccio, 1967.

———. *Victor Hammer: A Retrospective Exhibition, April 4–25, 1965.* North Carolina Museum of Art, Raleigh.

Herzogenrath, Wulf. "John Cage: An Artist who Accepts Life." In *Sounds of the Inner Eye: John Cage, Mark Tobey, Morris Graves.* Tacoma, Wash.: Museum of Glass, International Center for Contemporary Art and University of Washington Press, 2002.

Jahn, Fred, and Michael Krueger, eds. *Henri Michaux, 1942–1984.* Munich: Verlag Fred Jahn, 1987.

Lippard, Lucy R. *Ad Reinhardt.* New York: Abrams, 1981.

Magid, Barry, ed. *Father Louie: Photographs of Thomas Merton by Ralph Eugene Meatyard.* With an essay by Guy Davenport. New York: Timken, 1991.

Maritain, Jacques. *Art and Scholasticism, and The Frontiers of Poetry.* Trans. Joseph W. Evans. New York: Scribner, 1962.

———. *Creative Intuition in Art and Poetry,* The A. W. Mellon Lectures in the Fine Arts, 1952, National Gallery of Art, Washington, D.C. Bollingen Series 35.1. New York: Pantheon Books, 1953.

———. *Georges Rouault.* New York: Abrams, 1954.

Masheck, Joseph. "Five Unpublished Letters from Ad Reinhardt to Thomas Merton and Two in Return," *Artforum,* December 1978, pp. 23–27.

———. "Two Sorts of Monk: Reinhardt and Merton," in *Historical Present: Essays of the 1970s,* Ann Arbor: UMI Research Press, 1984, pp. 91–96.

McInerny, Ralph. *The Very Rich Hours of Jacques Maritain: A Spiritual Life.* Notre Dame: University of Notre Dame Press, 2003.

Mitchell, Stephen. *The Enlightened Heart: An Anthology of Sacred Poetry.* New York: HarperPerennial, 1993.

Miura, Isshu, and Ruth Fuller Sasaki. *The Zen Koan: Its History and Use in Rinzai Zen.* New York: Harcourt, Brace and World, 1965.

Monte, James K. *Mark di Suvero.* New York: Whitney Museum of Art, 1975.

Nordland, Gerald. *Ulfert Wilke: A Retrospective.* Salt Lake City: Utah Museum of Fine Arts, 1983.

Novak, Michael. "Human Dignity, Human Rights." *First Things,* November 1, 1999.

Owen Merton: Expatriate Painter. Christchurch, New Zealand, Christchurch Art Gallery, 2004.

Richards, I. A. *Mencius on the Mind.* London: Routledge and Kegan Paul, 1932.

Rothenstein, John. *Victor Hammer: Artist and Craftsman.* Boston: David R. Godine, 1978.

Sekida, Katsuki, trans. and commentary. *Two Zen Classics: Mumonkan and Hekiganroku,* New York and Tokyo: Weatherhill, 1977.

Stevens, Wallace. *Letters of Wallace Stevens.* Ed. Holly Stevens. New York: Alfred A. Knopf, 1966.

Suzuki, Daisetz T. *Sengai: The Zen Master.* London: Faber and Faber, 1971.

Swan, Laura. *The Forgotten Desert Mothers: Sayings, Lives, and Stories of Early Christian Women.* New York: Paulist Press, 2001.

Switzer, A. Irwin. *D. T. Suzuki: A Biography.* London: Buddhist Society, 1985.

Sze, Mai-Mai. *The Tao of Painting: A Study of the Ritual Disposition of Chinese Painting.* Bollingen Series 49. New York: Pantheon Books, 1956.

Tobey, Mark. Introduction to Ulfert Wilke, *Music To Be Seen: A Portfolio of Drawings.* Louisville, Ky.: Erewhon Press, n.d., ca. 1957.

Wilke, Ulfert. *An Artist Collects: Selections from Five Continents.* Iowa City: University of Iowa Museum of Art, 1975.

———. *One, Two and More.* Kyoto: Kuroyama Collotype Printing Company, 1960.

Williams, Rowan. *Grace and Necessity: Reflections on Art and Love.* London and Harrisburg, Pa.: Continuum-Morehourse, 2005.

CREDITS

Books and articles quoted or cited in the text under the usual fair use allowances are acknowledged in the endnotes and bibliography.

The author wishes to thank the following for permission to cite from the published and previously unpublished writings of Thomas Merton and to reproduce ink drawings and photographs by Thomas Merton in their collections:

The Merton Legacy Trust.

The Archives of American Art.

Burns Library, Boston College.

Columbia University Rare Book and Manuscript Library.

Doubleday/Random House: *Conjectures of a Guilty Bystander* © 1975 by the Trustees of the Merton Legacy Trust.

Farrar, Straus and Giroux: *The Courage for Truth: The Letters of Thomas Merton to Writers; The Hidden Ground of Love: The Letters of Thomas Merton on Religious Experience and Social Concerns; The Road to Joy: The Letters of Thomas Merton to New and Old Friends; The School of Charity: The Letters of Thomas Merton on Religious Renewal and Spiritual Direction.*

Harcourt Brace: *Witness to Freedom: Letters in a Time of Crisis.*

HarperSanFrancisco: *Dancing in the Water of Life: The Journals of Thomas Merton, Volume Five, 1963–1965* © 1997 by the Merton Legacy Trust; *Turning Toward the World: The Journals of Thomas Merton, Volume Four, 1960–1963* © 1996 by the Merton Legacy Trust. Reprinted by permission of HarperCollins Publishers.

New Directions: *The Asian Journal of Thomas Merton* © 1975 by the Trustees of the Merton Legacy Trust; *Raids on the Unspeakable; Zen and the Birds of Appetite* © 1968 by the Abbey of Gethsemani, Inc. Reprinted by permission of New Directions Publishing Corp.

Diligent efforts were made in every case to obtain rights for excerpted material from copyright holders. The author and publisher express gratitude for use of excerpted material in cases where these efforts were unsuccessful.

Kind thanks to these additional sources of permission:

Anna Reinhardt for the Estate of Ad Reinhardt, for permission to cite previously unpublished letters of Ad Reinhardt.

Mihoko Okamura-Bekku for permission to reproduce fig. 5.

The Estate of W. H. Ferry for permission to reproduce fig. 8.

William Claire for permission to reproduce fig. 9.

Credits

The Estate of Ralph Eugene Meatyard for permission to reproduce fig. 10.

The Archives of American Art and Nicholas Wilke for permission to cite from the journals of Ulfert Wilke, and Nicholas Wilke for permission to reproduce fig. 17.

John Stevens for permission to reproduce fig. 15.

The Estate of Victor and Carolyn Hammer for permission to reproduce figs. 18 and 19.

The Estate of Jacques Maritain and the Jacques Maritain Center at the University of Notre Dame for permission to cite and translate from the correspondence of Jacques Maritain.

INDEX

Boldface numbers indicate references to photographs or artwork.